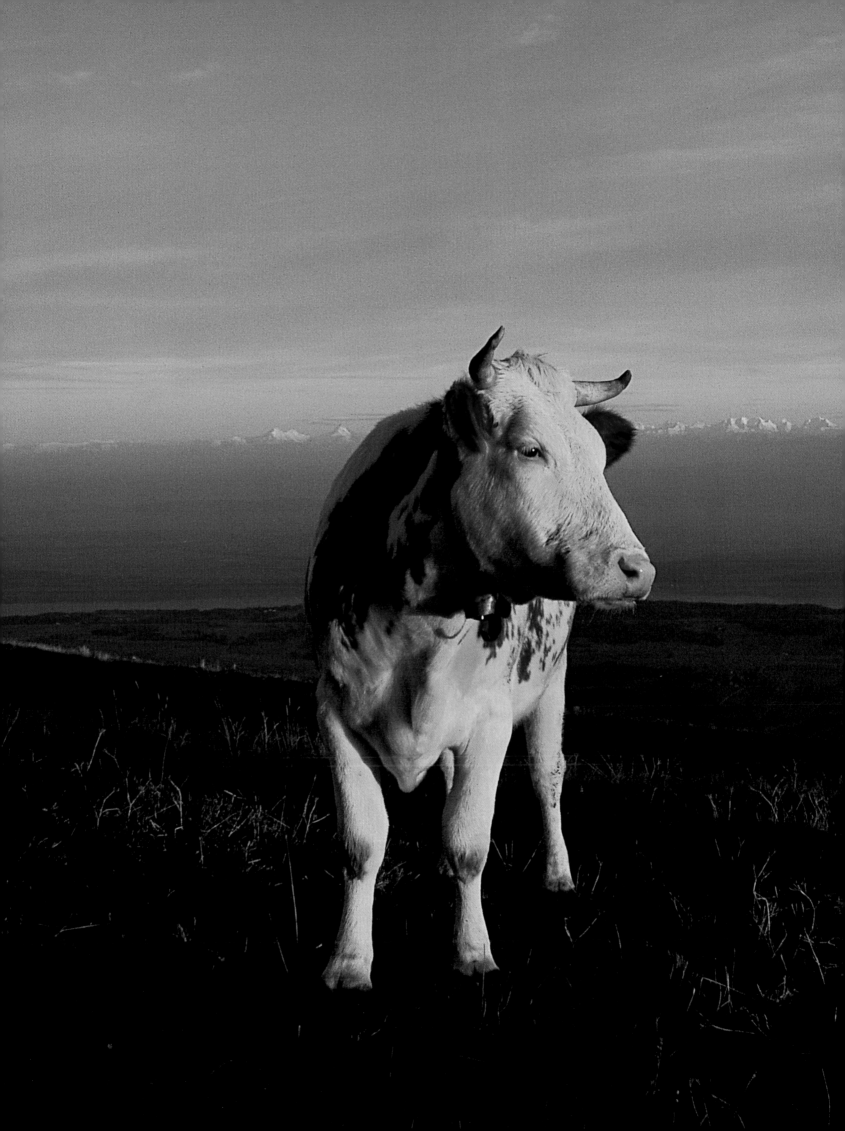

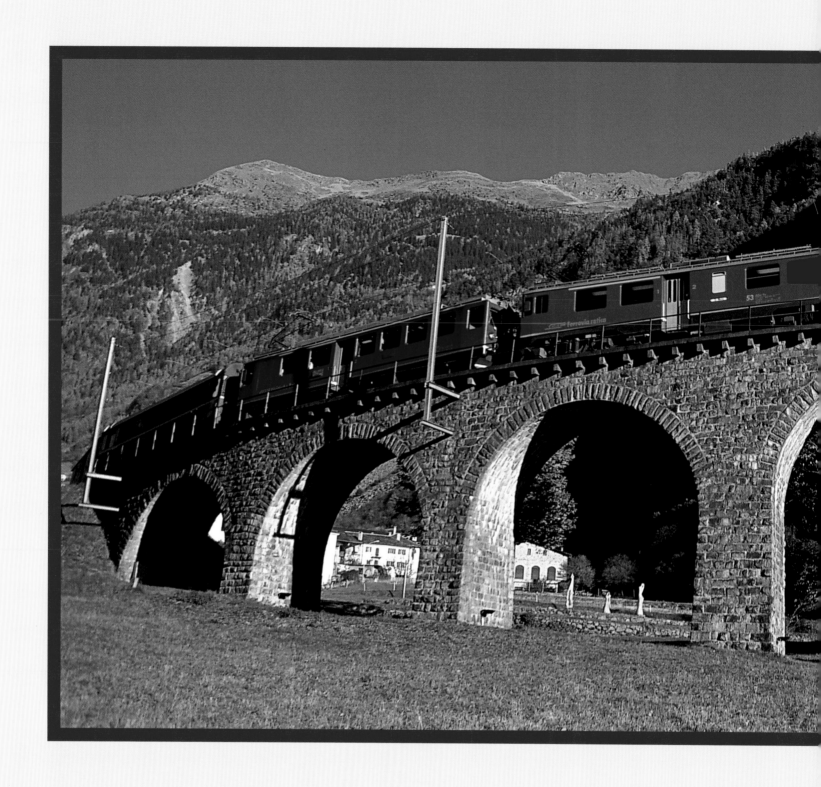

SWITZERLAND

Page 5:
Switzerland's unofficial national animal at dusk: the cow. This specimen grazes on the Chasseral in the Jura and like her 800,000 contemporaries produces the fresh milk exported all over the globe as Swiss chocolate and cheese.

The spiral viaduct near Brusio in Graubünden is a prime example of Swiss Alpine railway engineering. The train winds up a gradient of no less than 7%.

WITH PHOTOS BY
ROLAND GERTH AND
TEXT BY JUDITH
AND WOLFGANG ARLT

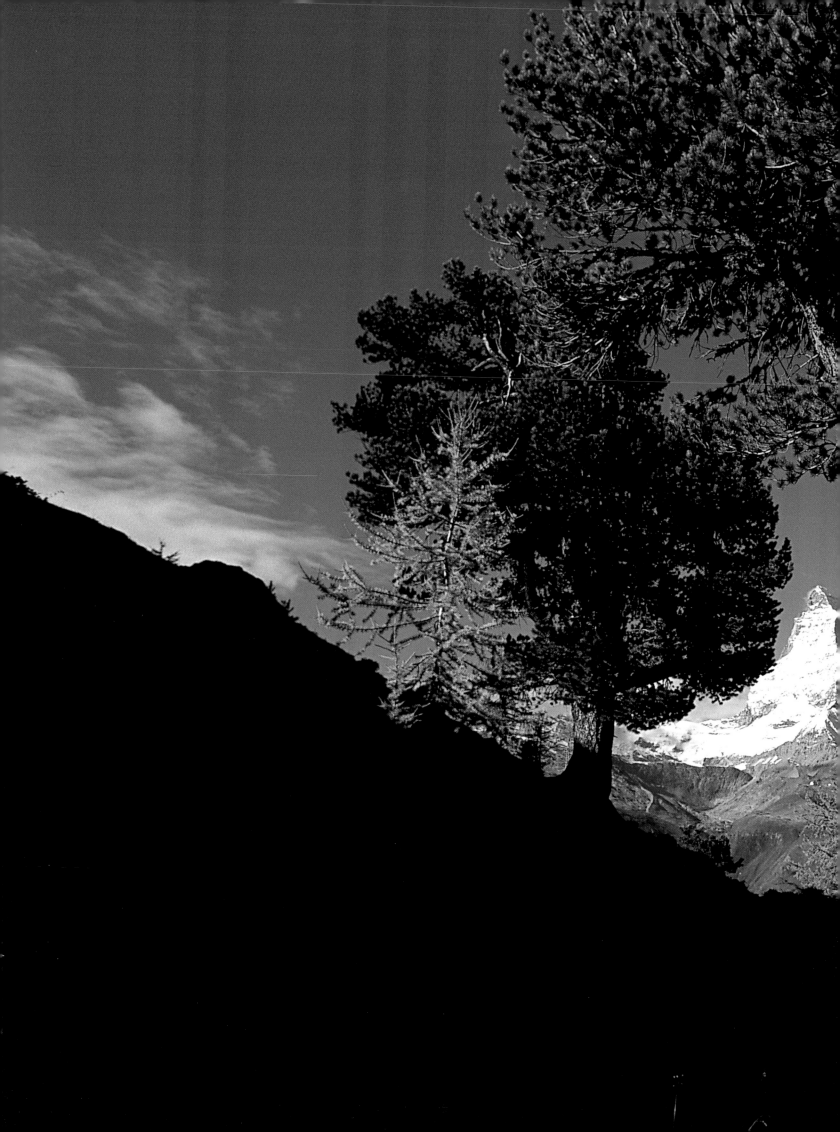

CONTENTS

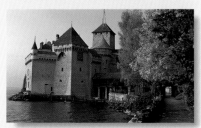

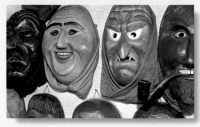

Page 8/9:
This unmistakable mountain peak looms large above the Riffelalp, at 2,222 m (7,290 ft) a dwarf compared to the 4,477.54 m (14,690.36 ft) of the majestic Matterhorn, recently re-measured using satellite technology.

Page 12/13:
Tucked into a loop in the River Aare, Bern is the capital of Switzerland's second-largest canton and the federal capital of the country as a whole. The late Gothic minster dedicated to St Vincent, built and constantly amended between 1421 and 1893, dominates the old town.

Page 14/15:
End of a sunny day in the Lower Maggia Valley north of Lake Maggiore. Celts and Romans settled here where a mild and sunny climate provided ideal conditions for farming.

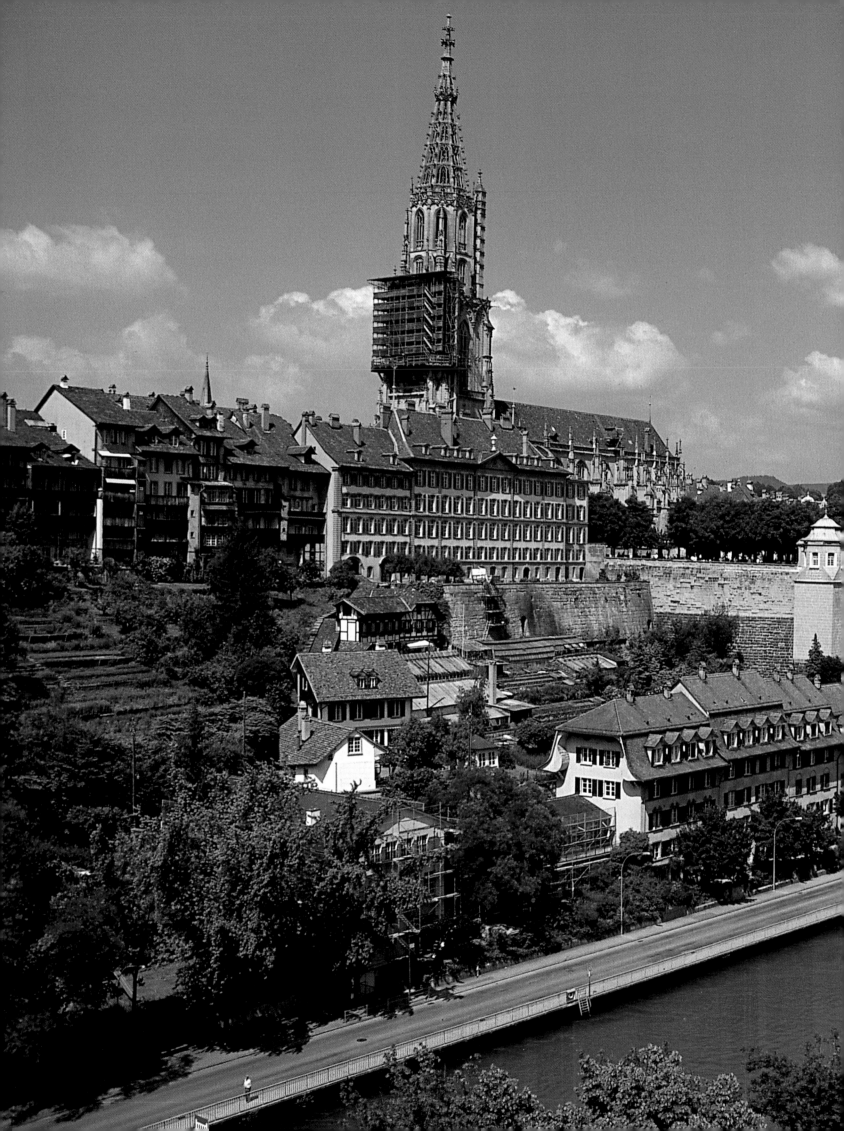

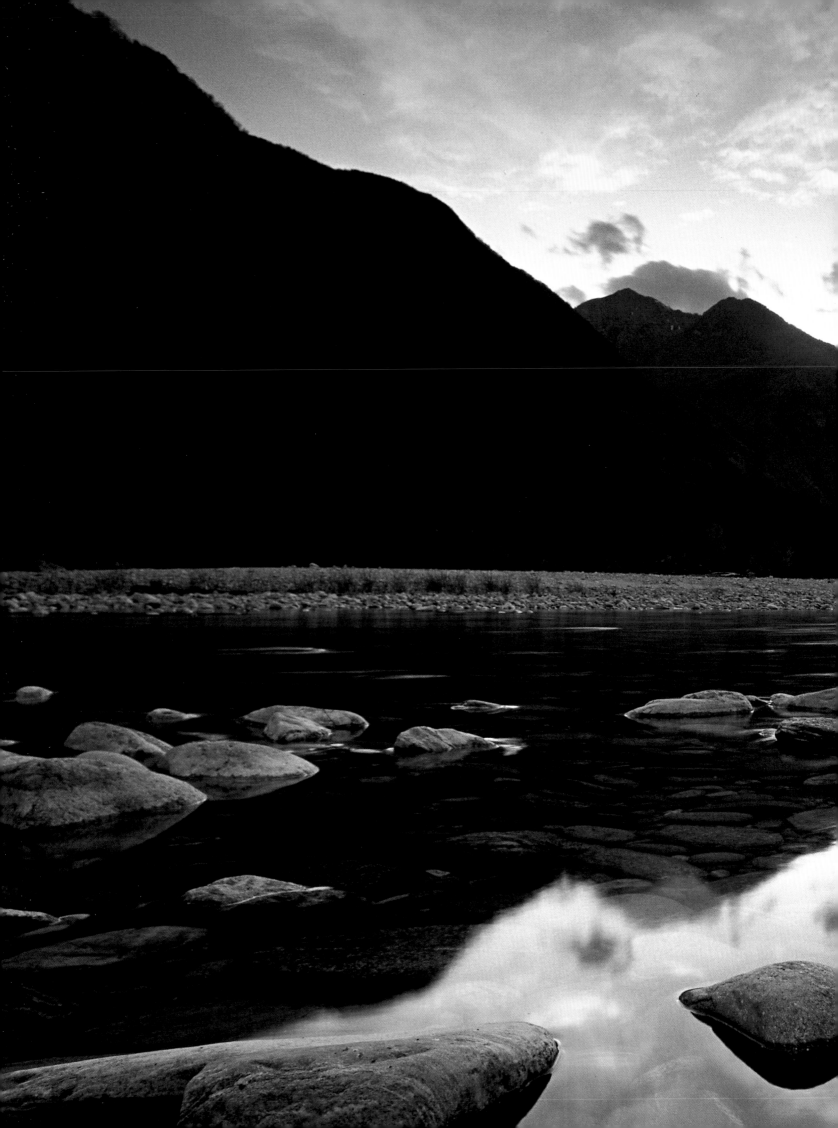

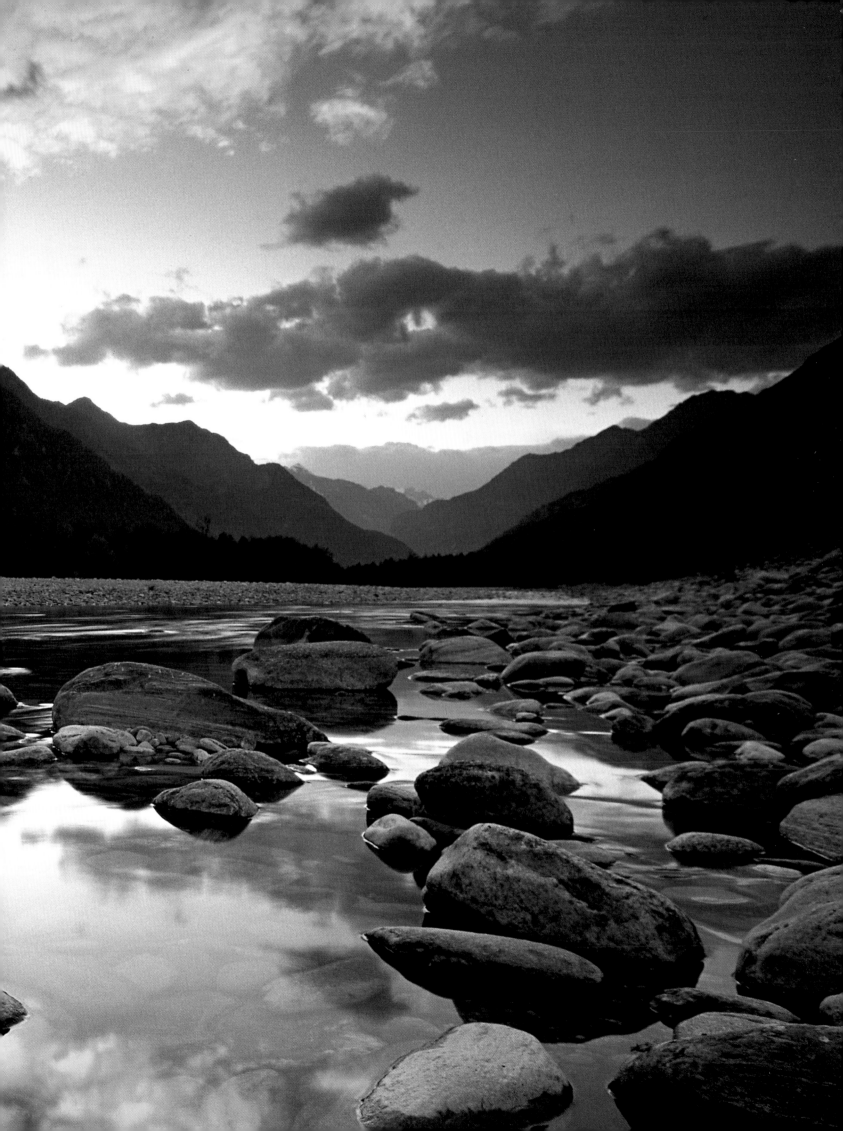

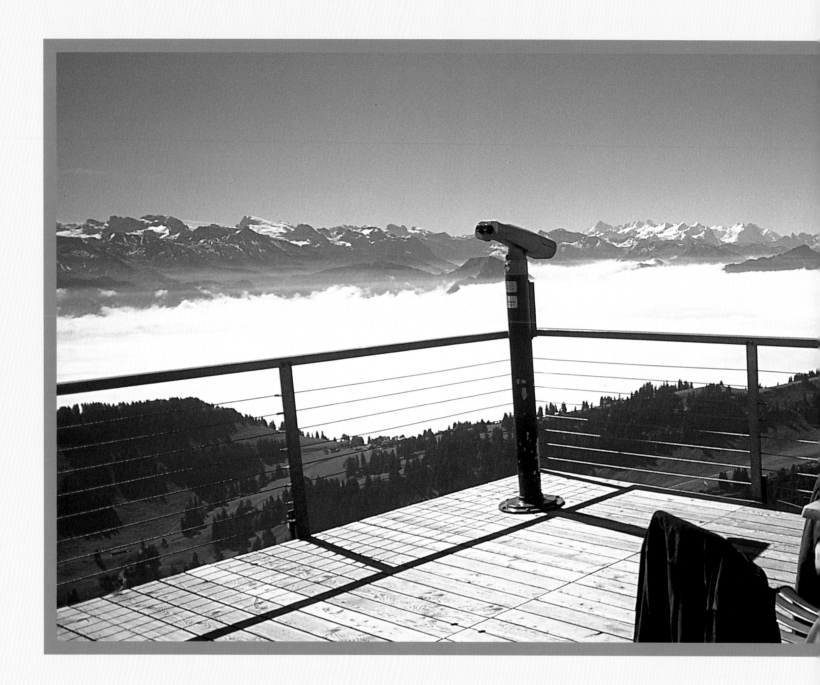

SWITZERLAND – THE BLISSFUL ISLAND

When in 1897 Switzerland's first travel writer Lina Bögli asked plantation workers on the island of Samoa where Switzerland was, several excited voices immediately replied: "In Europe, in the middle of Europe!" On hearing this Bögli claims she blushed with shame, not because she had underestimated the farmhands of Samoa's powers of orientation but because it suddenly dawned on her how unfamiliar she was with the world atlas. If she had been asked where Samoa was before she set off on her travels, she wrote, she wouldn't have been able to provide an answer.

Geographically speaking, this is of course true. Economically and mentally it isn't. Switzerland is

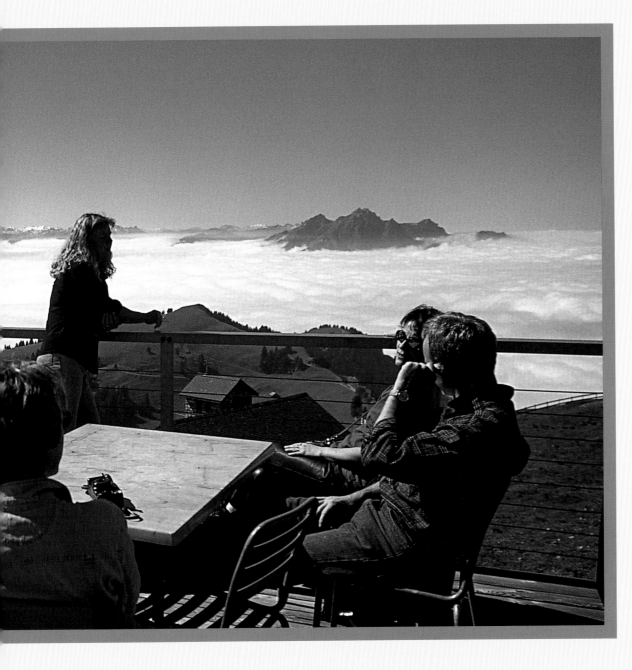

Rigi Kulm, an island in the sun above the fog and cloud 1,800 m (5,906 ft) above sea level. Hotels have catered for guests here for almost 200 years and in the chapel you can get married, helicopter shuttle for impulsive romantics all-inclusive!

a strange archaic island in the heart of Europe – and probably the highest in the world thanks to the Matterhorn. An island is an area which differs from its immediate environment.

THE SWISS MENTALITY

We Swiss are good at shutting ourselves off from the outside world yet, ironically enough, lack any sense of an inward-looking "we", something which would provide us with a common identity. "We Swiss" is thus a contradiction in terms, an illusionary concept, a non-word. We are the people of Zofingen, Lausanne, Romanshorn, Lenzburg, Winterthur, Entlebuch and Herisau – not Switzerland.

We are from Emmental, Valais, Ticino, the Engadine – and not German-, French-, Italian- or Romansch-speaking Swiss. Per head we make the highest number of phone calls to countries other than our own in the world and, according to statistics, travel abroad more often than any of our European cousins. This may be due to the smallness, to the narrowness of our country; if you want to venture far on a Sunday afternoon, you'll need your passport. It's no problem to leave and return to Switzerland within a couple of hours – no matter where in the country you start out from.

Despite these cosmopolitan delusions we refuse to let ourselves be talked into anything or dictated

to by anyone, least of all our neighbours. We function best when defending our neutrality, when insisting on retaining what is ours, when clinging to long-established traditions, when loudly proclaiming "no": no, we don't want to be in NATO; no, we don't wish to be part of the EU. We also don't want to get rid of our armed forces – nor do we want legal protection for expectant and nursing mothers. Those of us in Appenzell-Innerrhoden and -Ausserrhoden also didn't want to give women the right to legally decide on local policies until 1990, although the female electorate had had the vote in matters concerning the Confederation at large since 1971. However, we have begun to weaken; recently we said a loud "yes" to becoming a member of the UN.

"Have you ever noticed" asked Max Frisch in 1960 – and his words still hold true today – "that the word 'utopia' is only used negatively in Switzerland? That is the crux of the matter, for also Switzerland – and particularly Switzerland – stems from nothing less than the belief in a utopia. Yet today the Swiss are weaned with their mother's milk not only away from the idea of a utopia but from any desire to be radical whatsoever."

A LOOK AT HISTORY

Just two centuries ago the Switzerland we know today, stretching between Lake Geneva and Lake Constance, between the southern Alpine valleys and the River Rhine, was neither a national, political nor cultural unit.

Early Helvetian, Rhaetian and other Celtic settlements first flourished under the Romans in the first century AD, with Aventicum (now Avenches in the canton of Vaud) and Curia (now Chur in the canton of Graubünden) as regional capitals. The migration of the peoples and the arrival of Germanic tribes in the 6th century ended

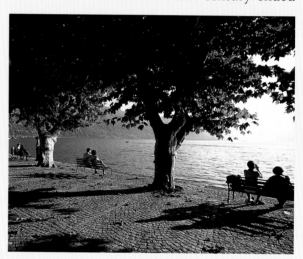

this period, with Romansch-speaking Burgundians settling in the west and German-speaking Alemanni in the east of modern Switzerland. This separation was upheld by allegiance to either the West or East Frankish kingdoms and is still mirrored today in the persisting division of the country into German- and French-speaking areas. Christianity and feudalism were established; the paling significance of Swiss towns and foreign trade in the 9th century was echoed by the dwindling importance of the Alpine passes.

The "dark period" of the Middle Ages also ended in Switzerland with the founding of numerous new towns from the 12th century onwards. The power and riches of Fribourg, Bern, Thun, Basle and Zürich soon overshadowed that of local magnates, with the cities forming alliances in an attempt to check their opponents. Whereas the league north of the Rhine finally wavered in the

face of aristocratic opposition, the areas of the German Empire south of the river profited from feuds between the houses of Zähringen, Staufen, Kyburg, Savoy, Burgundy and Habsburg, the Visconti in Milan and the Papal State. These rivalries enabled the city guilds and the village communities of free peasants in Ticino, around Lake Lucerne and in Rhaetia to secure themselves democratic rights and privileges. The foundations for a specifically Swiss interpretation of the concept of a state, direct democracy without aristocratic rule, were laid in 1182 with the Oath of Torre sworn by the farmers of the Levetina Valley around Airolo and of the Blenio Valley, who drove out the feudal lords and set up a "confed-

eration" of free citizens with their own powers of jurisdiction.

By the beginning of the 16th century, victorious battles, skilled diplomacy and a network of allegiances had given rise to the Swiss Confederation, initially an alliance of the eight ancient cantons of Uri, Schwyz, Unterwalden, Lucerne, Zürich, Glarus, Zug and Bern up until 1353 who were joined between 1481 and 1513 by Solothurn, Fribourg, Basle, Schaffhausen and finally Appenzell, forming a league of 13 cantons for the next three centuries to come.

Rhaetia, which up until the rise of the Frankish kingdom had clung to its traditional Roman language, rights and administration, was able to retain its cohesion through the strong position of its church or, more specifically, the episcopal see of Chur, despite great discrepancies in the language

and culture of its inhabitants. With the help of the cathedral chapter, the 49 juridical communities ruling the valleys more or less autonomously formed three alliances between 1367 and 1436: the Gotteshausbund (League of the House of God), the Grauer Bund (Grey League), which later gave the canton its new name of Graubünden, and the Zehngerichtenbund (League of the Ten Jurisdictions).

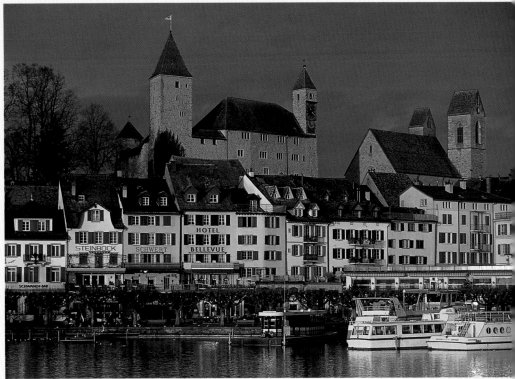

CRUEL AND FEARLESS SOLDIERS

Like Aargau, Thurgau, Valais, Valtellina and other regions before it, Ticino, however, long in the clutches of the Visconti and then the bishop of Milan, soon became dependent on the Confederation and the Confederates, who appointed bailiffs to rule their isolated communities and shared estates to their advantage.

In the course of their many battles over land the Confederates had earned themselves a reputation as cruel and fearless soldiers, meaning that from the 15th century onwards "Swiss" mercenaries could be found stiffening the ranks of almost all the armies of Europe, often having to fight against fellow countrymen.

The loose alliance of the 13 very different cantons and their various holdings survived the Reforma-

Above:
At the south end of Lake Zürich is Rapperswil Castle, museum and centre for Swiss-Polish relations. Poland's liberty column bearing the inscription MAGNA RES LIBERTAS ("Freedom is most important") has stood here since 1868; until 1927 the castle housed Poland's exiled national museum.

Top left:
The attractions of Switzerland in a nutshell: imposing mountains, crystal-clear water and buildings which have survived centuries without war or devastation. The old houses of Montellier perch scenically along Lake Geneva near Rivaz.

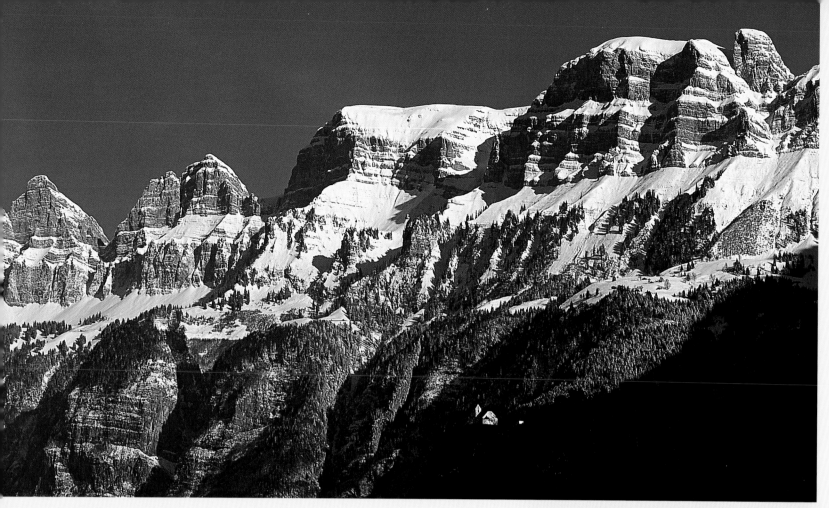

tion, Counter-Reformation, Thirty Years' War and industrial revolution of the 18th century with little amendment to the "ancien régime", although this period in its history was marred by constant inner turmoil and often bloody conflict between Calvinists, Protestants and Catholics, townsfolk and peasants and patricians and craftsmen. A change in foreign policy meant that in 1648 the Confederation ceased to be part of the German Empire, leaving it free to indulge its neutrality in close allegiance with France and to also earn good money through the "export" of mercenaries to the warring factions of Europe: "Pas d'argent, pas de Suisse".

THE END OF A LONG SLUMBER

It took a revolution in France and the advance of Napoleon Bonaparte in 1798 to rudely awaken Switzerland from its blissful slumber. Although Napoleon was forced to reverse his dissolution of the Confederation in favour of a Helvetic Republic in 1803, Aargau, St Gallen, Graubünden, Ticino, Thurgau, Vaud and after 1813 Geneva, Valais and Neuchâtel had now achieved a permanent state of equality in the league of states whose individual components were forthwith renamed "cantons".

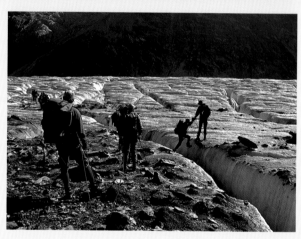

THE CONGRESS OF VIENNA

At the Congress of Vienna mutual competition and recognition of the fact that a neutral zone in the heart of Europe could prove useful outweighed the territorial hankerings of the participating European powers. The Swiss Confederation, still the official title of modern Switzerland, was born. It took another 33 years and two civil wars, however, for the country's coalition of cantons to become a national state in its own right in 1848, complete with a democratic federal constitution, parliament, capital city and common system of weights, measurements and currency – acquisitions its German and Italian neighbours still had to wait for.

Since 1848 no military conflict has been fought on Swiss soil. The country's neutrality survived the trials and tribulations of the Franco-Prussian War and the First World War intact, although the inhabitants of the various cantons harboured clear sympathies for one side or the other, depending on their native tongue. Under these conditions Swiss industry boomed and agriculture focussed more and more on livestock farming, churning out a rich yield of milk products which were exported abroad.

At the same time Switzerland reinvented itself as the first holiday destination in the world, with chic hotels, mountain railways and the idea of using its elevated peaks for new modes of sport, which included skiing, tobogganing, bobsleighing and ice skating. Those who had the necessary means spent their winters in St Moritz and summers on the shores of Lake Lucerne, impervious to the wars and conflicts raging beyond the snow-capped summits.

GONE WITH THE WIND

When the air is clear and the mountains appear particularly majestic and almost close enough to touch, then Switzerland is in the grips of a föhn, a dry, warm katabatic wind formed by the passage

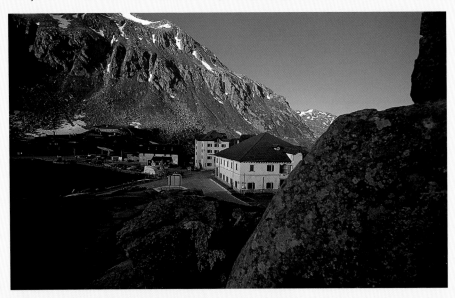

Above:
The St Gotthard Hospice 2,095 m (6,874 ft) above sea level has provided shelter for weary travellers since the 14th century. Today it is both a hotel and national museum dedicated to the Gotthard Pass with exhibits and documents focussing on the geographical and religious centre of Switzerland.

Left:
In summer the eldorado of water sports fanatics, in winter the rich and beautiful play golf and polo or waterski across frozen Lake St Moritz, pulled by not by motor boat but by horse.

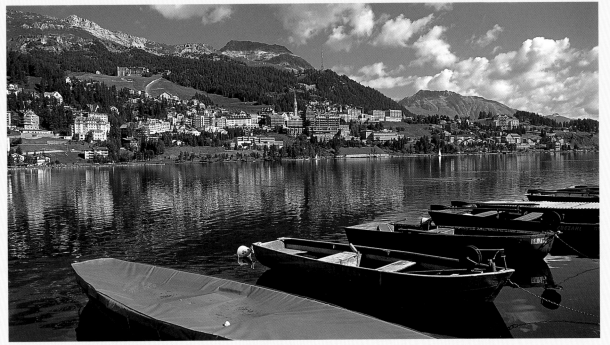

With new job opportunities in factories, banks, the construction industry, the tourist trade and the possibility of doing good business with any country or ruling power in the world the poor, rather backward Confederation of emigrants mutated into the modern, rich nation boasting all the social and political trimmings of the 21st century. This lucrative neutrality came at a price, however: international isolation.

of air currents across the Alps. Instead of then enjoying the larger-than-life panorama of our unique mountain scenery we Swiss suffer from headaches, circulatory and nervous disorders, depression and anxiety.

These inclement conditions are probably one of the factors which have prompted our mass exodus abroad. Today around one fifth of the country's in-

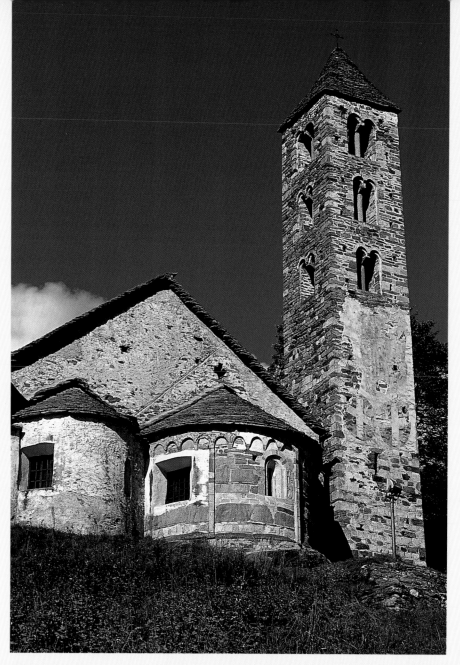

yet social contact beyond the everyday "grüezi", exchanges of ideas and a general sense of belonging is something newcomers have to fight hard for.

GREAT GUESTS OF SWITZERLAND

Humanist Desiderius Erasmus of Rotterdam was the first famous foreigner to remain an outsider in Switzerland. He spent almost ten years in Basle where he was granted the freedom to write and print his ideas with little or no restriction. What the city was unable to provide, however, were like-minded individuals willing to engage in scholarly exchange. If it had, the great thinker might have gone down in the history books as Erasmus of Basle.

Voltaire, who settled on the Swiss shores of Lake Geneva as an "old" man in 1755 with the intention of spending the rest of his days there, soon vehemently championed the founding of a theatre in Geneva which was to unite "the wisdom of Sparta with the elegance of Athens". The great son of the city, Jean Jacques Rousseau, who was the first to laud the magic of the Geneva region in his novels, unwittingly making travel to Switzerland a fashionable pastime, bitterly contested Voltaire's plans for the theatre. He was convinced that his adversary's proposals would make a whore of the

Above:
One of the most beautiful Romanesque buildings in Switzerland is the church of San Carlo Negrentino above Castro in the Blenio Valley with its 12th-century frescos. There are marvellous views out across the valley from atop its campanile.

Right:
East of Lake Walenstadt near Berschis the pilgrimage chapel of St George's clings to a rocky outcrop. Inside the 15th-century frescos are impressive.

habitants reside in the "fifth Switzerland" as Swiss ex pats. Architects in particular have always seemed to make a better career for themselves beyond the narrow confines of our hilly homeland. One of the first Swiss pioneers of international renown was Le Corbusier, who left his home town of La Chaux-de-Fonds in the canton of Jura to become modern urbanism personified in his adopted France. William Lescaze from Geneva and Albert Frey from Zürich implemented revolutionary projects in the USA. And at the turn of the 20th century Swiss architects such as Mario Botta, Bernard Tschumi and the Basle team Herzog & de Meuron erected prestigious edifices on foreign terrain.

In return almost one fifth of the present Swiss population are foreigners. People persecuted across the globe have traditionally sought refuge in Switzerland. This has and in most cases still is provided,

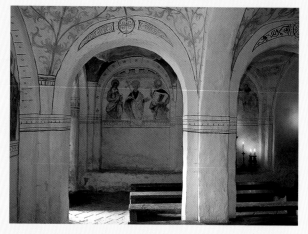

"unique virgin of Geneva", with men having to buy their wives expensive dresses and jewellery, signalling the beginning of the end, ruin and the road to eternal damnation. Despite Rousseau's misgivings Voltaire's theatre was finally built in wood in 1766. The advocates of decency, morality and tradition promptly set it alight.

Germany's "iron larch", revolutionary fighter and writer Georg Herwegh, was one of the first to seek political asylum in the new canton of Basle District. Deported from Prussia, Saxony and also the canton of Zürich he was finally made a citizen of the community of Augst in 1843 in return for a down payment of 600 Swiss franks and "the usual fire bucket". Herwegh left Switzerland in the same year and spent much of the rest of his life in France and Germany.

Mikhail Aleksandrovich Bakunin, the father of modern anarchism, lived in Switzerland from 1867 until his death. He found his most loyal, if critical, followers in the watchmakers of Jura. The meticulous work being carried out with the utmost precision at the timepiece studios was, according to Bakunin, "intelligent [and] artistic" and not as stultifying as operating machinery. He thought the horologers "better educated, more liberated and happier" than other proletariats; they were self-confident in their expression of rebellion, unhindered by dullness, and were at once self-willed, imaginative, bold and impetuous.

Important protagonists of the literary modern age, such as James Joyce, Alfred Döblin, Robert Musil, Thomas Mann and others, spent the First World War in Switzerland. The Dadaists fled the Great

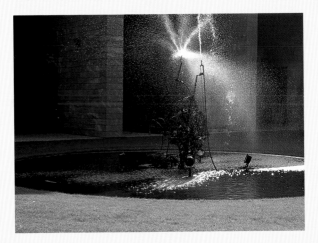

War to Zürich, "this great nature reserve, where the nations safeguard their final preserves" (Hugo Ball). They worked alone with almost no contribution from their Swiss-German counterparts; crime writer Friedrich Glauser, he of the legendary Constable Studer, was the only intellectual to constructively communicate with the Dadaists.

Their striving towards the modern in art with no respect for tradition had little to no consequence for Switzerland, however.

Hermann Hesse and Carlo Kerény lived in Ticino, their presence of little importance to contemporary cultural life. The same applied to Paul Klee and Stefan George. The people of Ticino have never made any particular effort to honour their guests. Even today the village of Ascona has shown

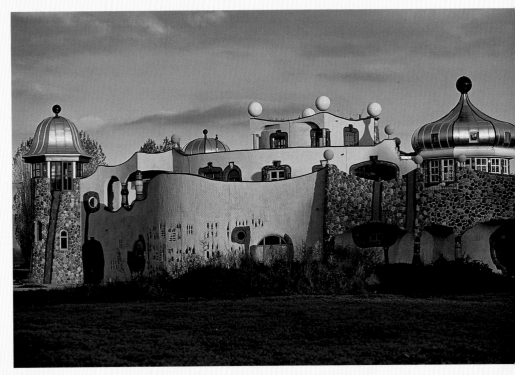

no reaction to the artistic escapades of the Monte Verità artists' colony or to the regular international Eranos congresses whatsoever. One sole acknowledgement has been to make Wolfgang Hildesheimer, who has lived and worked in Graubünden's Puschlav for over 35 years, an honorary citizen.

AMONGST OURSELVES

The sheer linguistic variety of Switzerland is generally considered exemplary. The supremacy of Swiss-German and German-Swiss is undisputed, if not always popular. With the exception of French, the percentage speaking Switzerland's official languages has slightly fallen over the past few decades in favour of other tongues. Today ca. 64 % of the Swiss speak German, 20 % French, about 8 % Italian and just 0.6 % Romansch. The frequency of use of lan-

Above:
The last edifice Austrian artist Friedensreich Hundertwasser created before his death in 2000 was the market hall in Staad-Altenrhein on Lake Constance. Opened in September 2001, its golden domes glint invitingly in the sun.

Left:
Jean Tinguely (1925–1991) made original "machine sculptures" out of scrap metal and old engines, such as the Carnival fountain outside the city theatre in Basle.

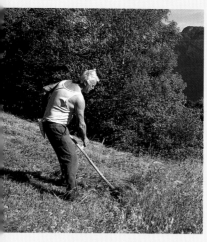

Above:
The Alpine slopes are often too steep for modern farming machinery. In such cases mountain farmers, here near Mels, have to resort to the traditional scythe.

Right:
In the valley near Lauterbrunnen cud-chewing bovines idly watch people puffing up the hillside in their walking boots. Why make life difficult when it can be this easy?

Far right:
Farmers and cows taking a well-earned rest on their ascent of Alp Selun. During the summer the cows' milk will be made into delicious mountain cheese.

guages common to immigrant workers and refugees, has however, increased. Switzerland is no longer quadrilingual but multilingual, with Slavonic languages, Spanish, Portuguese, Turkish and English hot on the heels of German, French and Italian and well in front of Romansch in the popularity stakes.

Even Swiss-German itself is not a common language; each canton, each village even has its own individual permutation. "Swiss-German" is thus another contradiction in terms, an illusionary concept and non-word. Nobody in Switzerland simply speaks Swiss-German. When I used to spend the school holidays with my grandma in central Switzerland the neighbour's children laughed at me because I didn't speak their singing cantonal dialect. At my gran's in Schwarzbubenland, however, it was me who mocked the kids there for softening every "d" to a Hinterwalden "ng". When years later my husband from Berlin

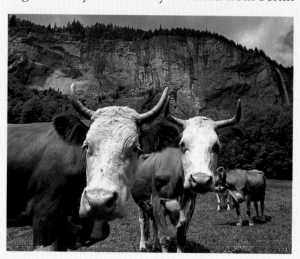

valiantly attempted to learn Swiss-German, he gave up after the first lesson when I presented him with at least 20 alternatives for the Swiss greeting. Friedrich Dürrenmatt described his linguistic situation as follows:

"I live in the French-speaking part of Switzerland because the people who live here speak neither the language I write nor the one I speak. With my wife and children I only speak Bernese German, and if I'm with my Swiss friends, with Frisch or Bichsel, for example, I speak Bernese German, Bichsel the Solothurn dialect (almost Bernese German) and Frisch the German they speak in Zürich.

When they were younger my children answered Frisch in German when he spoke to them, thinking Zürich German was German."

OF MEN AND WOMEN

At the eastern bridgehead of the oldest bridge in Basle Bettina Eichin's bronze Helvetica squats atop a sandstone pillar, chin propped in the palm of her hand and elbow resting on bended knee. This is an untypical, unheroic Mother Helvetica. She appears exhausted and vulnerable, has laid her sword and shield insignia to one side with her suitcase, her coat slung over the parapet. She's even removed her laurel wreath and dangles it carelessly in her left hand, as if about to drop it into the water. She stares downriver to where the Rhine exits Switzerland.

The allegorical figure of Helvetica had a genuine counterpart in Verena Leu from Ebersol in canton

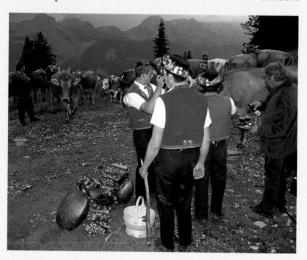

Lucerne. No less than two patriotic deeds which have borne considerable influence on the Swiss state in the making are attributed to this brave woman. On the eve of the Sonderbund civil war she managed to prevent the French prime minister from marching into a seething Switzerland. Three years later she saved the estate of Lucerne from the volunteer corps by kidnapping their captain. Leu was revered across Europe as Helvetica, the mother of all peoples. Her "school of life" founded near the Seelisberg in the canton of Uri was patronised by aristocrats, artists and writers from all corners of the globe. Plagued by local village inhabitants, however, she was

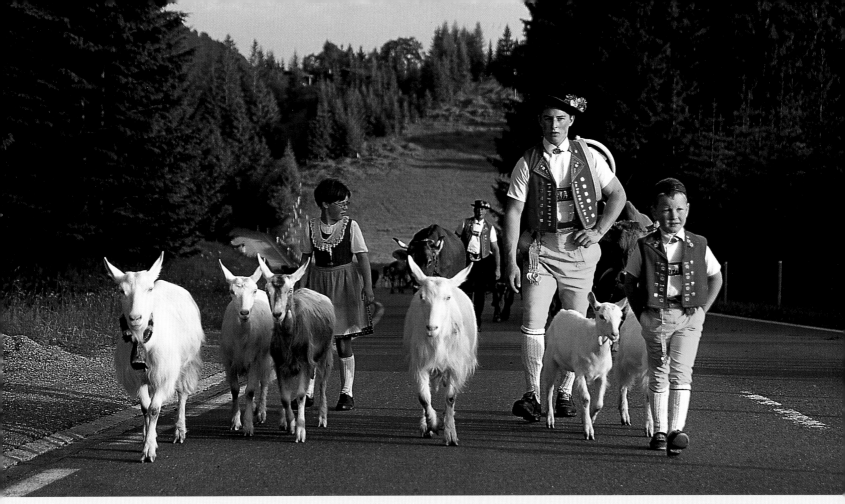

forced to flee in 1856 and died in a landslide of mud and scree. Legend has it that to this very day she haunts the lonely peaks of Mount Seelisberg.

Emily Kempin Spyri, the niece of children's author Johanna Spyri, was the first woman from the German-speaking part of Europe to become a lawyer. Walter Kempin, liberal-minded pastor and founder of the Red Cross as a civilian institution, promoted the studies and career of his wife for which he was thrown out of office. The Swiss allowed Emily to study in Zürich but once graduated nobody wanted to employ her as a lawyer, let alone a judge. She found both a job and a purpose in New York, setting up a school of law for women. Following a nervous breakdown she was committed to the Friedmatt Psychiatric Clinic in Basle, where she died in 1901 at the age of just 48.

The first step towards equal rights in the history of the Confederation was made by Sophie Sauer-Baumgartner in her last will and testament from 1938. In it she left 5,000 Swiss franks to the population of Liestal, stating that the money be used to present every female primary school pupil in the village with a special cake each year on May 15, St Sophia's Day. What became known as the "Sophieweggen" was intended to "make good a long-term neglect of the girls". For years Liestal's boys had been given a sweet bun on Ascension Day (an "Auffahrtsweggen") while the girls had gone empty-handed.

Lina Bögli, a contemporary of Emily Kempin Spyri, was one of the first Swiss women to gain freedom and independence without destroying herself in the process. The daughter of an impoverished farmer in Bernese Oberaargau, through sheer hard work and thriftiness she financed her teacher training course herself to then embark on an international career as a language teacher and travel writer. She worked in Galicia for many years, travelled the world on her own for ten years and spent three years in India before retiring to Herzogenbuchsee and the first home for senior citizens in Switzerland. At the beginning of the extraordinarily emancipated stage in her life when she decided to set off on her ten-year journey, in July 1892 Lina Bögli wrote in the travel journal which was to make her world-famous: "Yes, to be a man; now that would be freedom!"

Heidi and Peter the goatherd reincarnated during the traditional yearly driving of goats and cattle up to the high Schwägalp on Mount Säntis.

Page 26/27:
The Säntis is the highest elevation in the Alpstein Massif. 2,504 m (8,215 ft) up, there are panoramic views of the two halves of Appenzell and the canton of St Gallen.

25

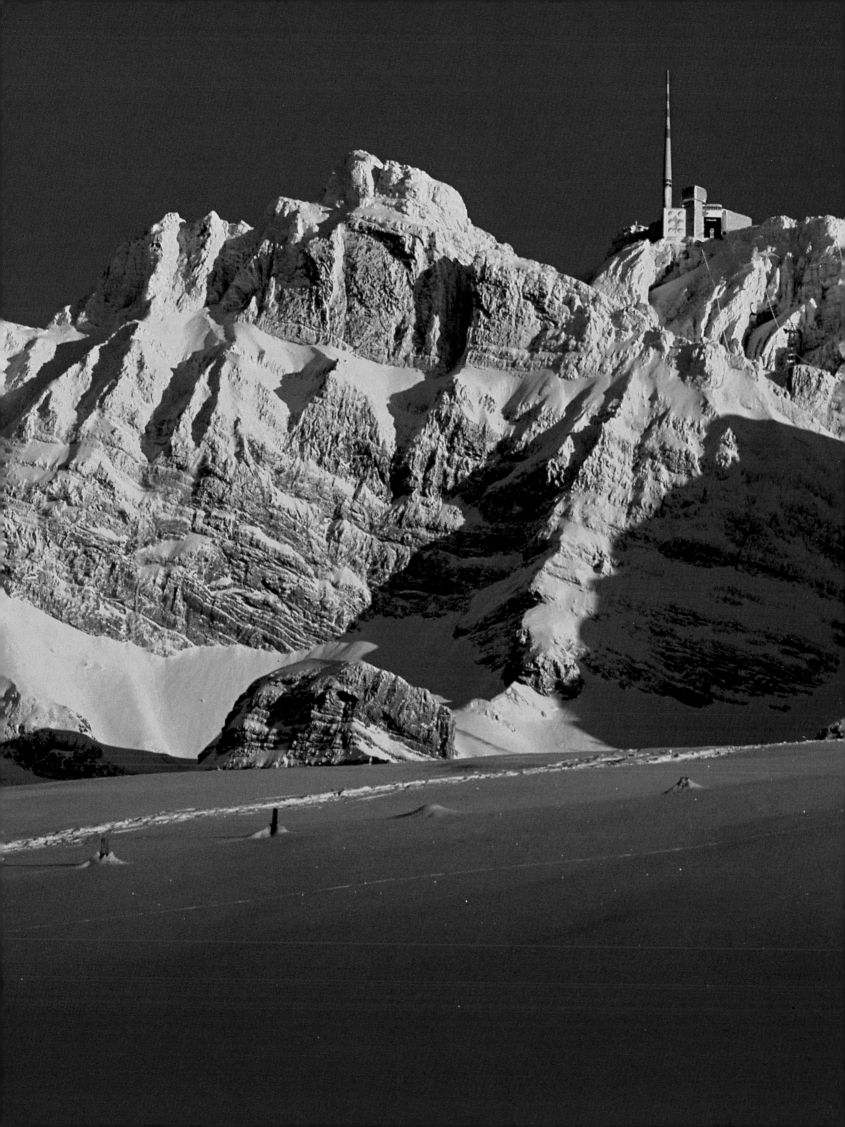

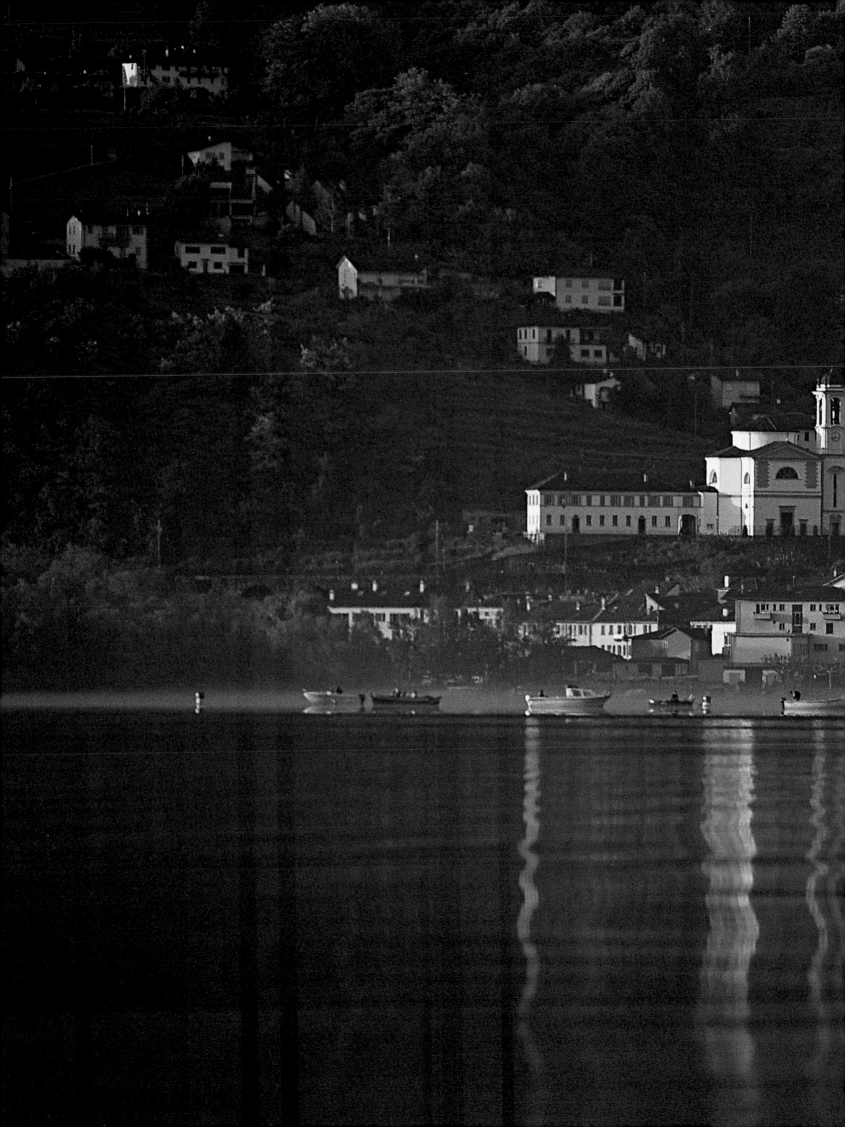

WATER AND WINE – FRENCH-SPEAKING SWITZERLAND

Over a thousand years ago, after settling in the Helvetian region, the two Germanic tribes of the Burgundians and the Alemanni linguistically went their separate ways. West of what is now scathingly referred to as the "Rösti divide" French developed, with various German dialects spreading throughout the east. Up until the beginning of the 19th century this linguistic boundary also served as a barrier hindering Confederate expansion, with just small areas of Bern and Fribourg inhabited by French-speaking minorities. These cantons have remained bilingual to date, as has Vallais (German Wallis), which together with Genève (Genf or Geneva), Neuchâtel (Neuenburg), Vaud (Waadt) and the Jura make up French Switzerland.

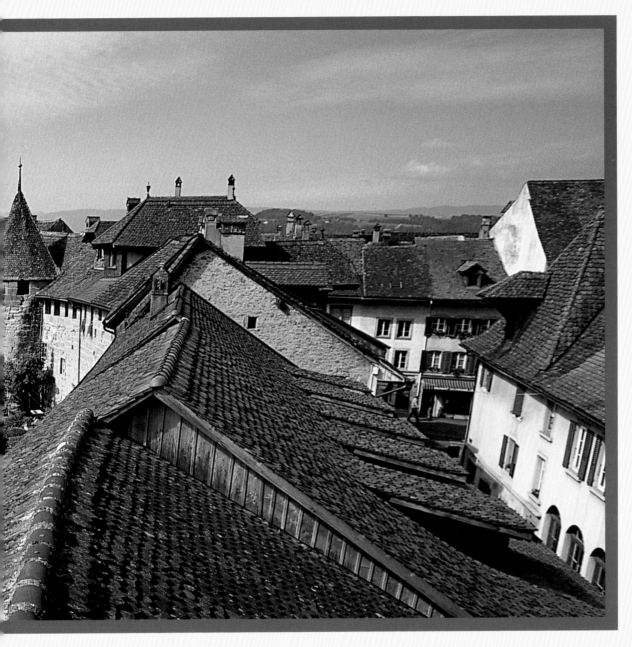

Page 28/29:
The parish church of San Carlo beams down on the fishing boats bobbing along the northeastern shores of Lake Maggiore at Magadino, once a major trading port. The nearby Bolle di Magadino bird sanctuary on the River Ticino delta is today a big pull for nature lovers.

Morat (Murten) is on the border to French-speaking Switzerland. The fortified town walls from the 15th century are among the best preserved in the country. At the Battle of Morat in 1476 the Confederates seized the Burgundian crown jewels, providing them with an instant source of income.

Other predominant features of western Switzerland are water and wine. The River Rhône runs the entire length of Valais from its source at the Rhône Glacier, its steep riverside slopes providing ideal conditions for Switzerland's largest wine-growing area. The velvety red Pinot Noir is typical of this region. The many vineyards along the northern shores of Lake Geneva, through which the Rhône flows from Montreux to Geneva, are home to the white Chasselas or Gutedel grape. Beyond Geneva the river traverses the final miles of Switzerland with vineyards lining its banks before entering France. The fruity red Gamay wine produced here is typical of western Switzerland and a good vintage to savour when gazing out over the waters of Geneva.

If you want to get on the wrong side of the French-speaking populace of Lake Geneva, call it precisely that – the English equivalent of the rather plump, German "Genfer See" – and not the more elegant Lac Léman of Celtic and Roman origin the French-Swiss prefer. Whichever nomenclature you use, at 90 thousand million cubic metres (3,178 thousand million cubic feet) of water it's the largest lake in Europe, the almost 600 square kilometres (230 square miles) of which lap the shores of three Swiss cantons and the French "département" of Haute-Savoie. Shaped like a crescent moon it stretches 72 kilometres (44 miles) east to west and measures 14 kilometres (9 miles) across at its widest point. Picturesque towns

31

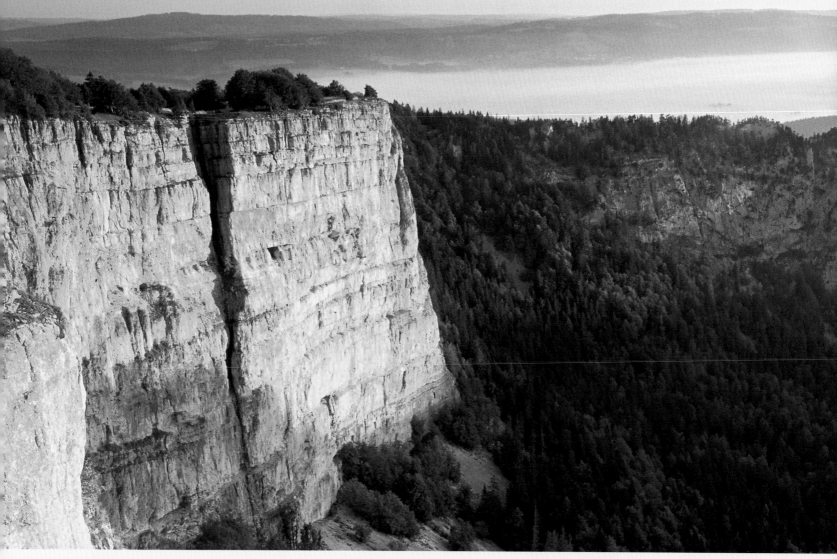

Above:
In places the rocky walls of Creux du Van, the largest gorge in the Swiss Jura, have a sheer drop of 160 m (525 ft). The gorge is four km (2.5 m) long, up to 1,200 m (3,937 ft) wide and 500 m (1,640 ft) deep. The magic of this beautiful place is best experienced at dawn or sunset.

Right:
St Ursanne in the canton of Jura nestles in the only bend in River Doubs which runs through Swiss territory. The romantic little town started off as a hermitage where in the 7th century Irish monk Ursicinus lived a life of recluse.

and castles in the midst of lush countryside line its northern shores like a string of pearls, made famous by Voltaire, Rousseau, Byron and other masters of the pen. Montreux, Vevey and Lausanne, the "capital of French-speaking Switzerland", effuse the French way of life and "joie de vivre", trumped only by the metropolis nestling at the southwestern tip of the Swiss Confederation: Geneva.

Almost 200 years ago French foreign secretary Talleyrand claimed: "There are five continents: Europe, Asia, Africa, America – and Geneva". Mentioned in the annals of Julius Caesar, rather untypically for Switzerland this city has had more influence on the world at large than on its immediate surroundings. From the fall of the Roman Empire to the invasion of Napoleon the city's lucky inhabitants, never numbering more than a few tens of thousands, managed to doggedly defend their independence. Geneva is the stuff revolutionary ideas are made of. In the 16th century the rigorous Reformation of Farel and Calvin turned the little town into the

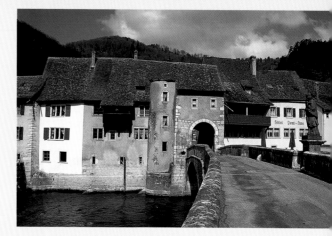

Rome of Protestantism, helping to establish the code of puritanical ethics which has been instrumental in the development of our modern world economy. 200 years later Jean Jacques Rousseau, the city's most famous personality, provided much of the impetus for the French Revolution. The concept of a peaceful coexistence of the peoples of the world has been embodied here in organisations such as the Red Cross, the League of Nations and the numerous divisions of the UN. The greatest radical change to our modern age was also made in Geneva at

Wine from Neuchâtel was even served at the Prussian court, for from 1707 onwards the city and province of Neuchâtel were ruled by Berlin. Frederick I, who had just been crowned the first king of Prussia, came into the possession of the Swiss town after a series of complicated tussles over inheritance and succession. Nothing changed when in 1814 the Congress of Vienna handed Neuchâtel – and Geneva – over to the Confederation. For decades the good burghers of Neuchâtel were thus both Helvetian republicans and monarchists, French-speaking Swiss and Prussians alike, before in 1857 Frederick William IV bowed to French pressure to renounce his rights to the city. He retained the title of count of Neuchâtel, however;

Below:
Place de la Palud in Lausanne, centre of the market quarter in Vaud's provincial capital. Fruit and vegetables from the sunny northern slopes and fresh fish from Lake Geneva are on sale here.

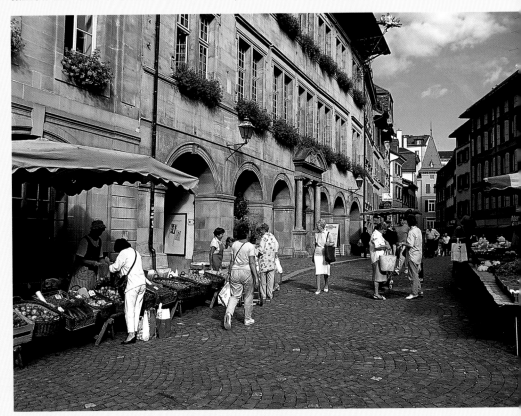

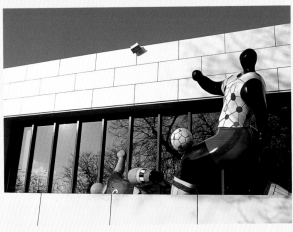

the CERN research centre, where not only the first antimatter particle was artificially created but where in 1989 Tim Berners-Lee invented the World Wide Web, the major element behind today's internet data highway.

Water and wine don't just play an important role in the southern parts of French Switzerland; the sun-soaked northern slopes of Lake Morat in the canton of Fribourg and also the elongated Lake Neuchâtel produce good yields of Chasselas and Pinto Noir grapes.

Emperor William II was one of his more infamous successors to include this epithet among his long list of names.

The Jura is not only the nothernmost region in French Switzerland but also the youngest. The Catholic, French-speaking region which had to be forced onto the canton of Bern by the Congress of Vienna in 1815 has been a canton in its own right only since 1979. This is energetically celebrated each year on January 1 – naturally not without a bottle or two of good Swiss wine.

Left:
Lausanne is the seat of the International Olympic Committee IOC. The adjoining Olympic Museum is adorned with figures fashioned by French artist Niki de Saint Phalle.

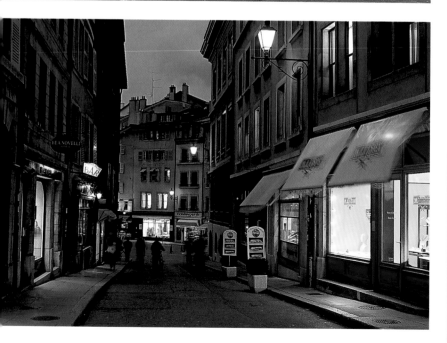

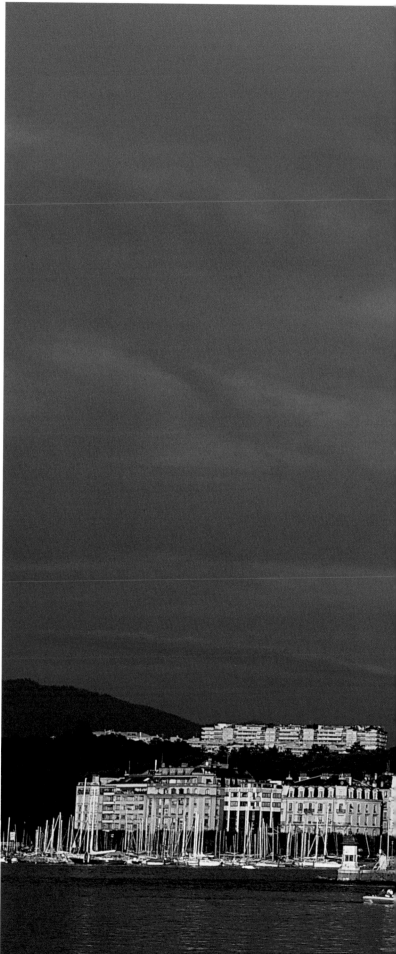

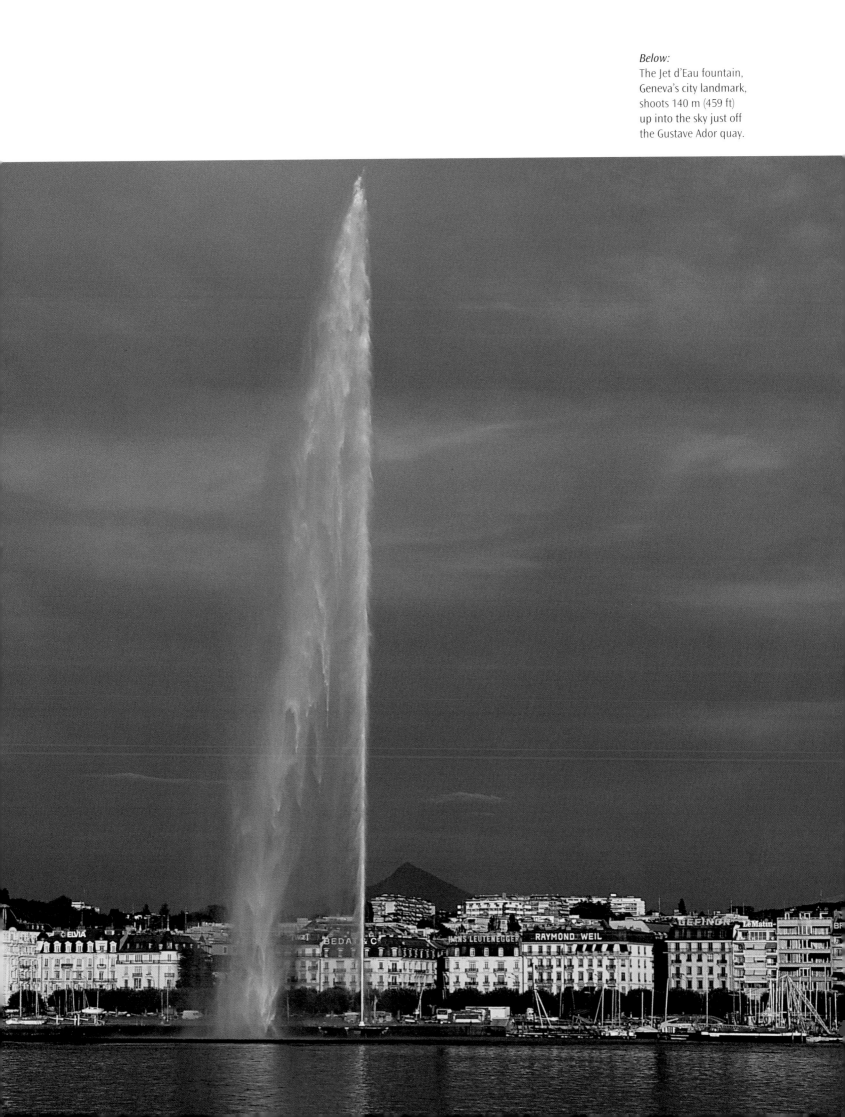

Below:
The Jet d'Eau fountain,
Geneva's city landmark,
shoots 140 m (459 ft)
up into the sky just off
the Gustave Ador quay.

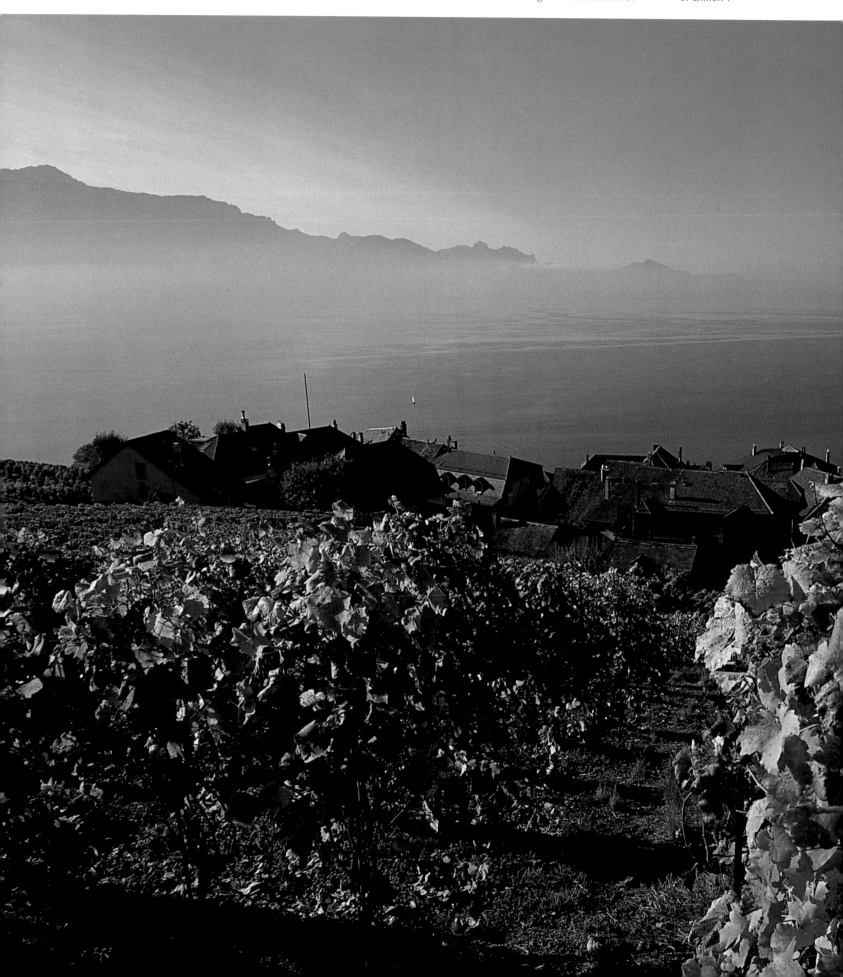

Below:
High up on the northern slopes above Lake Geneva grow the grapes which produce the area's excellent vintages. Pinot Gris and Chasselas vines, such as these outside Epesses, have been cultivated here for centuries.

Top right:
Château de Chillon outside Montreux has controlled the route along the northeastern edge of Lake Geneva for 1,000 years. Lord Byron made the castle famous in 1816 with his poem "The Prisoner of Chillon".

Centre right:
Château Chatelard is also not far from Montreux. Its architecture strongly betrays the influence of northern Italy.

Bottom right:
In the 13th century Count Amadeus V of Savoy had a fortress built in Rolle, halfway between Montreux and Geneva. Instead of taxes the castle now only demands money for souvenirs from passers-by.

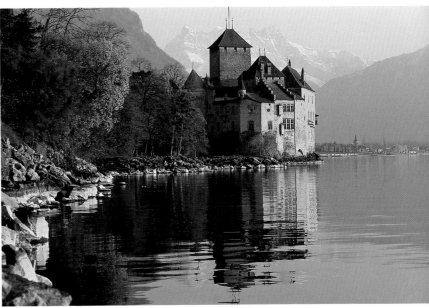

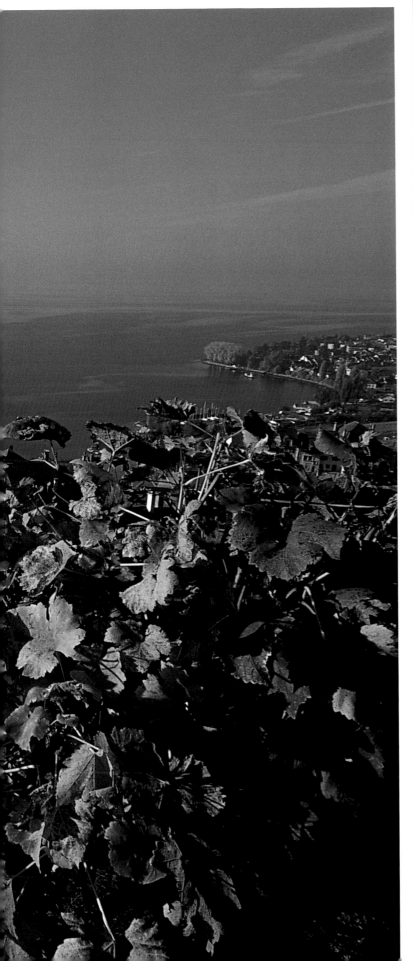

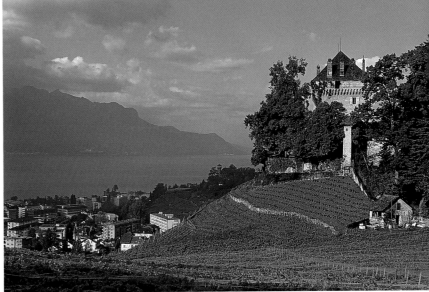

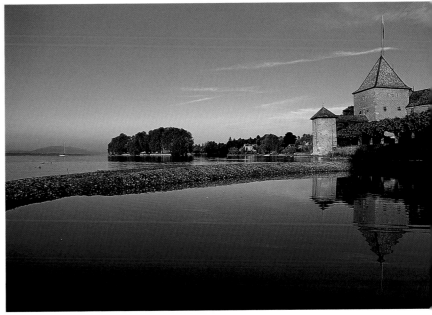

37

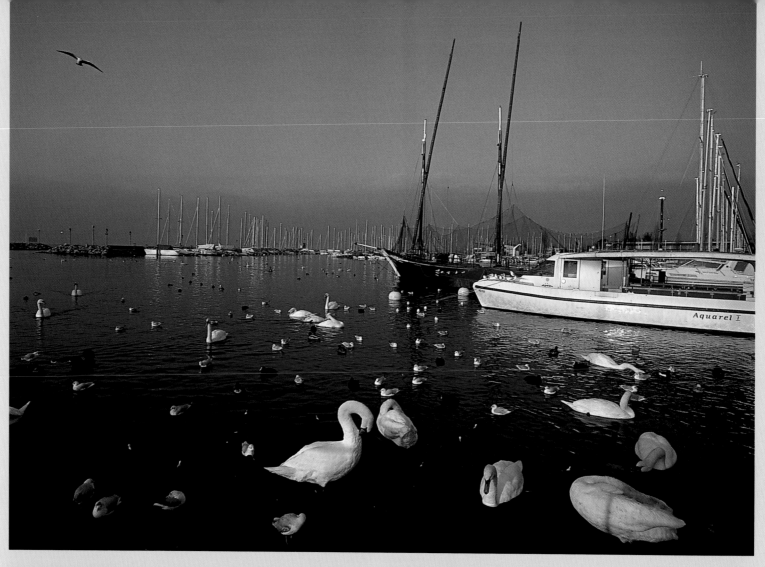

Left:
Ouchy, suburb and port of Lausanne, was once home to ships flying the "Latin" cross on their sails, carrying stone for construction of the city across the lake. Today expensive yachts moor here.

Below:
The Hôtel de Ville (town hall) in Lausanne, from which covered steps, the Escaliers du Marché, lead up the hill to the higher old town and cathedral.

Below:
The Cathedral of Our Lady in Lausanne was consecrated in 1275 by Pope Gregory X. Since the Reformation in 1536 Protestant services only have been held in this splendid early Gothic building.

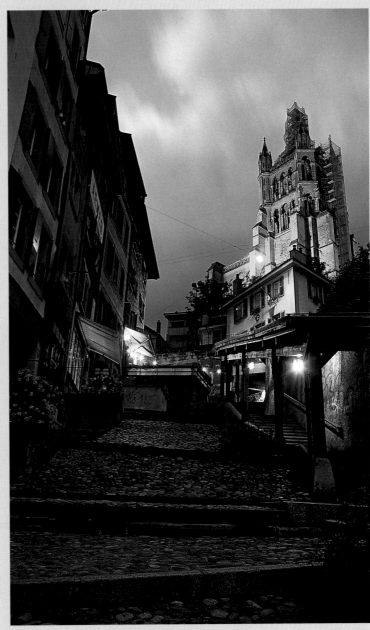

Left:
"Il a sonné douze!" (It has struck twelve), calls the night watchman from the cathedral at midnight, telling the good burghers of Lausanne that it's time to go to bed.

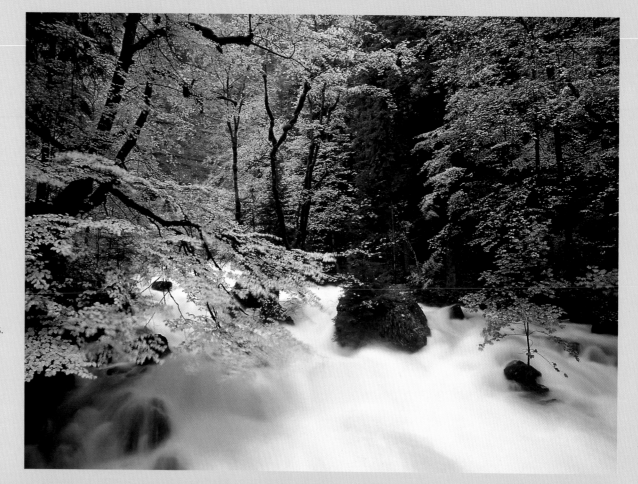

Right:
The little River Orbe once provided the power to run grain, saw and hammer mills. Today the peaceful valley is popular with hikers.

Below:
Etang de la Gruère, a remarkable area of high moorland in the canton of Jura. The nature reserve is home to many plants and animals otherwise rarely found in Switzerland.

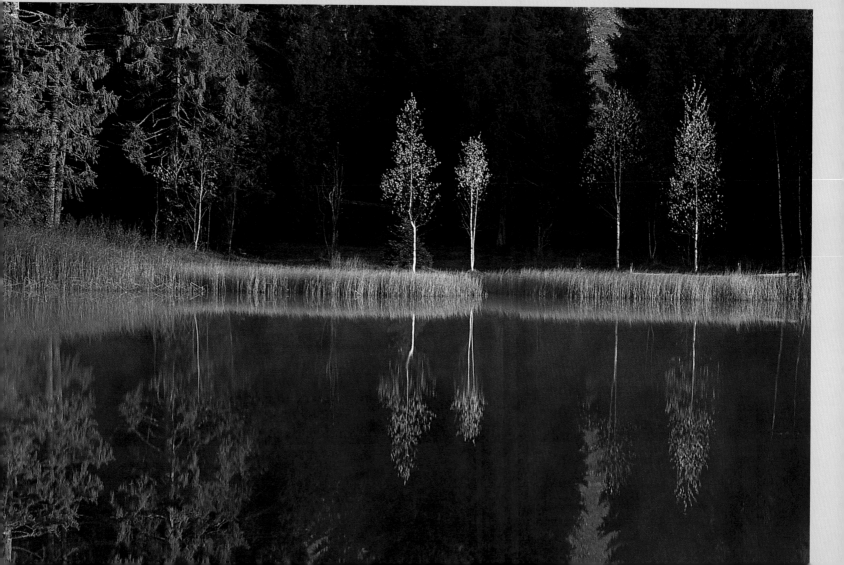

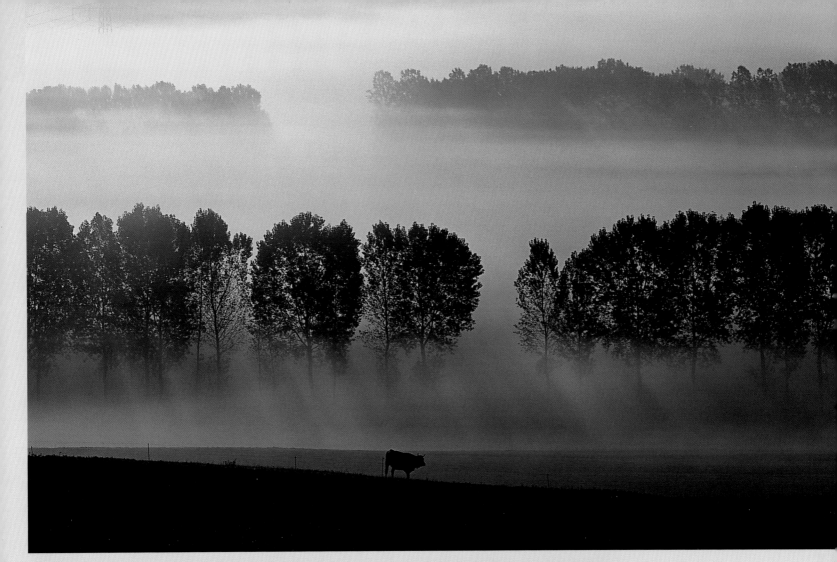

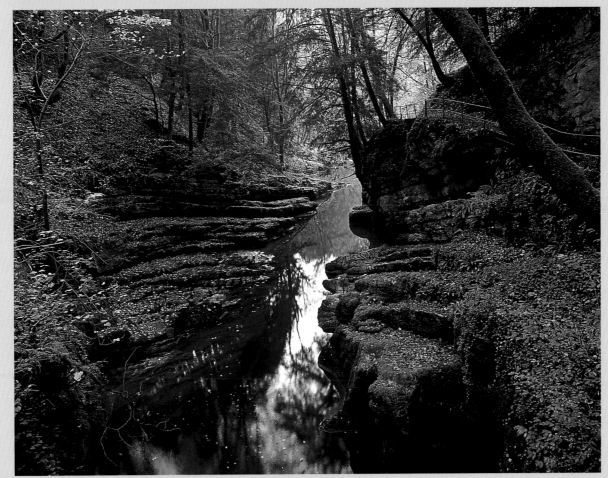

Above:
Shortly before flowing into
Lake Neuchâtel the Orbe
passes through a stretch of
country the Romans used
to retire to for relaxation.

Left:
The River Areuse supplies
enough drinking water for
almost the entire canton of
Neuchâtel. At Noiraigue the
river crashes down into the
deep Gorge de l'Areuse, at
one end of which stands the
house where Jean-Jacques
Rousseau drew up the con-
cept for his "Back to Nature"
in 1764.

Right page:
With its wonderful castle and ban on cars, the centre of Gruyères has managed to retain much of its original character. Perhaps its most famous attribute, however, is its tasty cheese.

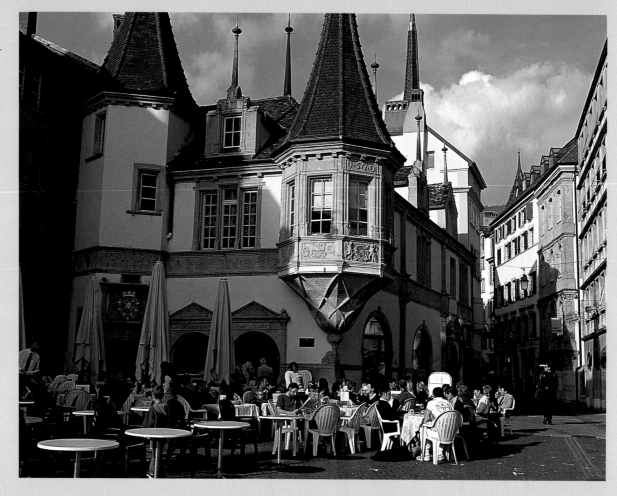

The little town of Moudon northwest of Lausanne was the Roman town of Minnodunum. No less than three castles watch over the upper city.

The city centre of Neuchâtel with its characteristic houses built of yellow Jura limestone. When in 1857 Frederick William IV was forced to renounce his Prussian rights to this gemstone on the lake, he was so unhappy that a few years later he died.

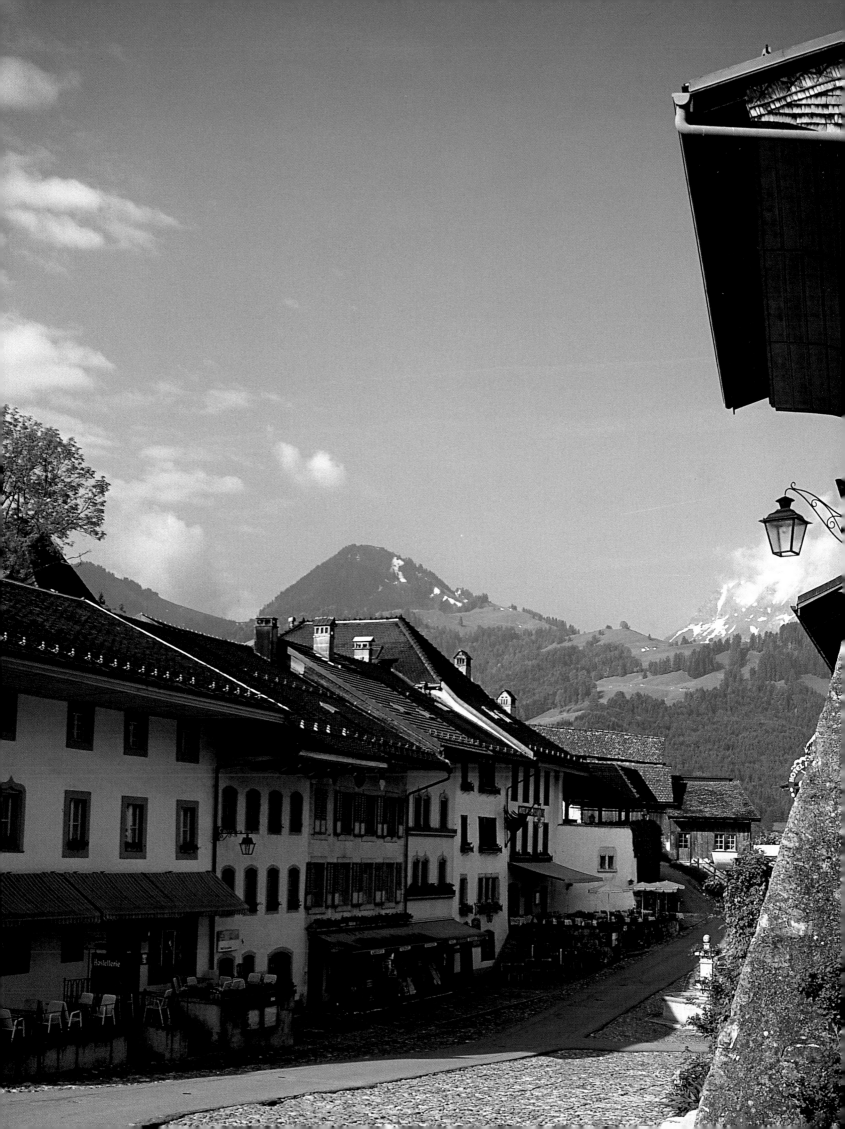

"SCHWINGEN" AND "HORNUSSEN" –
LOCAL CUSTOMS

Above:
In Catholic areas of German-speaking Switzerland, after evening milking the dairyman ask God "to guard and protect everything which lives and belongs on this Alp" in a traditional mountain prayer.

Centre right:
Decked out in all their traditional finery, each spring herdsmen and cattle make their long, weary way up the mountain to their summer pastureland, in this case the Schwägalp above the Toggenburg Valley in Appenzell.

The customs of Switzerland are as manifold as its scenery and inhabitants. Carnival or "Fasnacht", a fusion of heathen and Christian elements with local farming traditions and celebrations, is just one of the inestimable number of local ceremonies scattered about the festive calendar. Some of these have become tourist attractions, such as the "Almauftrieb", the driving of cattle up to their Alpine summer pastures, the wine festivals in Vevey and Bern's famous onion market. Others are pure expressions of community spirit, provincial pride and the urge to defend what is dear. The latter, for example, requires the men of Beromünster, Liestal and a handful of other villages to patrol parish boundaries armed with rifles each year on Corpus Christi. This ancient rite, known as "Banntag", is naturally accompanied by much shooting, singing and plenty of breaks for liquid and solid sustenance.

Whereas in other countries traditional regional sports have gradually died out, during the last century in Switzerland they were revamped and re-organised into a series of specialist competitions. Two which are almost unheard of outside the Confederation are "Schwingen" and "Hornussen".

"Schwingen" is an old form of where farmers and shepherds grappled in a ring strewn with an inch or two of sawdust. Together with the disciplines of running, jumping and stone throwing, it was

one of the sports in the 16th-century Alpine 'quadathlon'. Those in authority were none to pleased by the "irritating event" of local sporting festivities which usually took place on Sundays or public holidays, generally disturbing the peace and

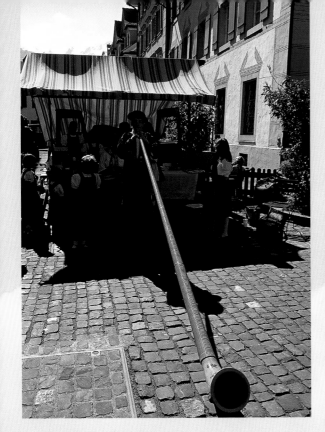

Left:
Alpine horns, being played here on the market square in Stans, have experienced something of a renaissance over the past few decades.

now a special Swiss wrestling association has managed numerous regional and national contests of the sport. Stringent regulations forbid the wearing of "fashionable or fantastical shirts", for example, or of those smothered in advertising slogans. Beneath their plain upper attire contenders don drill wrestling shorts held up by a wide leather belt.

In trying to throw each other to the floor a number of specified moves and grips are employed whose various termini leave much to the imagination. As in Japanese sumo wrestling the aim is to grab the belt of your opponent and then to "pull and tug and push and shove, and lift and twist and pant and grapple and press and grunt", as writer Gerold Späth from Rapperswil so knowledgeably puts it. The referee yells "Hepp!" when the victorious wrestler has his opposite number flat on his back in the sawdust.

The art of "Hornussen" seems even more aboriginal to the uninitiated. Initially only practised in the regions around Bern, Solothurn, Oberaargau and Emmental, the last few decades have seen teams battling it out on long playing fields all over German-speaking Switzerland. Not unlike cricket (but far less complicated), one group wallops the "Hornuss" or small plastic ball as far as they can down the pitch while the 18 players of the opposite team attempt to divert it with wooden slats.

Above:
The most important event in the year for the people of Bern is the onion market, held every fourth Monday in November from 4 am until dusk. Elaborate plaits of onions are popular presents with visitors from all over the world.

Top:
An Alpine trek up to the Selun Alp in the St Gallen canton. On this trip the cowbells have to be carried by the farmer.

Above left:
On the first Sunday in May in Bad Ragaz in St Gallen the beech "May bear" is paraded through the streets amid much clanging of cowbells. It ends its journey being ceremoniously thrown into the River Tamina to drive out the spirits of winter.

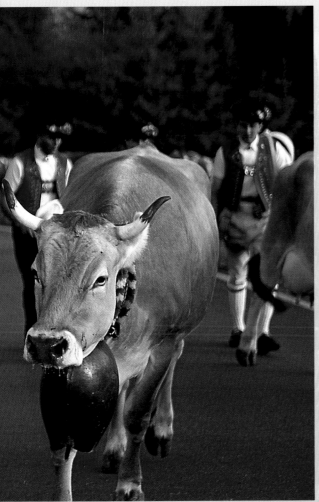

religious worship with their "brawling, wassailing and gluttony".

The rediscovery of Helvetian culture has done much to promote this age-old ritual. For over 100 years

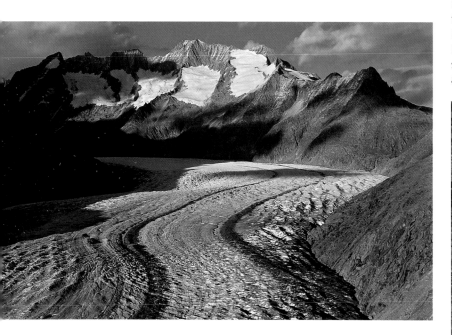

Top left:
The frozen Aletsch Glacier runs from the south side of the Bernese Oberland to Riederfurka, where at Villa Kassel Sir Winston Churchill spent his summer holidays as a boy.

Centre left:
The Gornergrat, 3,100 m (10,171 ft) above sea level, offers grand views of the Gorner Glacier, the Matterhorn and Zermatt, starting point for Europe's highest rack railway which covers over 1,500 m (4,920 ft) in altitude in just 45 minutes.

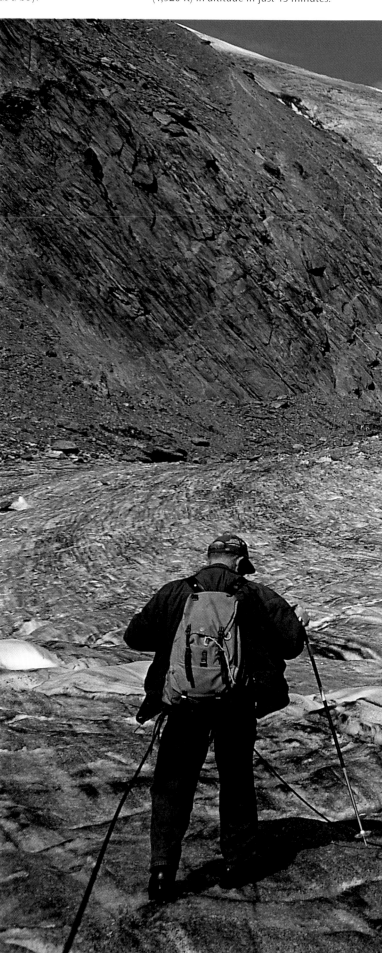

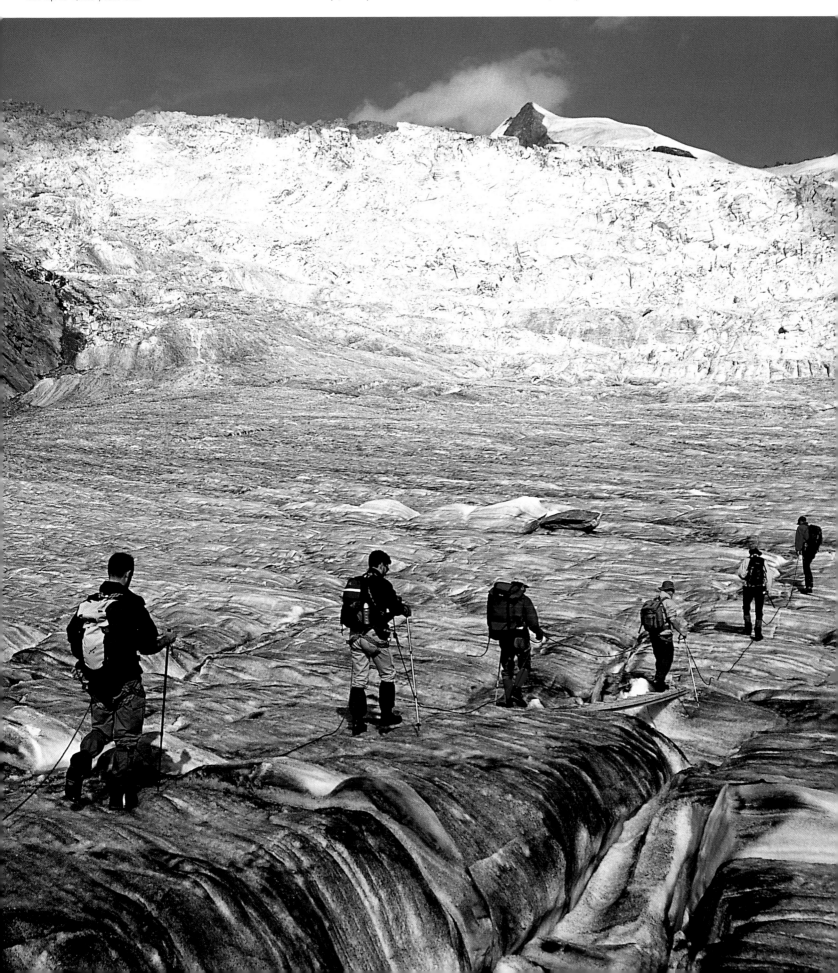

Bottom left:
The Aletsch Forest at the south end of the glacier is the highest wood of Swiss pines in Europe. Hikers can rest beneath ancient trees which are up to 1,000 years old.

Below:
At 170 square kilometres (66 square miles) in area and 25 kilometres (16 miles) in length the Great Aletsch is the biggest firn in Europe. The layer of ice at Konkordia-platz is almost flat and 800 m (2,625 ft) thick.

Page 48/49:
The Matterhorn, king of the Swiss Alps. First climbed by a group of Alpinists from Great Britain in 1865, today several thousand mountain tourists a year tackle the six-hour ascent from Hörnlihütte to the summit.

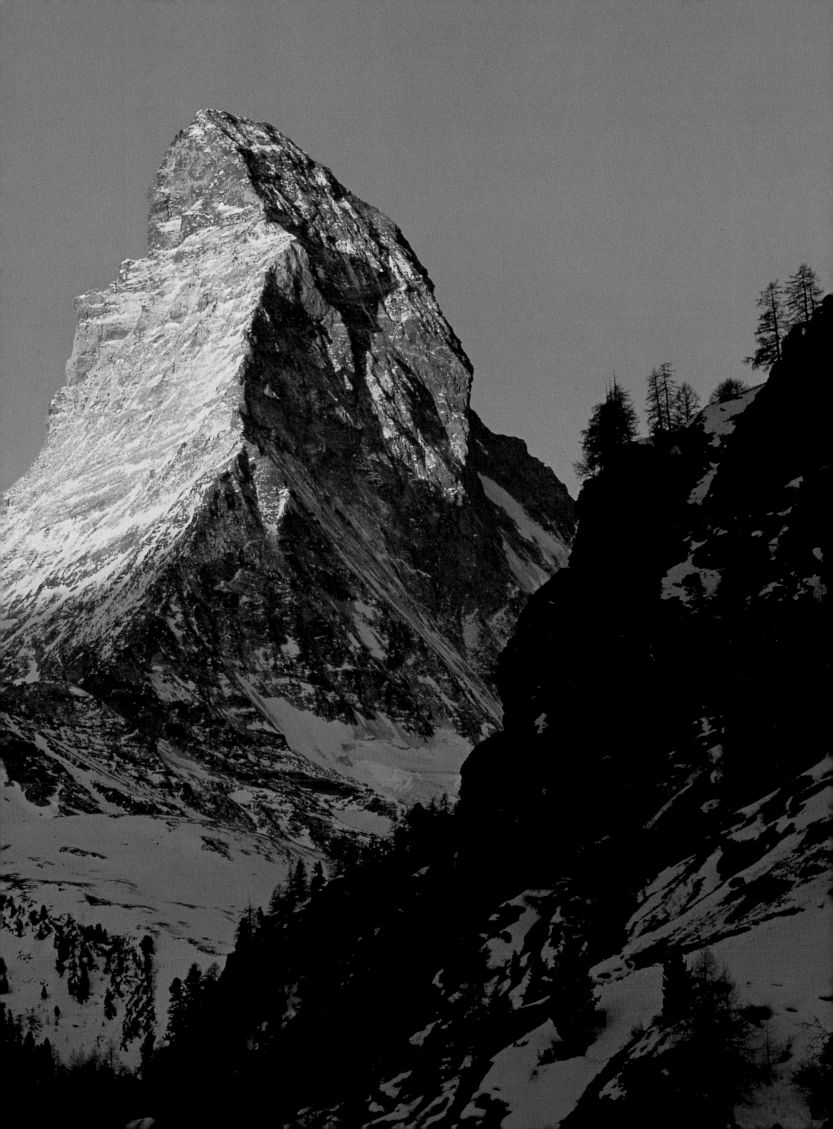

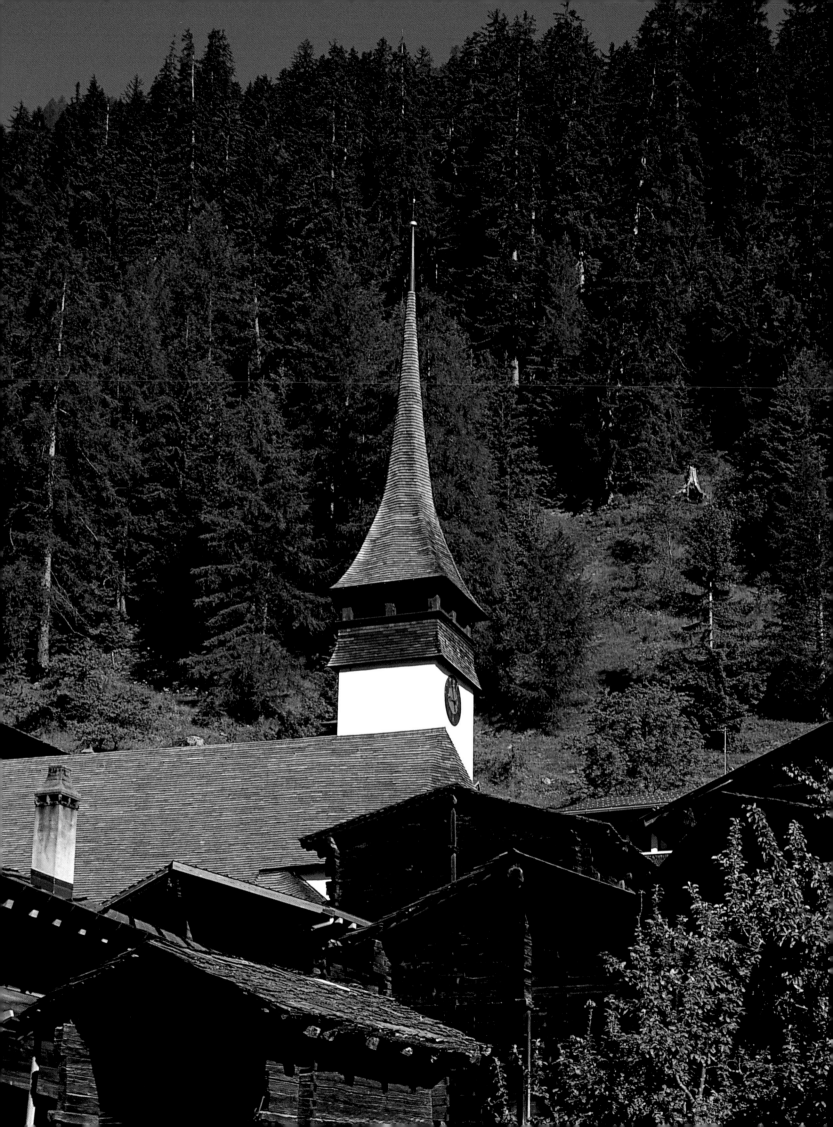

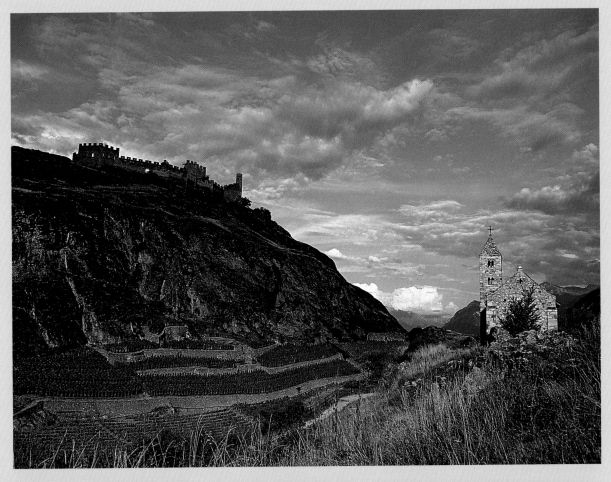

Left page:
Niederwald, with the church of St Theodul at its centre, is a typical village in the Goms region of the upper Rhône Valley. The legendary restaurateur and pioneer of the luxury hotel, César Ritz, was born here. The Ritz in Paris opened in 1898, providing guests with private bathrooms, telephones and electric lighting in all rooms for the first time in hotel history.

Sion, the capital of the canton of Valais, huddles at the foot of two fortified peaks. The higher Château de Tourbillon was destroyed by fire in 1788; Château de Valère opposite was erected on the ancient foundations of Roman Sedunum.

In the Hérens Valley near Euseigne nature has been particularly inventive. The ice-age moraine has gradually been beaten down by heavy rainfall to produce these bizarre pyramids of rock.

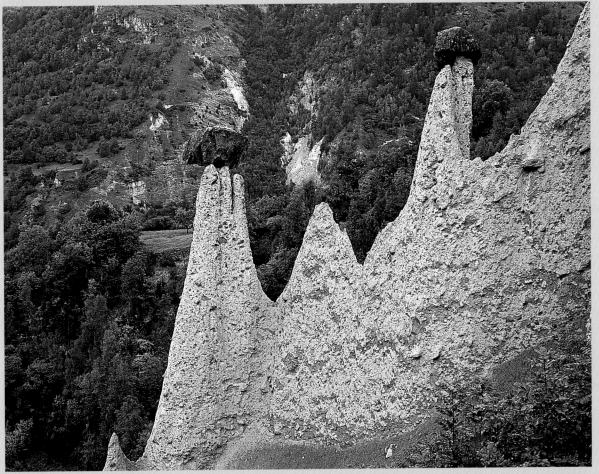

Below:
The Grimsel Pass (2,165 m/ 7,103 ft) marks the boundary between the cantons of Valais and Bern. From both sides the road winds upwards in a series of hairpin bends, past the spectacular Rhône and Gries glaciers.

Top right:
The Rhône Glacier, source of the River Rhône which after a very long journey eventually flows into the Mediterranean. Over the past hundred years the glacier has shrunk about one kilometre, cutting its length from ten down to nine kilometres (ca. 6 miles).

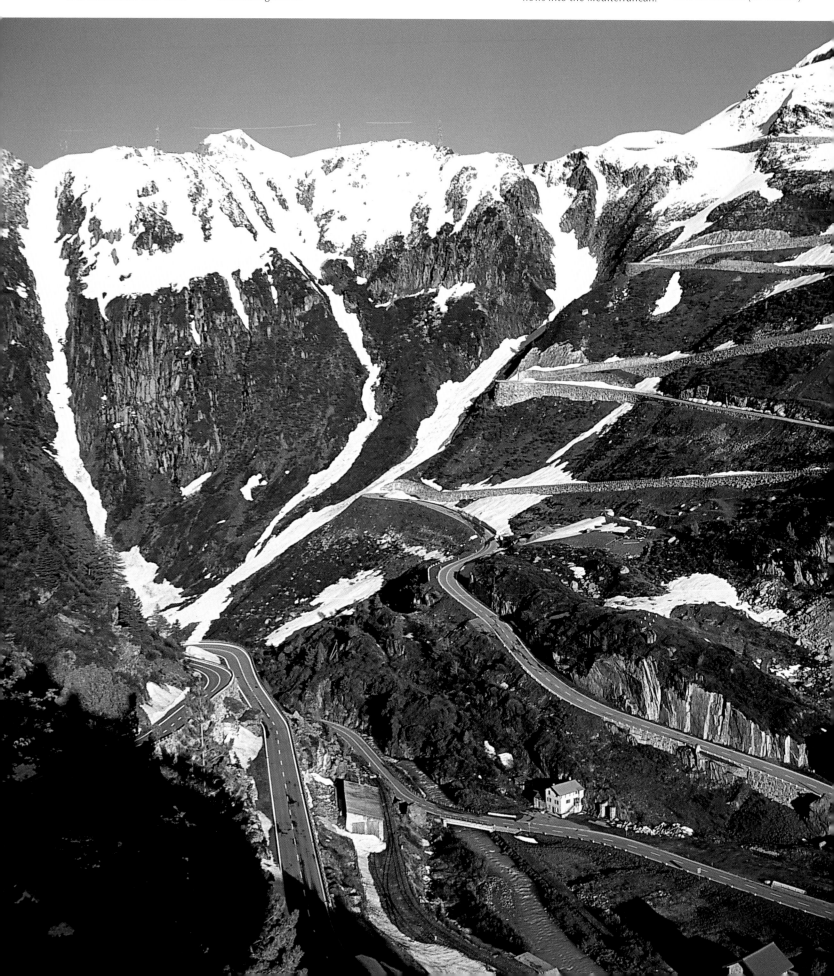

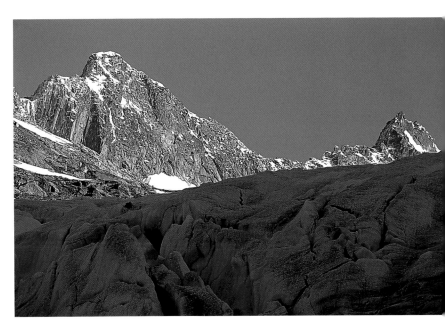

Centre right:
Les Haudères, the highest village in the Hérens Valley, is popular both as a winter ski resort and summer spa.

Bottom right:
The yellow buses of Switzerland's PTT postal service ferry skiers and hikers safely up to the top of the Grimsel Pass all year round. Over a hundred years ago only a mule track provided passage across the mountains.

WHY EMMENTALER HAS HOLES —
SWISS CHEESE

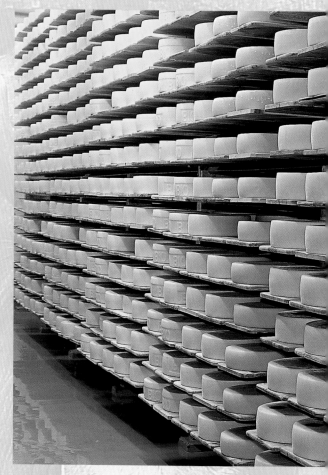

Above:
The Gotthard Pass pays homage to both the provider of the raw materials and the finished product: a Swiss cow and that triangular bar of international renown.

Centre right:
Appenzeller is stored for four to five months in the ripening room in Stein and regularly rubbed with a mixture of white wine, herbs and spices. The recipe for this special brew is a well-guarded trade secret.

Below right:
Switzerland's other top milk export is chocolate, being made here in St Gallen for cocoa fans all over the world.

"What on earth do you do with all that grass?" some visitors to Switzerland ask on seeing the never-ending pastures and lush meadowlands, which thanks to meticulous farming on mountain slopes stretch right up to the snow line. The valleys, too, are grass green where in other countries they are ploughed into various fields of crops. "Milk" is the answer, the grass being turned into the "white gold" of the Alps by the cattle which graze it. It's not true, of course, that the milk used to make chocolate comes from purple cows, as the TV adverts would have inner city kids believe. The majority of the milk produced in Switzerland, whether by brown or Fresian bovines, ends up neither in the chocolate box, butter churn nor glass – but as cheese.

Dairy farming, particulalry in the mountain regions, has long ceased to be a lucrative business. Only massive subsidies paid out from the state coffers secure the existence of traditional small farms, ensuring that local cheese industries continue to manufacture produce which is as high in quality as it is in diversity.

At Switzerland's over 1,000 village dairies the unpasteurised or raw milk is taken straight from the cow to the cheese-making vat. The milk is heated in this huge copper vat and curdles when inoculated with bacteria and rennet. Cheese harps or knives, which look like giant egg slicers fixed to a mixer, cut the curd into smaller and smaller pieces until it resembles grains of wheat. These tiny grains and some of the

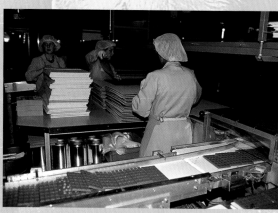

residual whey are then pressed into rounds of cheese. Small wonder, then, that ten to twelve litres (17 to 21 pints) of milk produce just one kilogram (two pounds) of cheese! Depending on the vintage, the rounds are then stored for up to

three years in humid curing cellars where they are regularly turned and washed.

During the ripening process for Emmentaler, "the" legendary Swiss cheese, carbon dioxide is produced which collects in cherry-sized bubbles of gas, thus providing the answer to Kurt Tucholsky's curious question of how Swiss cheese gets its

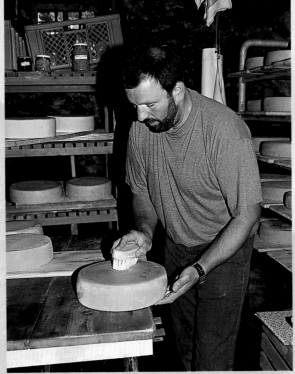

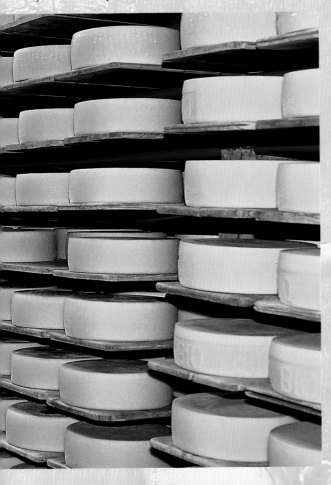

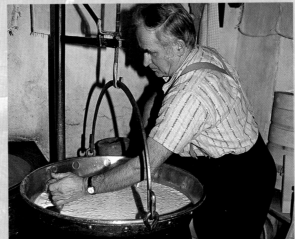

their characteristic nutty flavour and almost black rind which helps to distinguish them from most of the imitations.

Gruyère from the west, Sbrinz from the heart and Appenzeller from the east of the country and Tête-de-Moine ("monk's head") from the Jura are other well-known varieties of hard Swiss cheese. So that the crumbly Sbrinz can be cut into the definite wafer-thin, aromatic slices the Romans were so fond of a special cutter has been developed.

There are also a number of Swiss cheeses made from pasteurised milk. Although less famous, Tilsiter, whose recipe was brought to St Gallen all the way from East Prussia in the 19th century, and Vacherin from Vaud, encased in a bark rind from the fir tree, also have their connoisseurs.

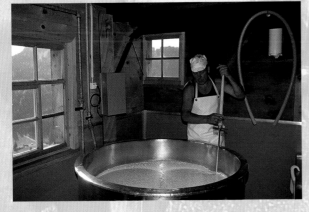

holes. In the past few years Emmental's cheesemakers have started using the sandstone caves under the Santenberg as a ripening room. The rounds, weighing up to 80 kilograms (176 pounds), are stored here for a year until they have developed

Schloss Stockalper in Brig, the most magnificent baroque palace in Switzerland, is dominated by three distinctive onion-domed towers. Merchant Kaspar Jodok Stockalper von Thurm, the "King of the Simplon", had it erected between 1658 and 1678. It now houses the Upper Valais archives and regional museum.

In summer Niederhäusern in the Vispa Valley is the ideal starting point for hikes to Gspon or Visperterminen. Those too tired to walk back can hitch a lift with the postman.

Right:
The highest vineyards in Europe are to be found in the Vispa Valley. The "heathen vines" grow at altitudes of up to 1,200 m (3,937 ft) in the dry, sunniest region of Switzerland.

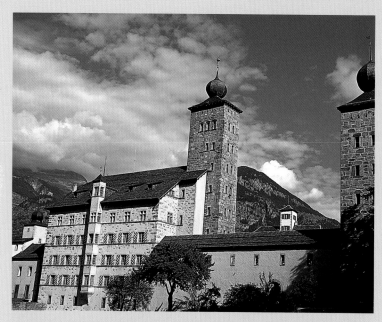

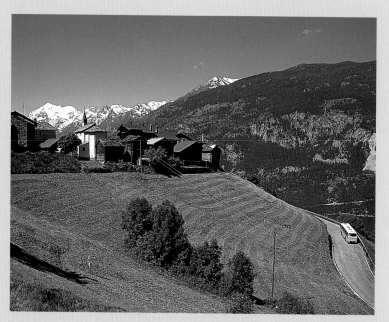

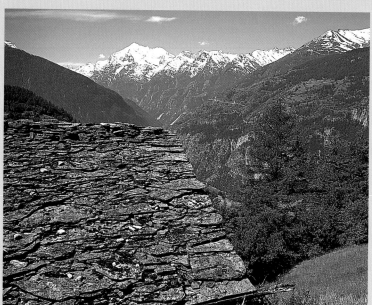

An ingenious system of irrigation channels enables the meadows to be watered high up the Vispa Valley.

An extremely turbulent stretch of road zigzags up from Visp to the village of Visperterminen, 1,340 m (4,396 ft) above sea level. The breathtaking views of snow-capped peaks more than make up for the giddy journey.

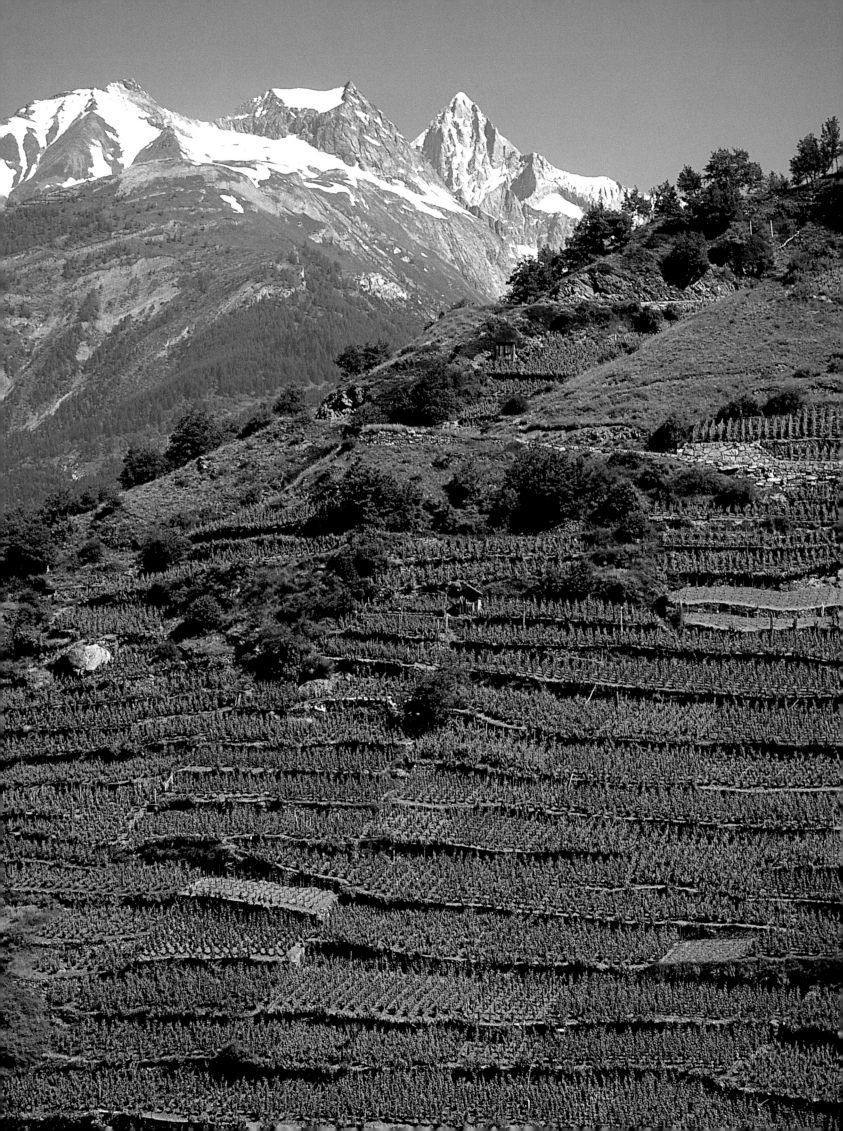

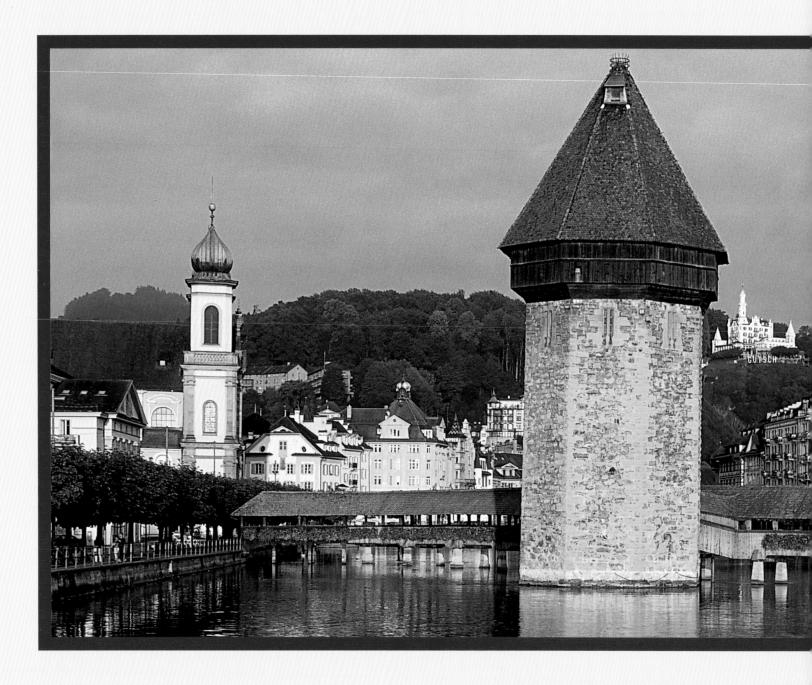

SWITZERLAND'S SCHWYZ – SWISS HEARTLAND AROUND LAKE LUCERNE

A white cross on a red background, Schwyz as the name of both canton and provincial capital: you don't have to be Sherlock Holmes to deduce that this is probably where the Swiss Confederation was born. The people living in the valley between lakes Zug and Lucerne, shepherds and farmers who believed they could manage their lives perfectly well without the interference of a lord or king, were derided by their adversaries as deadly, revolutionary enemies of the feudal order "willed by God". "Schwyzerei", originally used in scorn and abuse, soon became a geographical and political term which referred to the entire German-speaking region north of the Gotthard Massif. Three out of four Swiss people today have one

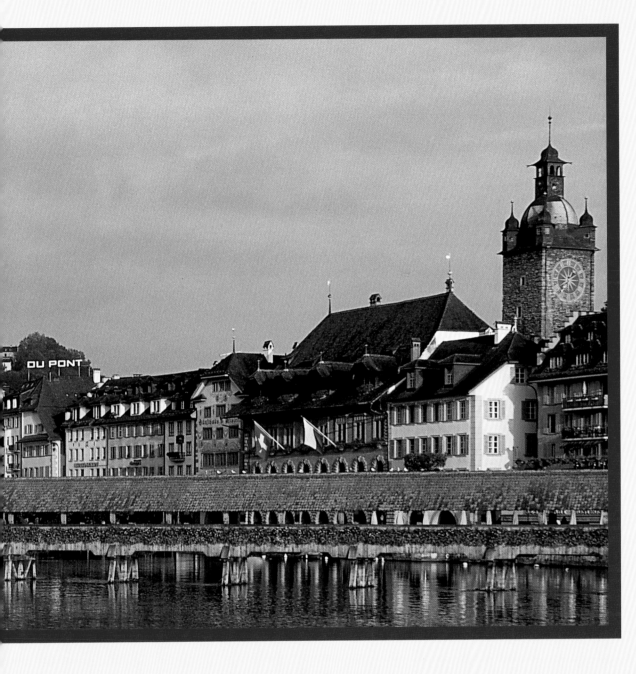

Lucerne was the first city to join the Confederation in 1332. A year later construction began on the Kapellbrücke which with the octagonal water tower monitored the outlet of the River Reuss from Lake Lucerne. In 1993 the bridge burned down but was soon rebuilt in its original guise.

of the Swiss-German dialects as their mother tongue; the dominance of German Switzerland in the economy, politics and in the way the modern Confederation sees itself cannot be overlooked.

"La suisse primitive", as the people of western Switzerland like to call central Switzerland, the cantons of Uri, Schwyz, Obwalden, Nidwalden, Lucerne und Zug bordering on Lake Lucerne, is often still seen as the epitome of the original, eccentric, democratic Switzerland. Rütli folklore, the tourist trade and transit highways and byways, however, have done much to destroy what was once an isolated part of the country. Since its abo-

lition in 1998 in Obwalden, the "Landsgemeinde" or cantonal parliament – the open-air assembly of all inhabitants as a chief, legislative referendum committee – is now defunct in central Switzerland. Only held in Appenzell-Innerrhoden and Glarus once a year in spring, you now have to travel to the east of the country to get a real taste of primeval Switzerland.

The canton of Glarus, which joined the Confederation way back in 1352, largely consists of the Linth Valley, 40 kilometres (25 miles) long and subject to frequent föhn winds, blocked at its terminus by Mount Tödi towering 3,614 metres (11,857 feet) up into the heavens. Even by

Above:
On the Swiss side of Lake Constance, opposite Reichenau Island, Schloss Arnenberg has a museum dedicated to Napoleon. At the beginning of the 19th century Napoleon III spent a happy youth within the walls of the palace, built after 1540.

Right:
Evening light over Lake Walenstadt. Cut deep into a gap between the Glarus Alps and the ragged rocks of the Churfirsten (2,306 m/7,566 ft), the lake has an entire range of dramatic perspectives.

Swiss-German standards the people of Glarus are said to be extremely conservative; frustrated by their stubbornness, even Reformer Huldrych Zwingli, parish priest to the cantonal capital of Glarus, was heard to complain that his flock were "bull-necked". Despite all this the apparent seclusion is deceptive. Colonies of Swiss across the globe can be traced back to early emigrants escaping a life of poverty in the Linth Valley; the textiles industry which brought employment and wealth to the region in the 19th century was almost totally geared towards export. It's only in the more recent past that Glarus, like the rest of eastern Switzerland, has melted into the shadows.

Yet even on this side of the mountains northeast Switzerland has a lot to offer in the way of scenery: the orchards of the Thurgau, the lush green hills of Appenzell, the floral shores of Lake Constance. In Schaffhausen and Stein am Rhein, the only parts of Switzerland north of the River Rhine, magnificent fortresses dwarf the medieval towns below, and a splendid baroque monastery rises proud above St Gallen.

Lucerne, scenically poised at the mouth of the River Reuss on Lake Lucerne and at just 65,000 inhabitants the smallest of the four, rightly claims to be the first central Swiss city to have joined the Confederation. The lion monument, together with the Kapellbrücke an absolute must on any tourist itinerary, for once has not been erected in honour of some legendary freedom fighter but in memory of the 700 Swiss guardsmen serving under Louis XVI who, on storming the Tuileries in 1792, were lynched by an angry Paris mob.

Zürich's image is so strongly defined by its banks and "gold coast", as the opulent assortment of villas embellishing the northern shores of Lake Zürich is enviously referred to, that the city itself and its environs tend to be overlooked. The canton of Zürich is, however, home to almost 20 % of the country's population, more than live in the smallest 13 of the 26 cantons and most of which are far from being millionaires. Like Lucerne, Zürich is situated on "both a lake and a river", the distinguishing characteristics of Switzerland's most beautiful cities, as Gottfried Keller notes – quite accurately – in his novel "Grüner Heinrich".

GATEWAY TO SWITZERLAND

Basle, the gateway to Switzerland in a particularly international pocket of Europe, is, in allegiance to its neighbours, more German and French than Swiss. Unlike other cities in Switzerland, the rich councillors of Basle were so adverse to the idea of their underlings becoming part of a democratic voting process that in 1833 they decided to split

the canton up into Basle Town and Basle District. Liestal on the River Ergolz was promptly made the provincial capital of the latter, having earned itself a reputation as "the root of all rebellion" in the Peasant War of 1653. Liestal was also the site of the first tree of freedom on Swiss-German terrain in 1798.

And finally to Bern, seat of the Swiss government, which in the eyes of Switzerland's French- and Italian-speaking populace is the embodiment of everything which is Swiss-German – and which they prefer to distance themselves from. To them, life here is slow, ponderous and stilted, reflected even to the untrained ear in the thick dialect nurtured by the locals. Yet like in so many other places in Switzerland, here, too, first impressions are often misleading; the splendid arcaded houses in Old Bern are proud reminders of the time when the federal capital once held economic supremacy over the rest of the Confederation and kept brown bears as a symbol of power, still today the mascot of the city on the River Aare.

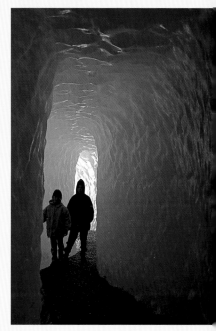

Below:
Each summer busy hands carve fantastic ice grottoes into Switzerland's glaciers. Inside (here the Upper Grindelwald Glacier) you find yourself transported into a magical world bathed in sparkling light, more reminiscent of the deep blue sea than the sunny slopes of the Alps.

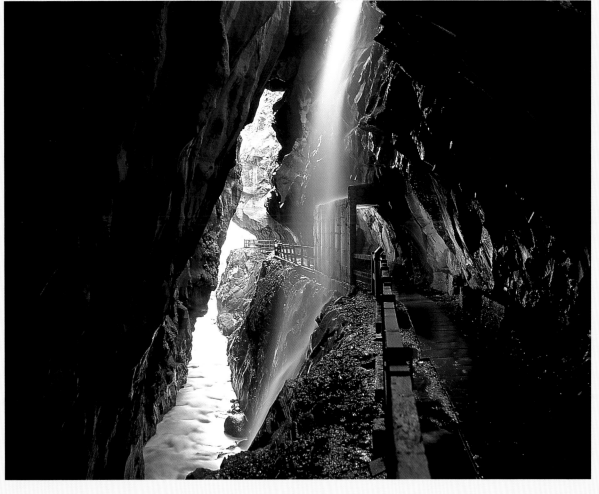

Left:
Visitors have been coming to Bad Pfäfers near Bad Ragaz to take the waters since the 13th century. The healing liquid bubbles from a source at the end of the Tamina Gorge with an impressive burst of steam.

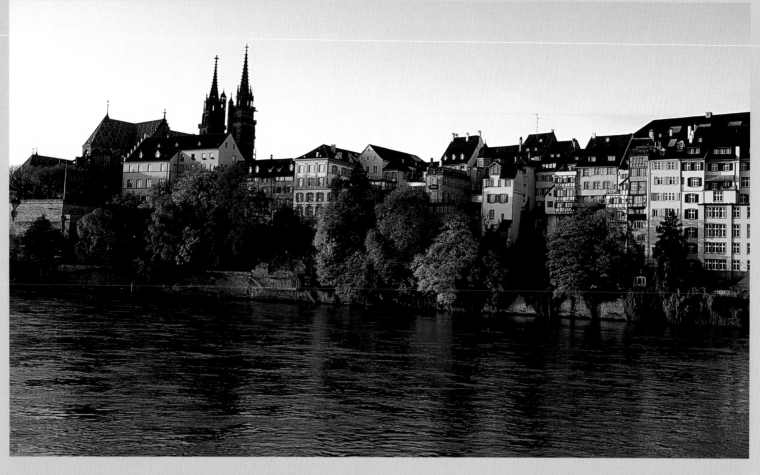

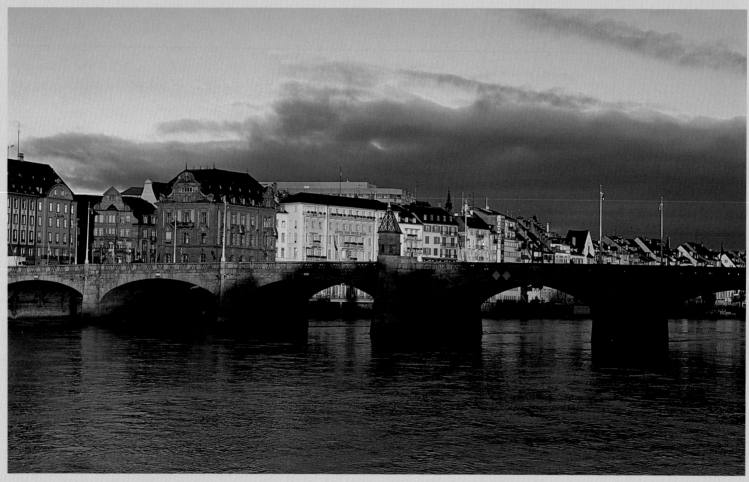

Left:
The thin twin towers of Basle's minster rise up into the skies where the Roman camp of Basilia once stood. Built from red Vosges sandstone, the cathedral elegantly punctuates the city silhouette.

Below:
The 12th-century Gallus Gate survived the great earthquake of 1356 which destroyed much of the minster. With its many Romanesque figures the portal effuses an archaic severity.

Below:
Built at the beginning of the 16th century in Burgundian late Gothic and extended to include the high gilt tower in the 19th, the red town hall dominates the market place in Basle. A monument at the foot of the steps commemorates Munatius Plancus, the legendary Roman founder of the city.

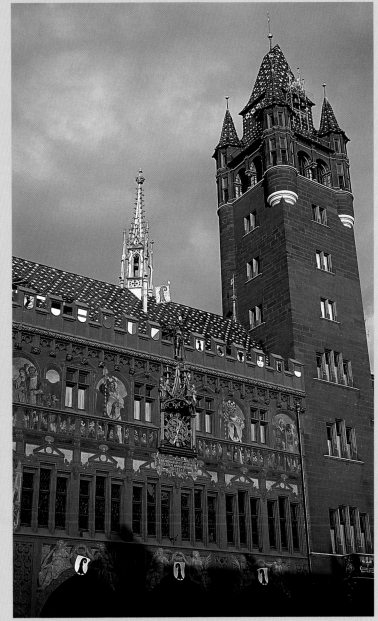

Left:
In Basle the High Rhine or Hochrhein turns north, flowing into the Upper Rhine of Germany. The river was a major thoroughfare in the past, providing Old Basle with an excellent means of trade.

Right page:
The Romanesque Basilica of St George's rises proud above medieval Stein am Rhein. Remains of the Roman Rhine fortress of Tasgaetium can be found atop the castle mound on the left bank of the river.

With its elaborate oriels and fancy frescos Stein am Rhein is considered to be the best-preserved medieval town in German-speaking Switzerland.

Thierstein Fortress high up above Büsserach in Solothurn was built at the end of the 12th century. Damaged by the earthquake of 1356, Napoleonic troops and partial collapse in 1997, the recently renovated ruin on the Lüssel River is now once again open to the public.

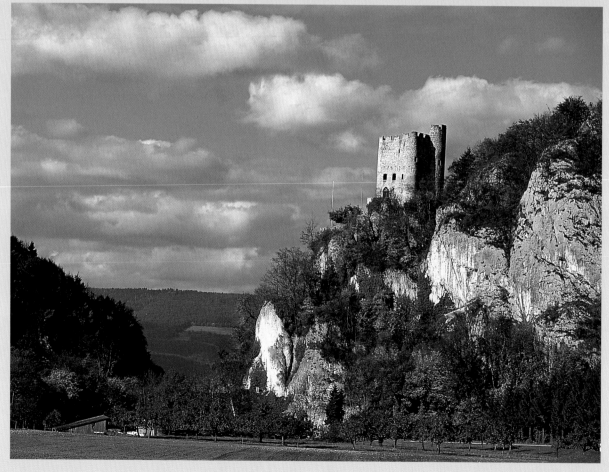

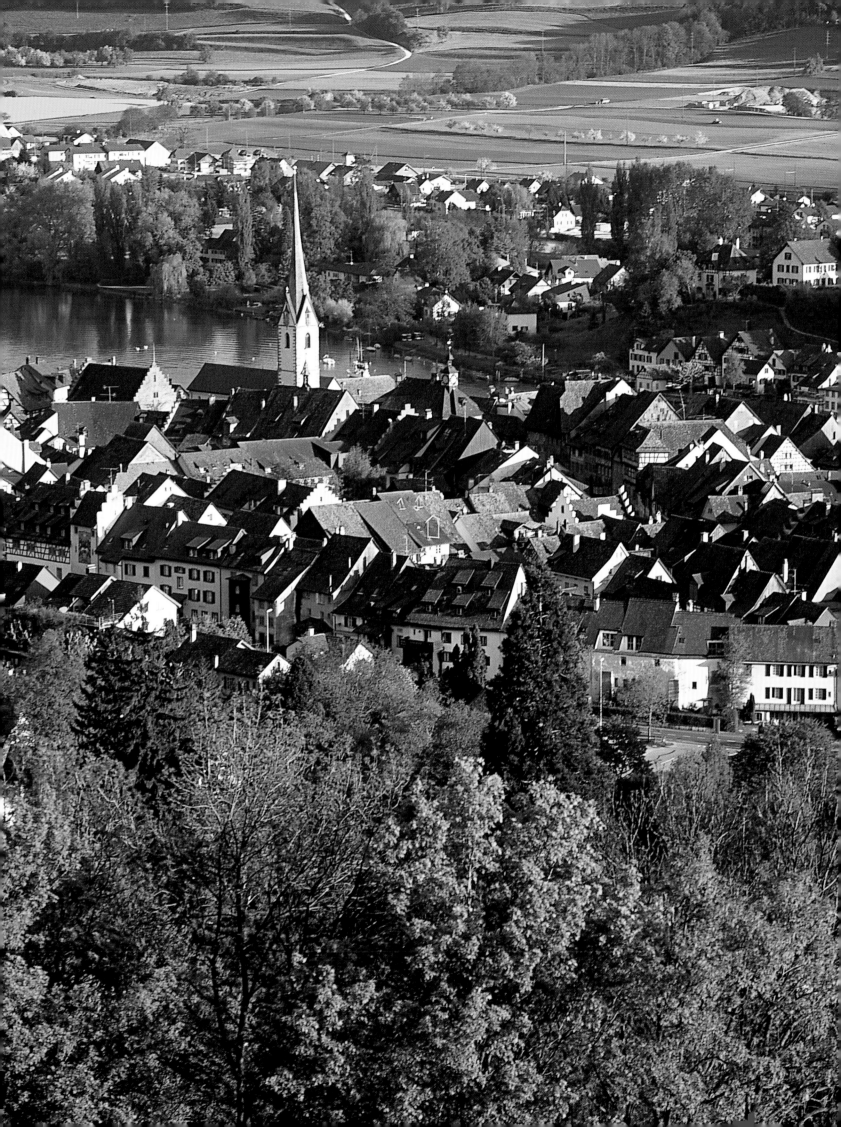

Below:
Surrounded by steep vineyards, Munot Castle towers above the city of Schaffhausen, the provincial capital of the only Swiss canton north of the River Rhine. The Rhine Falls, just beyond the point where the Rhine exits Lake Constance and impassable for shipping, were once an important depot for goods.

Top right:
Aarburg near Olten is famous for its fortress high up on the hill which has controlled the confluence of Wigger and Aare rivers since the 11th century.

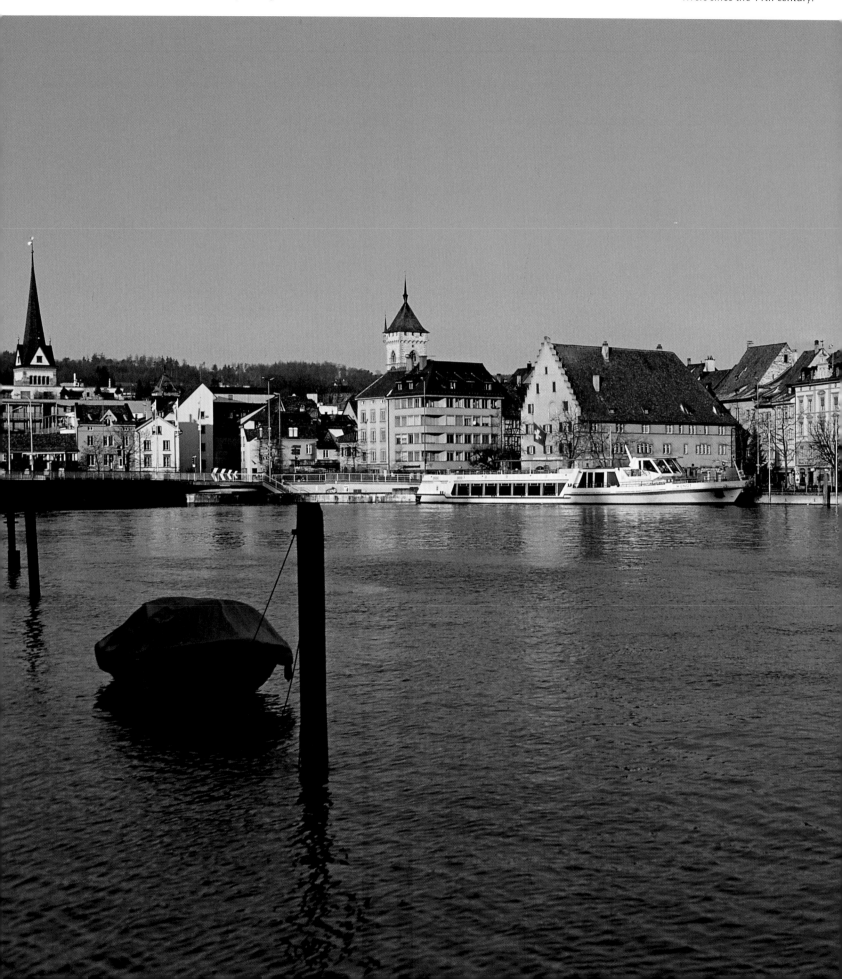

Centre right:
Carl Spitteler described Solothurn as a "fairytale city with golden roofs", from 1530 to 1792 seat of the French envoy to the Swiss Confederation. The riches and splendour of this period in the city's history are manifested in the main street with the Cathedral of St Ursus and stylish Mauritius Fountain.

Bottom right:
Regarded by many as just a major railway junction, Olten has an interesting old town waiting to be discovered, with the beautiful River Aare flowing through its centre.

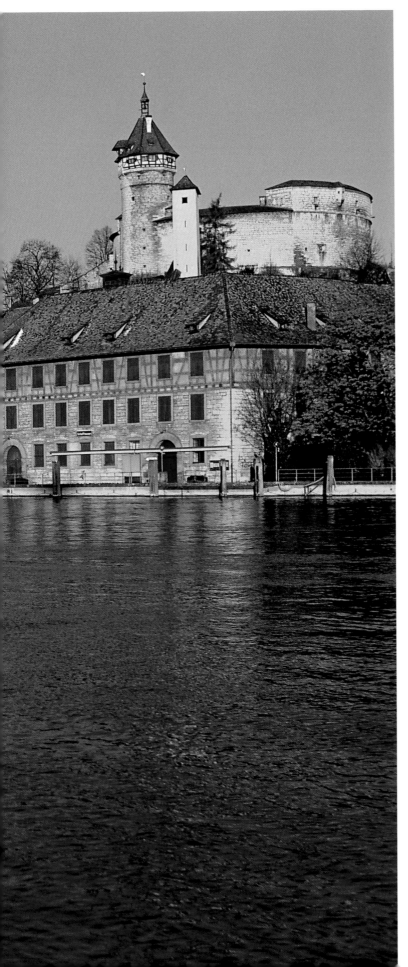

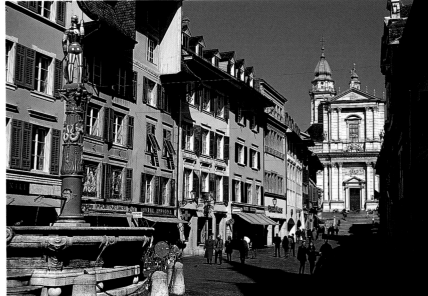

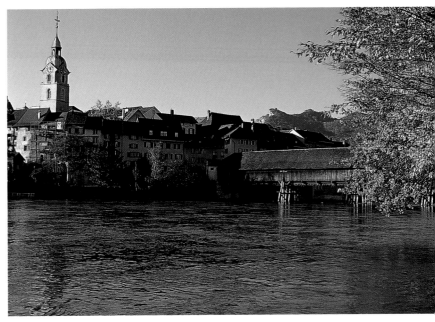

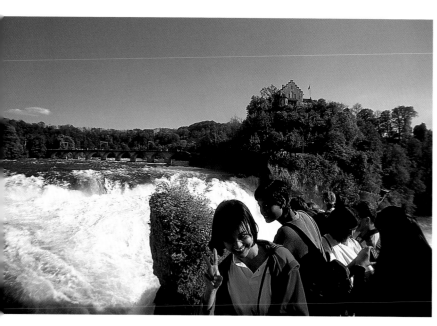

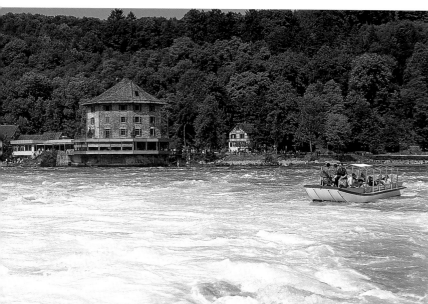

The Rhine Falls are the most powerful waterfall in Central Europe. 150 m (492 ft) wide, at Neuhausen in the canton of Schaffhausen they crash 23 m (75 ft) down into the depths. Where the Rhine is otherwise lush, peaceful and romantic, here it is wild and untameable. Goethe came to the Falls on all three of his journeys to Switzerland and was mightily impressed, writing in his diary of "... fast waves, blobs of foam, spray on descent, spray below in the basin".

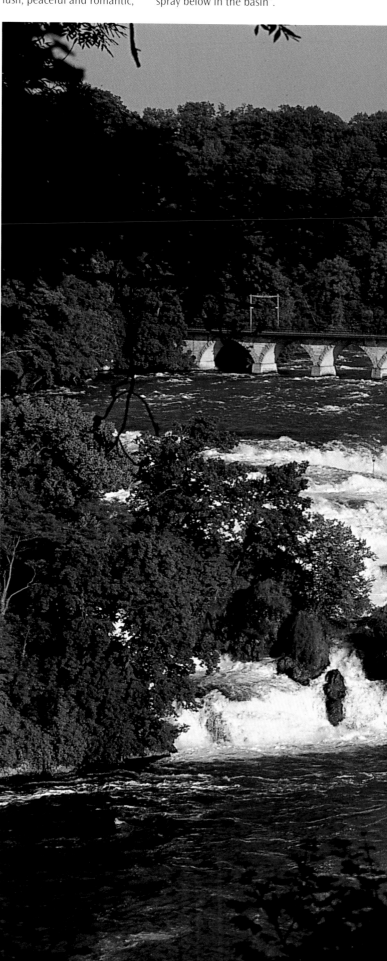

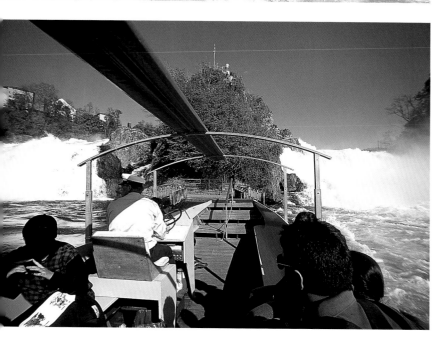

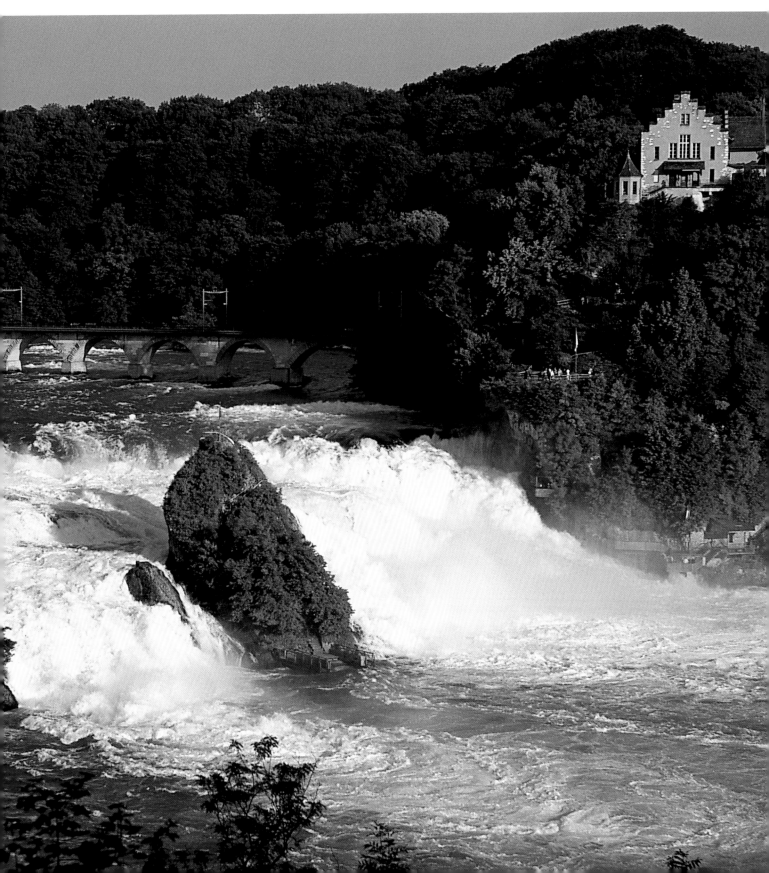

third-largest lake in Central
Europe, with one third of its
area and southern shores
part of Switzerland.

villages, such as this one at
Ermatingen, which appear
particularly romantic in the
pink sunset.

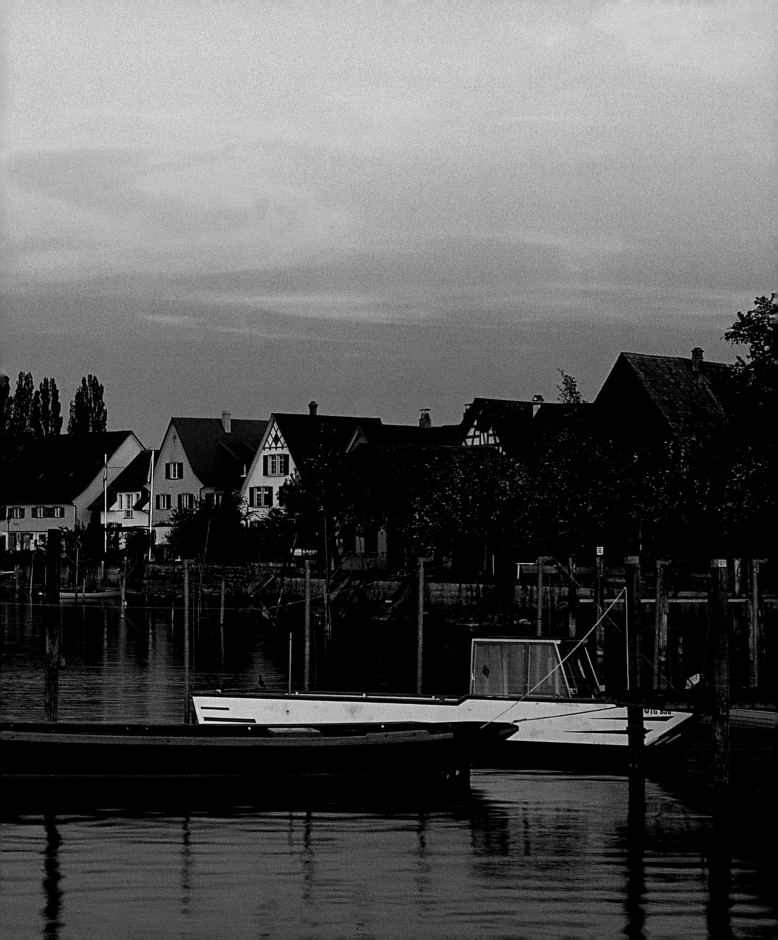

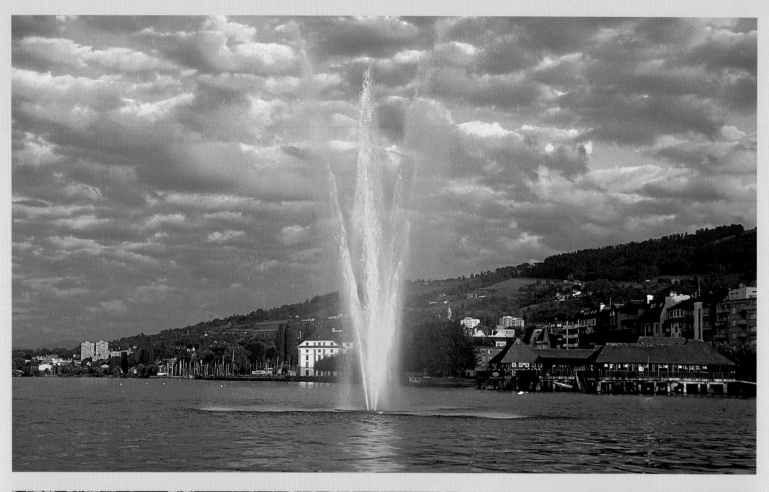

Left:
The little town of Rorschach perches at almost the southernmost point of Lake Constance. Once a harbour for the monastery at St Gallen, today the fountain greets tourists and hobby sailors.

Below:
West of Arbon is Romanshorn, the biggest shipping port on Lake Constance. Switzerland's Lake Constance pleasure boats are moored here and operate a popular ferry service to Friedrichshafen.

Below:
The castle of Turmhof on the Steckborn peninsula is mirrored in the southwest end of Lake Constance, known as the Untersee or lower lake. Abbot Dietrich von Castell from Reichenau had the palace erected in 1320.

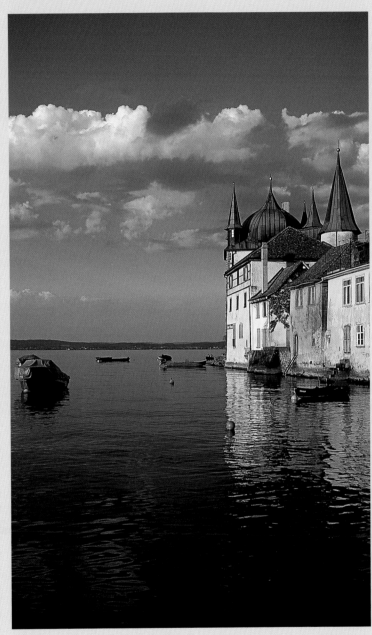

Left:
The gnarled trees along the shores of Lake Constance at Arbon have witnessed much in their long lives. The peninsula began as a Celtic settlement called Arbona, which later became the Roman Arbor Felix. St Gallus, founder of the monastery of St Gallen, died here in 645.

Below:
From the top of Säntis Mountain there are marvellous vistas of the beautiful Alps and central Switzerland. The summit can be reached by cable car from Schwägalp in the space of a few minutes.

Bottom:
Bird's-eye view of Mount Säntis (2,502 m/8,209 ft). The cable car takes you almost this far up, with marvellous panoramic views of the Graubünden, Glarus and Uri Alps on one side and Lake Constance and its Swabian hinterland on the other.

Right:
The Alpine Rhine flows from Chur to Lake Constance. Shortly before entering the lake the valley widens at Altstätten, a pretty country town with romantic arbours lining its streets.

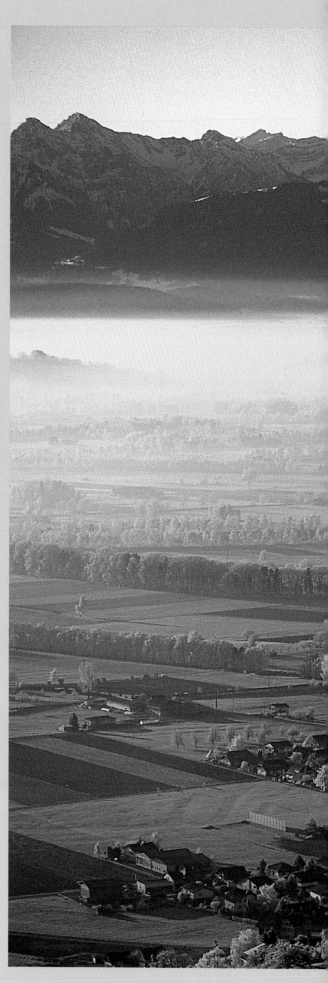

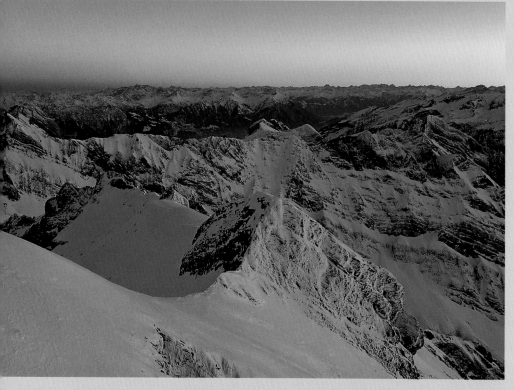

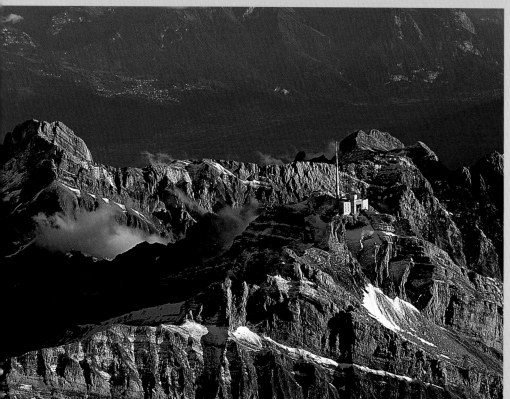

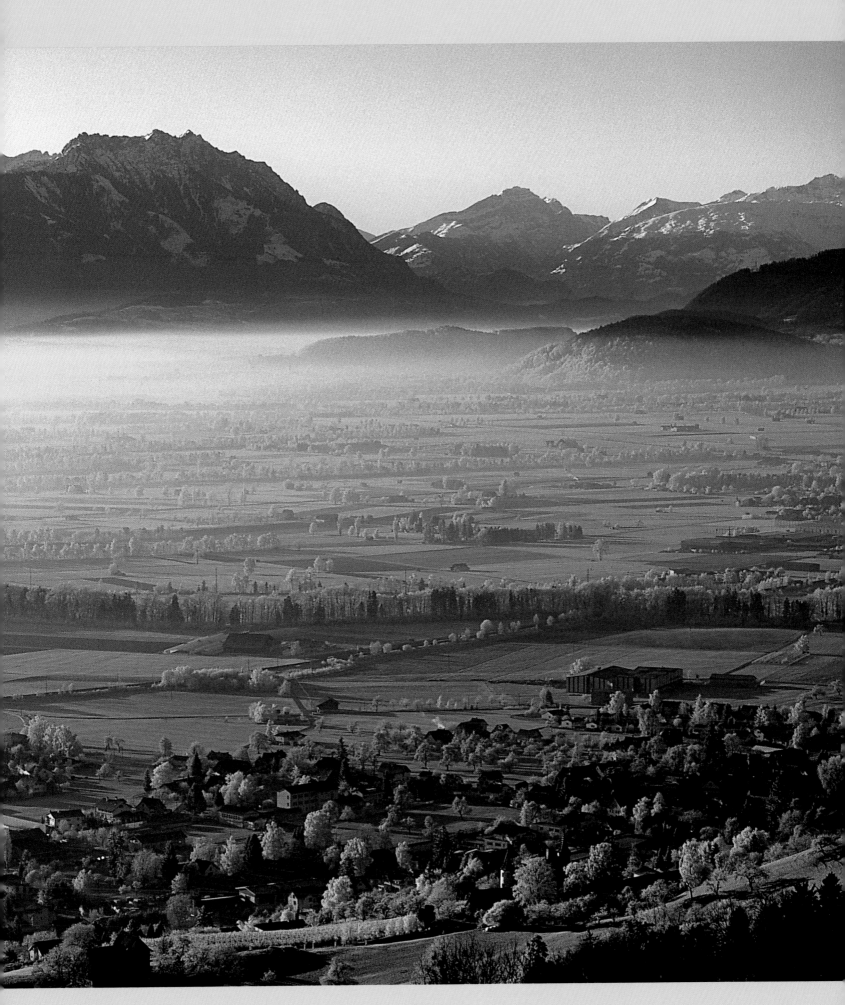

Below:
The remote inaccessibility of the area was what encouraged Irish monk and missionary Gallus to set up his hermitage here. Today baroque St Gallen is the busy economic, scholarly and cultural centre of eastern Switzerland.

Right:
For many centuries the Benedictine monastery of St Gallen has been and still is a major centre of Catholic learning in the Alps. This is underlined by the priceless books and manuscripts lining the shelves of the monastery library which was designed in ornate Rococo in c. 1760. From 1206 to 1805, as princes of the Reich the abbots of St Gallen held great political and economic sway over northeast Switzerland.

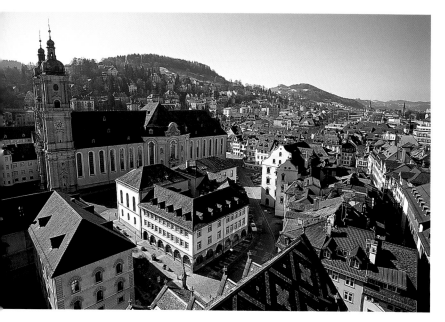

Above:
The inhabitants of the cantons of St Gallen, Thurgau and the two Appenzells like to come shopping to the provincial capital of St Gallen with its lively city centre.

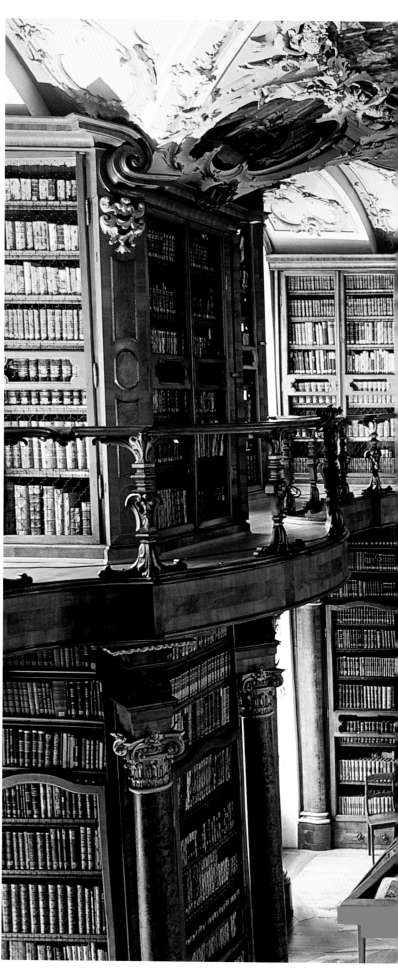

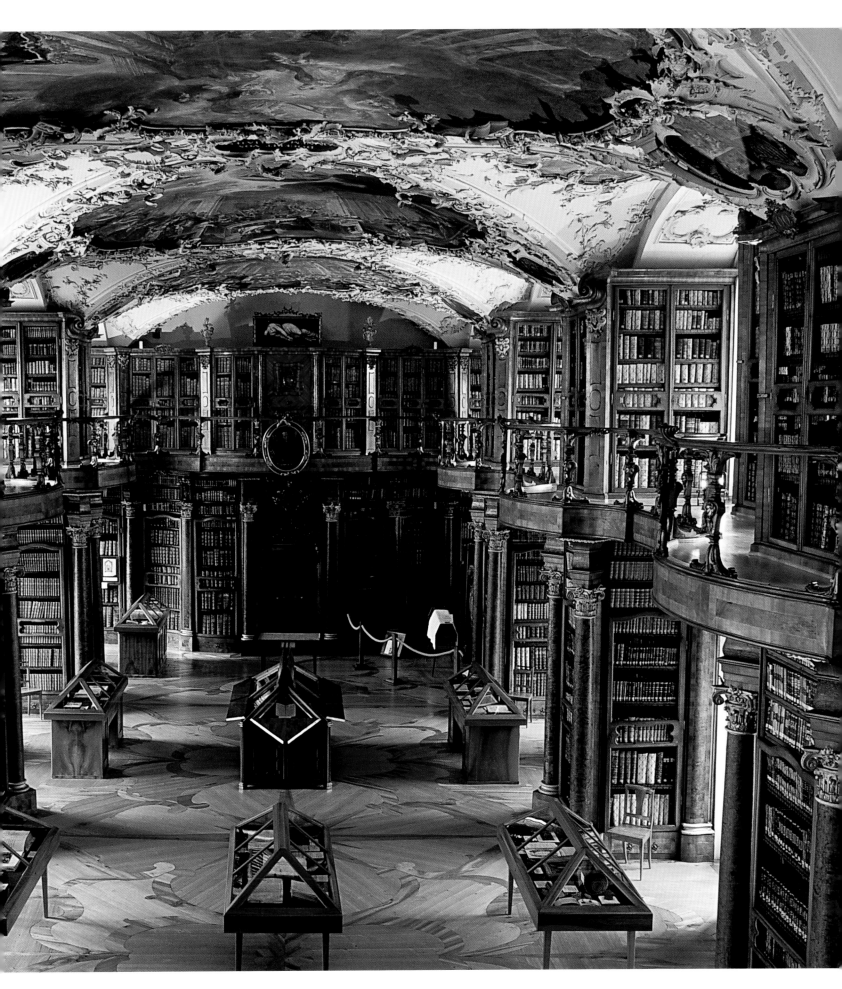

Above:

The Toggenburg region, here near Ebnat-Kappel, was once an independent and rather antiquated county in its own right. One famous inhabitant was the "poor man of Toggenburg", Ulrich Bräker (1735–1798). Although penniless all his life he taught himself to write books, commenting not only on his experiences as a Prussian mercenary in Berlin but also on the works of Shakespeare.

Right:

The Thur, after which the canton of Thurgau is named, is less frequented than many of Switzerland's rivers. Rising on Mount Säntis, it runs through the entire Toggenburg Valley before spilling into the Rhine at Andelfingen in Zürich canton. The Giessen Falls near Nesslau and the Thur Falls at Brübach are not to be missed.

Left:
The Rössli restaurant in St Peterzell in the Necker Valley with its unusual facade serves specialities from Toggenburg. It seems almost impossible to believe, but in 1842 the entire building was rolled nearer the street while guests munched and drank away inside.

Below:
As meek and mild as the River Thur in the Toggenburg Valley seems here, at other places along its course wild rapids test the nerves of white-water river rafters.

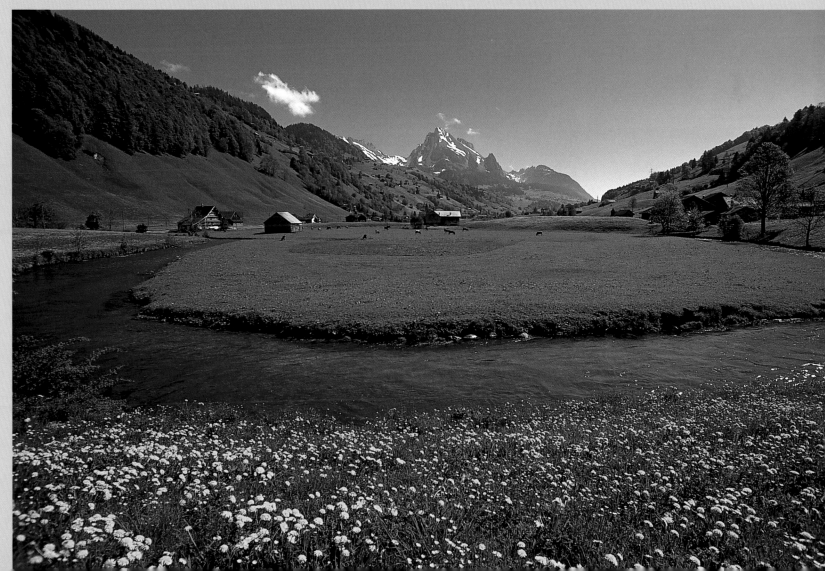

"CHESSLETE" IN HONOLULU, "SCHNITZELBÄNKE" ON THE RHINE –
TRADITIONAL SWISS CARNIVAL

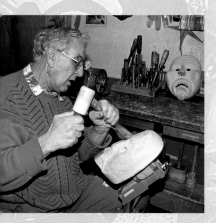

Above:
Mask maker Paul Mannhart from Berschis near Walenstadt carves Carnival masks in the tradition fashion.

Below right:
Carnival in Wangs used to be celebrated in a series of dances or "Spiele". In 1977 these were replaced by the procession common to most Carnival communities.

Below:
The "Röllis" in Walenstadt in their masks and rag costumes obviously have no trouble convincing the next generation to follow in their footsteps.

"Gugge" and "Schnitzelbänke", "Chesslete" and "Böögg" – even traditional Swiss Carnival mirrors the diversity of the Confederation. With their mad music and satirical verse, dawn processions and cardboard cut-outs, the democratic Confederates have no need to deride a feudal and military past like their German contemporaries in the Rhineland, who feel the urge to dress up as pseudo-French guards, princes, fools and dancing soldier girls during the silly season before Lent.

One manifestation of Swiss autonomy is the Carnival celebrated in Solothurn. The season opens on January 13 with "Hilari-Tag", when the guild of fools convenes at the Zum alten Stephan restaurant on Friedhofsplatz, as it has done since 1888. In a traditional ceremony the fools' lantern is lit and Solothurn renamed Honolulu, with the Rathausgasse or town hall street becoming the "street of asses" for the duration of the festivities.

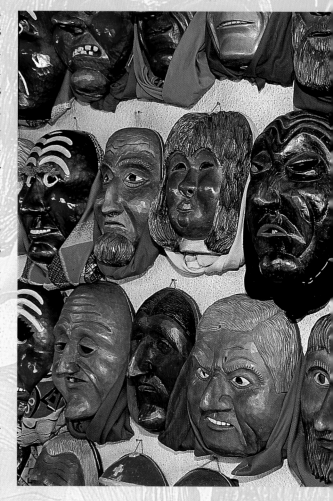

On "dirty Thursday" Solothurn – or Honolulu – finds itself suddenly gripped by the raucous spirit of Carnival. From 5 in the morning at Chesslete the old town echoes to the din of cowbells, horns and rattles enthusiastically wielded by fools large and small dressed in nightshirts, pointed caps and red neckerchiefs. The grand parade with its colourful floats kicks off on Sunday at 2.31 pm on the dot – and not a minute sooner or later. The season ends on Ash Wednesday with the ceremonial burning of the Böögg, a larger-than-life cardboard figure, after which Honolulu once again becomes meek and mild Solothurn – until next year's Carnival begins.

The people of Lucerne are proud of celebrating the wildest version of Carnival in the land.

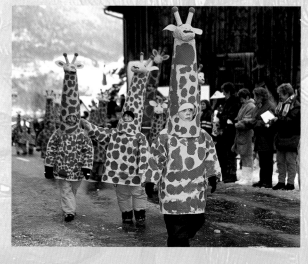

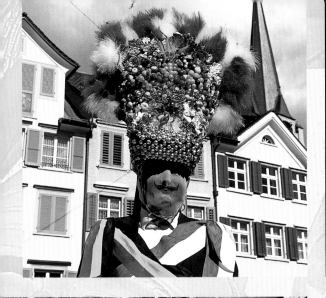

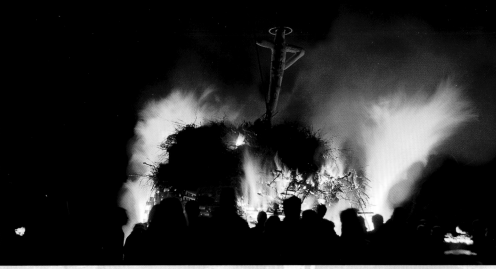

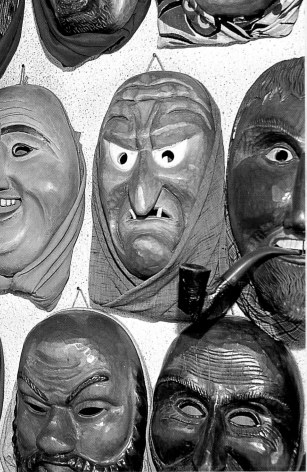

The mad days of "Fasnacht" affect the entire city. Being an innocent bystander is not allowed on Lake Lucerne; you don't just watch the parades, you throw yourself body and soul into the ongoing outdoor jollies. Everyone is involved, with tuneless music howling through the streets and pubs until the small hours and groups of friends and individuals getting up to all kinds of tricks.

All over the world noise has traditionally been diagnosed as a sure means of driving out evil spirits. Over the past 100 years the "Guggenmusiker" of Basle have exported their particular brand of musical pandemonium to all corners of Switzerland. Imaginatively clothed and armed with trombones, trumpets, saxophones, drums, cymbals, horns and all kinds of crazy home-made instruments, they march through the streets playing haunting melodies, mimicking Carnival marches and pieces of classical music and unleashing their own improvisations and composed ditties on the unsuspecting public.

The absolute highlight and also the end of the mad goings-on is Carnival in Basle a week after Ash Wednesday. At four on Monday morning the festivities begin to the sound of drums and piccolo flutes cheerily piping through the old part of town by lamplight. This, the cortège parade and the mass Carnival concert on Barfüsserplatz and Claraplatz attract visitors from all parts of the world.

Above:
On the Sunday after Carnival in Thal in the canton of St Gallen winter symbolically goes up in flames.

Above left:
During Carnival in Altstätten in the Rhine Valley, St Gallen, the "Rölleli-Butzen" dress up in crazy hats and squirt water pistols into the crowds, a tradition which has been preserved for over 300 years and is still very much alive.

Left:
On Carnival Sunday the "Rölleli-Butzen" are the main attraction of the colourful street parade in Altstätten, enthusiastically and raucously accompanied by lots of other mad figures.

Centre left:
All kinds of masks from jolly to grotesque hang on the walls of Paul Mannhart's studio, awaiting their grand performance during the silly season.

Much of the hard work on Alpine farms is still done by hand. In fine weather everyone has to muck in, even this elderly lady farmer from Mols on Lake Walenstadt.

The Seez Valley between Lake Walenstadt and Sargans is right out of "Heidi": rolling hills and a gently meandering river set against snowy peaks.

Right:
The pilgrimage chapel of St George's in Berschis near Walenstadt has Roman foundations. A Roman outpost was installed on the

wooded outcrop in 15 AD, with the chapel erected in the 12th and again in the 15th centuries and later also a Lourdes grotto.

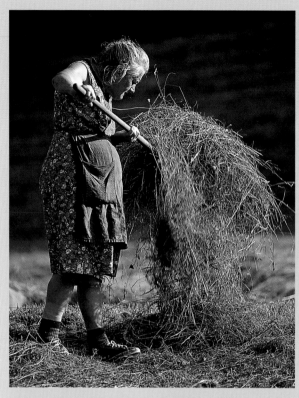

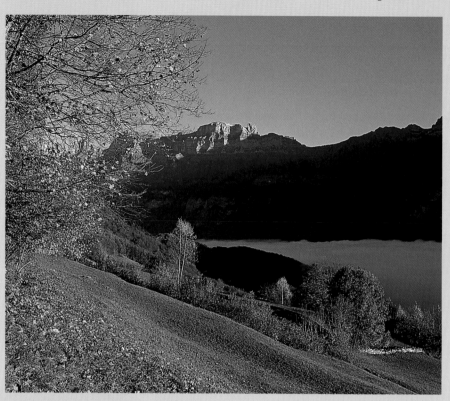

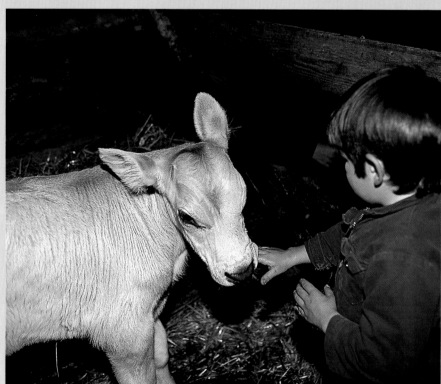

Dairy farming is the key to Swiss agriculture. Milk quotas and state subsidies are a long way off for this young man, however, happily playing with his new animal friend.

A family of farmers proudly posing in front of their Alpine chalet. One wonders how many of the children will later take up the same strenuous job as their parents ...

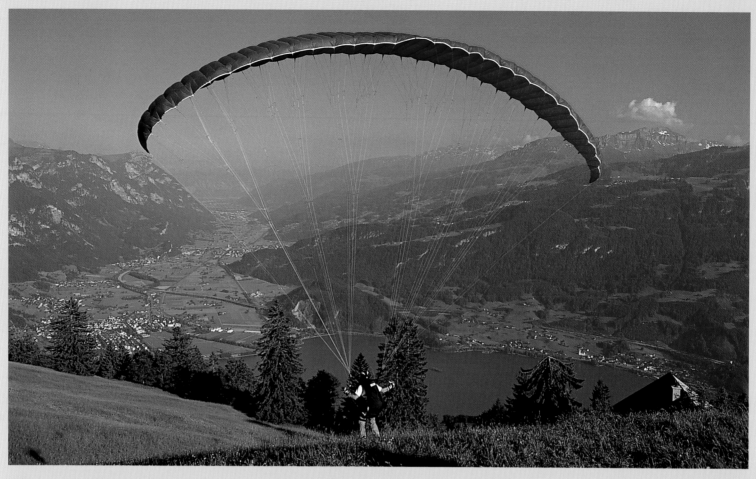

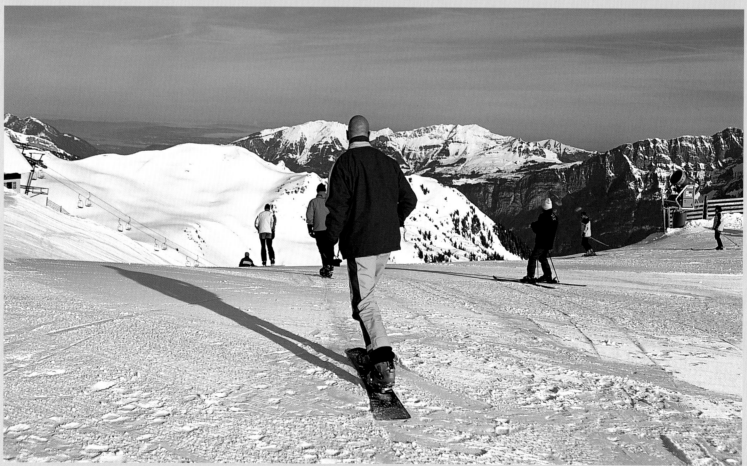

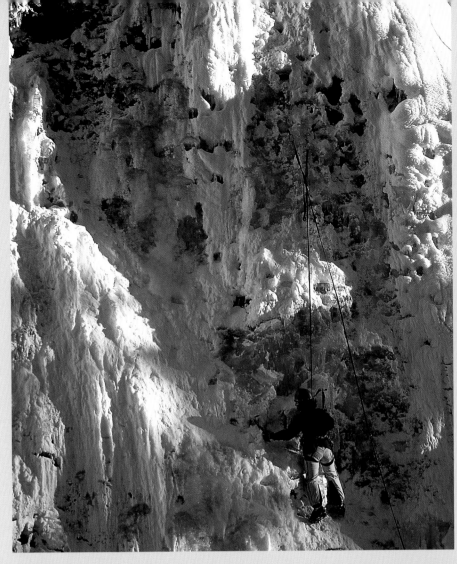

Switzerland, paradise for holiday-makers and the country which saw the birth of modern tourism. The Confederation has much to offer in the way of sporting activities; intrepid individuals can leap into the air from the slopes above Walenstadt (top left) and the extremely adventurous climb the frozen falls of the Weisstannen Valley (top right). Less isolated are the many pistes of the Swiss Alps (bottom left near Flums), where skiers and snowboarders zoom through the snow to their heart's content, and in summer well-marked hiking tracks, such as the Five Lakes Trail (bottom right), accommodate walkers nationwide.

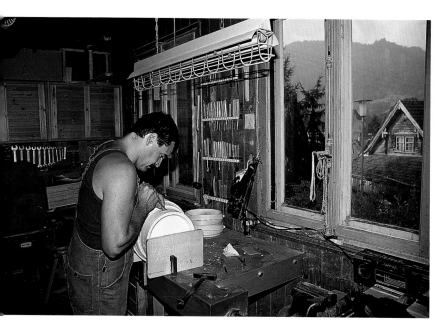

Top left:
At the museum dairy farm in Stein the art of cooping is still practised. The wooden vats and barrels for milk and cheese have to be precisely worked so that they are watertight and fit together without being glued.

Centre left:
Traditional instruments, such as the fretless "peasant's fiddle" the rebec, are still made by hand. Developed in Arabia, the rebec travelled to Europe via Spain in the 11th century. With the evolution of the violin in the 16th

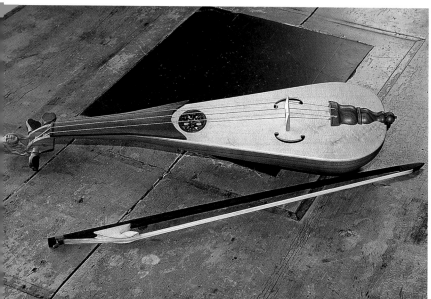

century the rebec was soon usurped at court and became instead the instrument of the farming population. Shaped like a pear, documents exist to prove that it has been played in Switzerland since the 15th century.

Bottom left:
This master instrument maker in Mels still patiently manufactures ancient instruments by hand.

Below:
High above Sargans with its parish church dedicated to St Oswald and St Cassian perches the castle of the counts of Werdenberg-Sargans. First mentioned in 1282, it was the seat of the landvogt until captured by Napoleonic troops.

Page 88/89:
Zürich, a rich, sparkling city on the Limmat River. Yet all that glitters is not gold; Zürich was also the scene of Zwingli's Reformation and Dadaism.

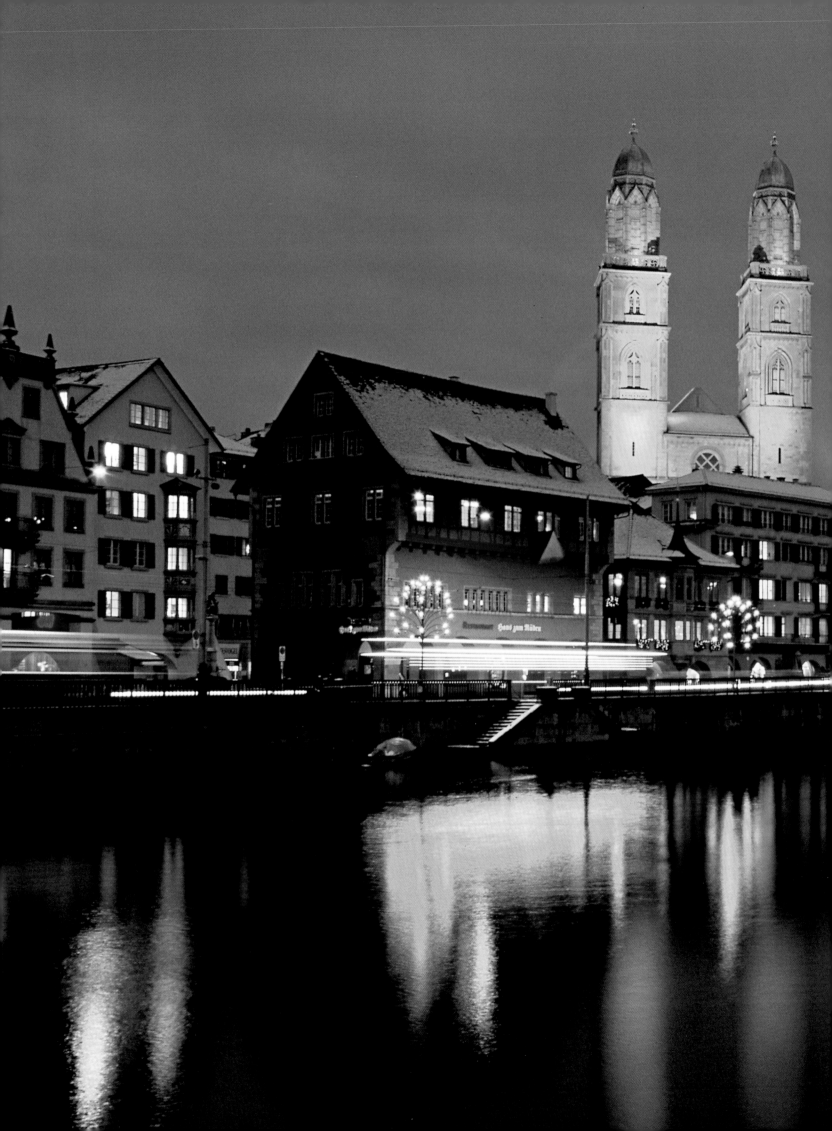

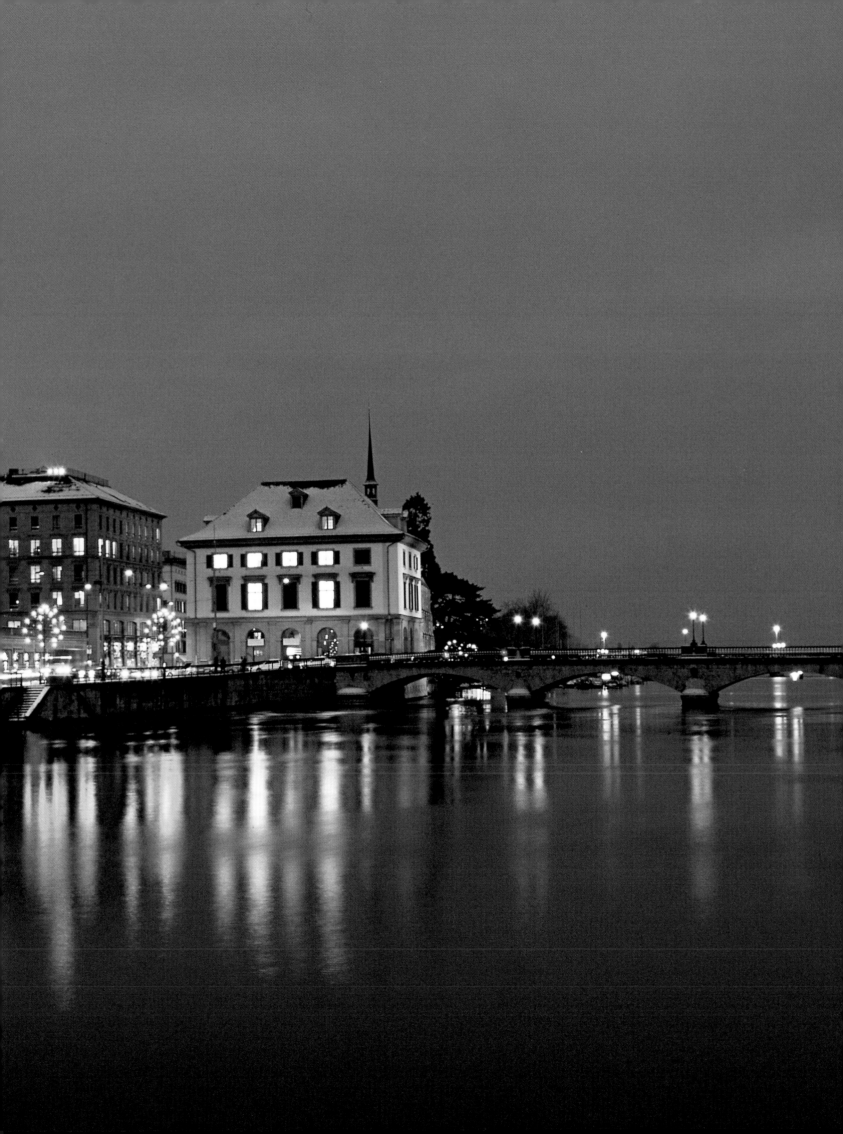

Below:
In his poem exalting Lake Zürich Klopstock sings of "pleasant strands". Trips aboard one of the lake's paddle steamers, past the fashionable villas of the superrich along its north-eastern shores, are indeed a pleasing experience.

Top right:
The great minster with its characteristic egg-shaped domes is reflected in the window of one of Zürich's many chic boutiques.

Centre right:
The town houses along Augustinergasse in Old Zürich have been lovingly restored. In the lower stories tasteful window arrangements light your way from Lindenhof to the minster.

Bottom right:
Crowding Paradeplatz are the headquarters of Switzerland's major banks who, when touting for custom, snootily quote Roman emperor Vespasian: "Pecunia non olet" (money doesn't stink). To get rid of the bitter taste in your mouth, pop into the Sprüngli cake shop next door and treat yourself to a gooey pastry.

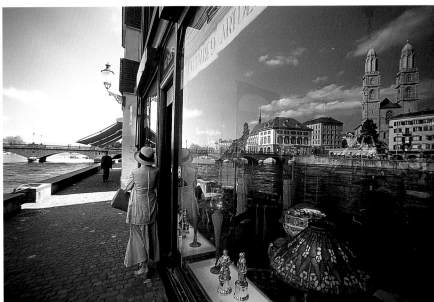

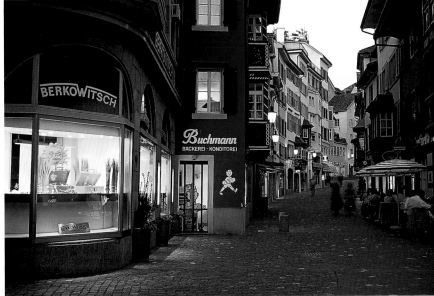

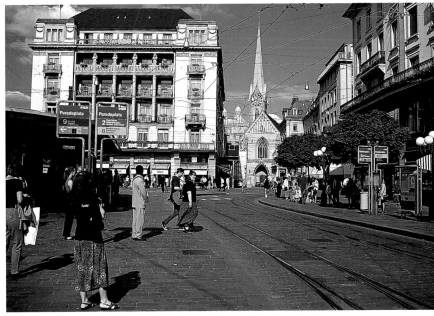

Below:
The covered Spreuerbrücke has linked the two halves of Lucerne north and south of the Reuss since 1406. With the opening of the Gotthard Pass in the 13th century the city began to expand and develop into a powerful and wealthy centre of trade.

Below:
Lucerne is the main point of departure for tours of Lake Lucerne with the largest fleet of paddle steamers serving an inland lake in the world. The largest of the boats has been traditionally named after the city of Lucerne since 1837.

Right:
Along the banks of the River Reuss Lucerne's restaurateurs entice you to dine in the midst of magnificent scenery. Top items on the menu are various types of fresh fish caught in local waters, such as perch and whitefish, traditionally coated in flour and fried in butter and herbs.

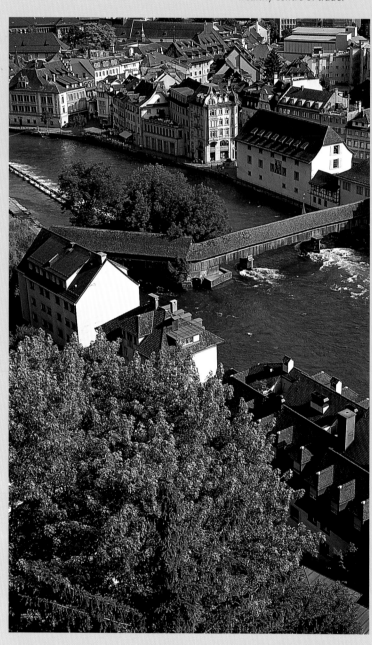

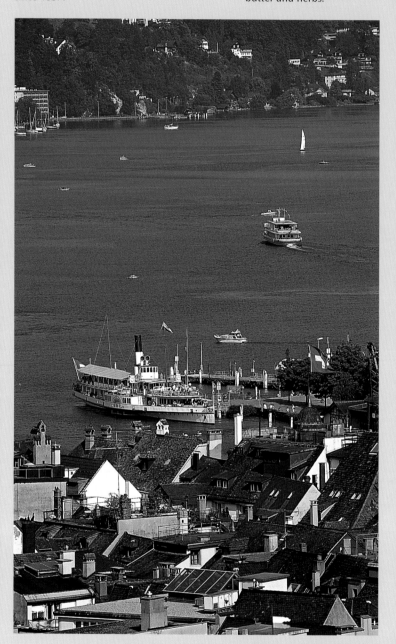

Right:
The old town hall has stood on Lucerne's corn market for 300 years. After Switzerland was seized by Napoleonic troops in 1798, for a brief period Lucerne was the capital of the short-lived Helvetic Republic.

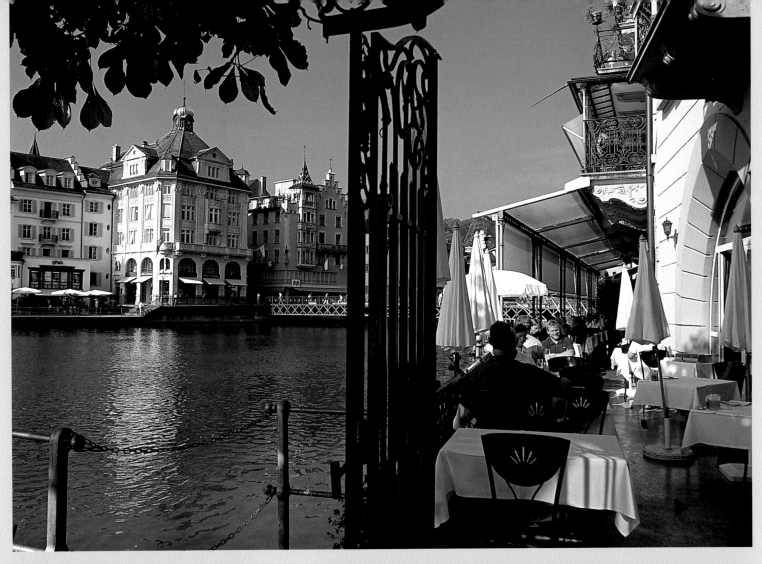

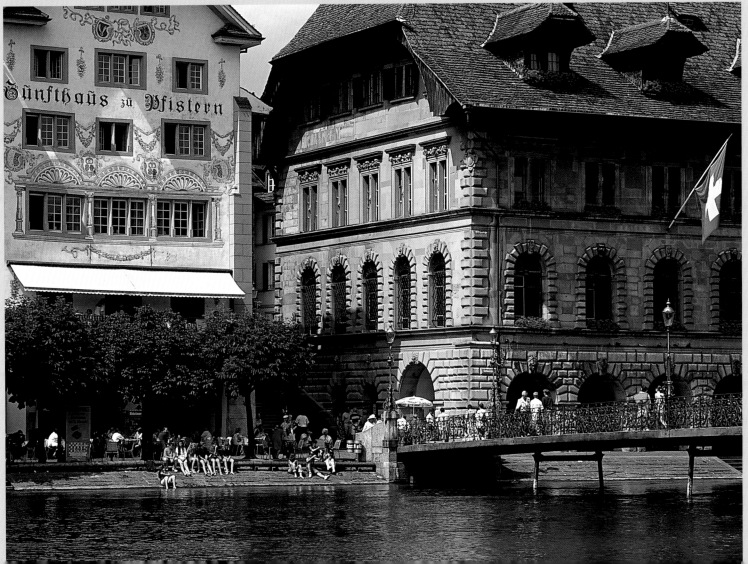

Below:
The last period of glaciation 10,000 years ago which caused great suffering to our forefathers today provides us with areas of astounding natural beauty and endless leisure opportunities. Here Lake Sempach in the Lucerne Mittelland, surrounded by rolling hills.

Top right:
An ancient Roman road runs along to the north end of Lake Sempach and the town of Sursee on the banks of the Suhre. The 16th-century town hall with its huge sundial and the gilt pub signs are the town landmarks.

Centre right:
The self-contained old town of Willisau with the Obertor from 1551 flying the flag. Willisau and neighbouring Menznau are shoemaking centres of nationwide acclaim.

Bottom right:
Between Sursee and Willisau is Schloss Wyher. First documented in 1304, for centuries the castle was owned by patricians from Lucerne until neglect and strikes by lightening made it uninhabitable. A special foundation has gradually rebuilt the moated castle with its manor house and "monastery".

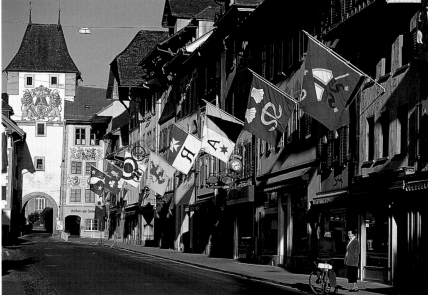

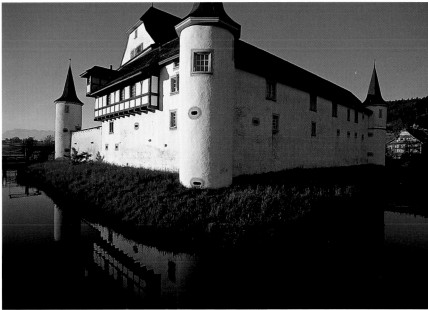

Right page:
Andermatt was populated
by people from Valais as the
building style of the oldest
houses in town clearly
indicates. Even before the
tunnel linking Andermatt to
the Gotthard was completed
the town was a humming
ski resort.

Isenthal in the canton of Uri
above the lake of the same
name is the place hikers
bound for the Uri Rotstock
(2,932 m/9,620 ft) set out
from. If you don't feel up
to the climb, there's a
convenient cable car.

The "Devil's bridge" across
the Schöllenen Gorge of the
River Reuss – a ravine Goethe
describes as "terrible" – was
the last section of the Gott-
hard route to be completed.
Legend has it that the Devil
promised to help the people
of Uri build the bridge if in
return they gave him the soul
of the first living creature to
cross the finished edifice.
The cunning villagers agreed –
and sent a goat scurrying
across to the incensed despot.

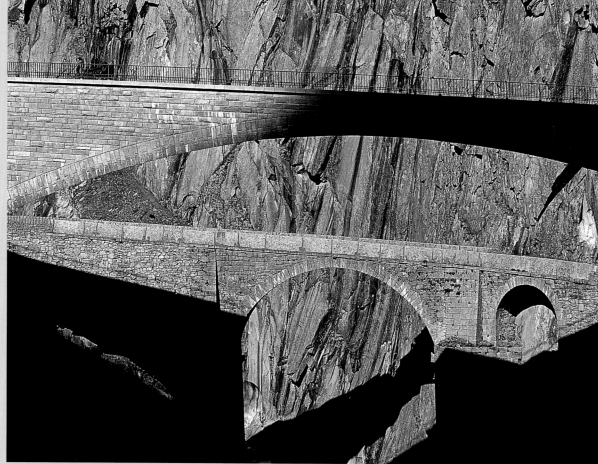

96

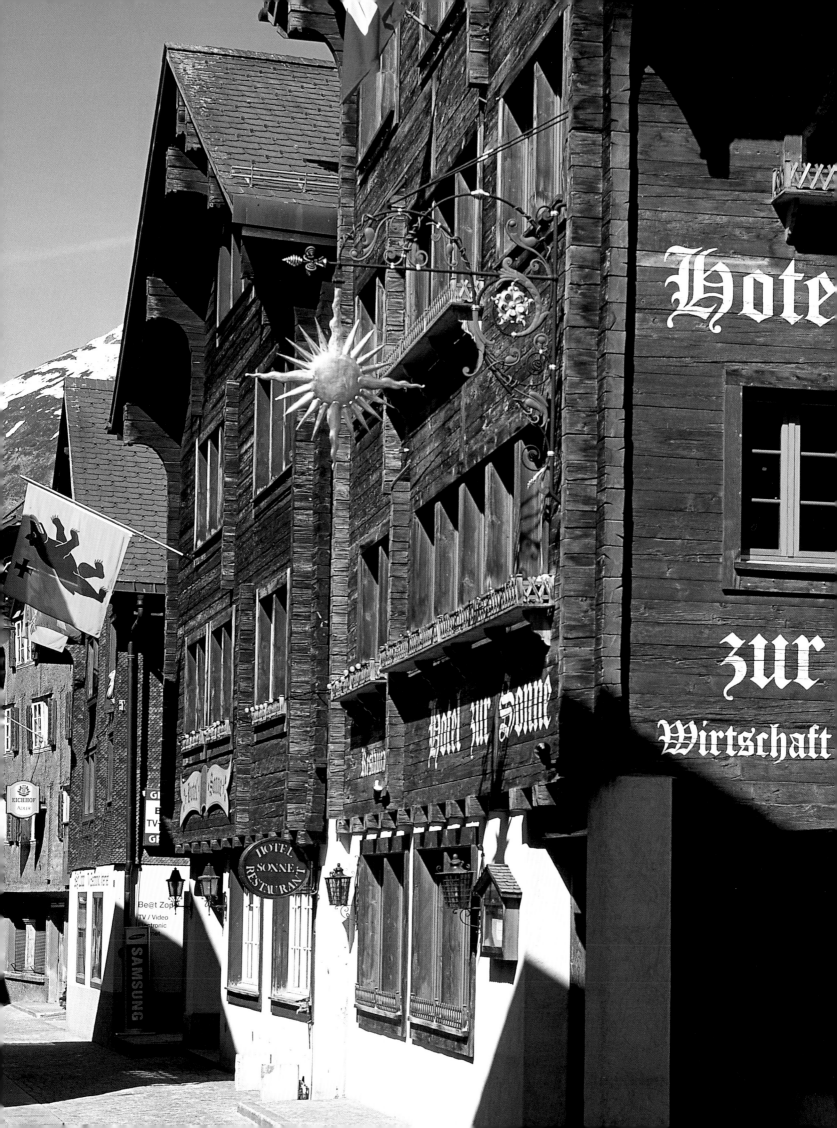

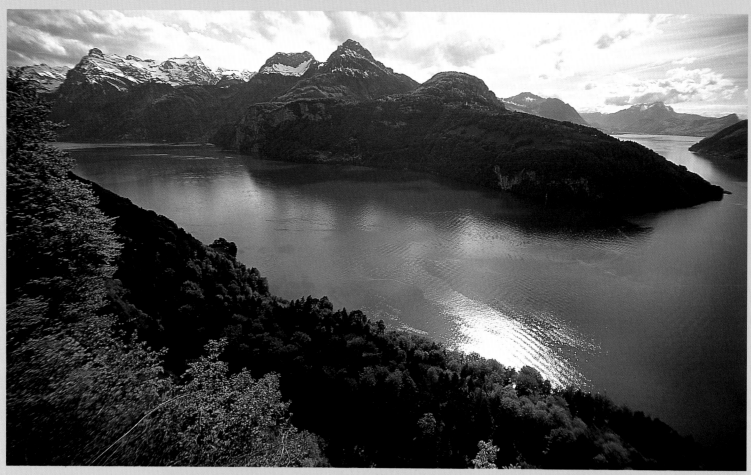

Above:
Lake Lucerne in the heart of German-speaking Switzerland may only be the fourth-largest in the country but it's certainly the most diverse. Enclosed by mountain peaks such as the Rigi (1,797 m/5,896 ft) and Pilatus (2,120 m/6,956 ft), the lake is split into five very different areas: Lake Lucerne, Lake Küssnacht, the Weggis and Gersau basins and the almost fjord-like Lake Uri.

Right:
Brunnen in the canton of Schwyz is poised at the transition of the Gersau Basin to Lake Uri, with the Rigi behind it. Feng shui fans are not the only people to be wowed by the impressive juxtaposition of lake and mountains.

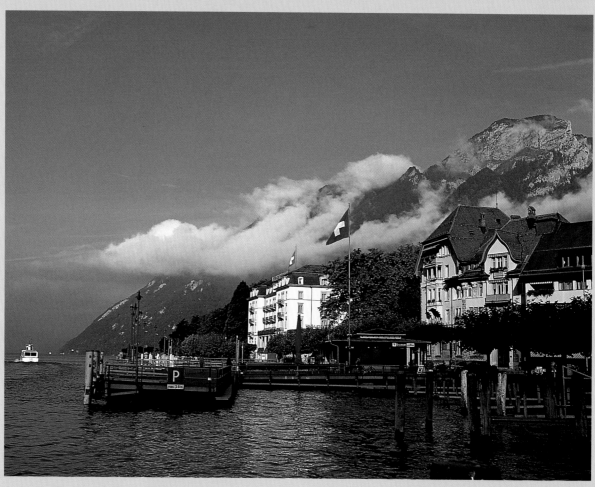

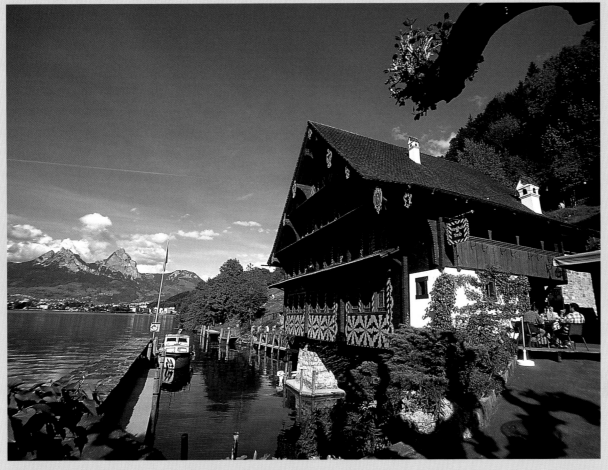

Left:
Haus Trieb clings to a spit of
land between lakes Lucerne
and Uri. It is both an inn
and the valley station of the
funicular railway up to the
Seelisberg (1,149 m/3,770 ft).

Below:
The scenic diversity of
Lake Lucerne is best enjoyed
by boat. Those without their
own craft can hop aboard
one of the comfortable
paddle steamers run by the
local shipping company
which operate all year round.

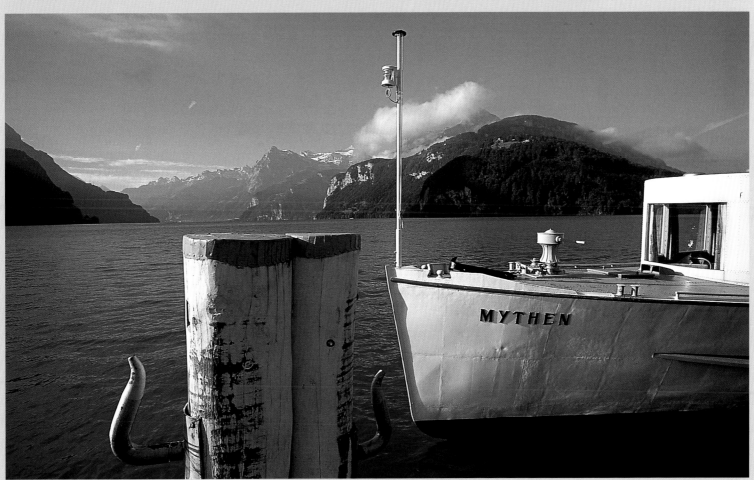

Schwyz, name of both the canton and its provincial capital, lies perched on the edge of a plateau strewn with fruit trees. The town hall built in 1645 is decorated with patriotic frescos documenting Switzerland's history.

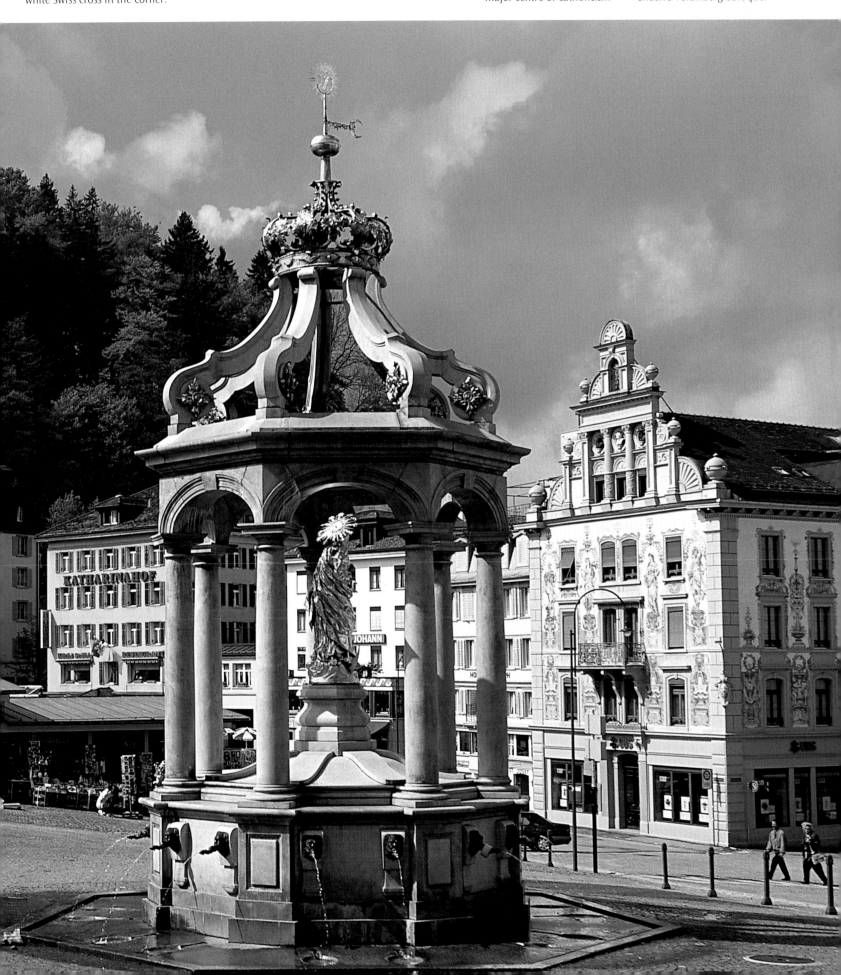

Bottom left:
Outside the town hall Schwyz flies the red flag – with a tiny white Swiss cross in the corner.

Below:
Place of pilgrimage, stop en route to Santiago de Compostela and monastic library housing 150,000 volumes, the Benedictine monastery of Maria Einsiedeln is a major centre of Catholicism north of the Alps. Dating back to the humble 9th-century hermitage of St Meinrad, during the 18th century the complex and its elaborate fountain were remodelled in effusive Vorarlberg baroque.

THE BOY AND THE APPLE

Right:
Friedrich Schiller: "Do you think I fear / The arrow from Father's hand? I will await it, / Steadfast, and not bat an eyelid. / Courageous Father, show them that you are a marksman / He who wishes to harm us does not believe you / To spite the brute, aim and strike."

Centre right:
Swearing the Oath of Allegiance on the Weinmarkt in Lucerne in 1332, with which the city denounced Austrian rule and joined forces with the forest cantons. The illustration is taken from Diebold Schilling's chronicle from 1513.

The opening of the Gotthard Pass at the beginning of the 13th century made supremacy over central Switzerland not only an attractive but also a viable proposition. The forest cantons around Lake Lucerne were initially able to ward off the increasingly covetous overtures made by Austria's Habsburg dukes with royal charters issued by the German emperor. The situation changed in 1273, however, with the fall of the Staufer dynasty and the crowning of the zealous Rudolf von

King Rudolf I died on July 15 1291. Just a few weeks later, the cantons of Schwyz, Uri and Unterwalden signed a document in Latin – which still exists – swearing mutual allegiance and rejecting any form of foreign jurisdiction. Under their own laws murderers were to be put to death and thieves have their entire possessions confiscated. These privileges came into effect on defeat of the Habsburgs at the Battle of Morgarten in 1315. In the decades which followed Lucerne,

Habsburg as the new king of Germany. The mountain communities, who had sacked and pillaged land and cattle owned by the rural gentry and local monasteries, were brought to order by Rudolf I's officials and made to answer to the new magnate's system of justice under which they now fell.

Zürich, Glarus, Zug and Bern were to join the Swiss Confederation.

Those are the historical facts, but where are the Oath of Allegiance, the "We want to be a single nation of brothers", William Tell, Gessler, the boy and the apple and the Hollow Way we are familiar

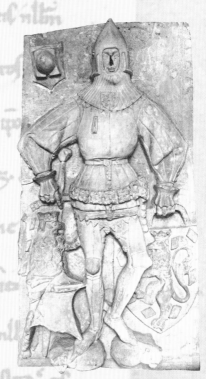

with from Schiller's play? Each year on August 1 the Swiss celebrate their national day in memory of the birth of the Swiss Confederation, when centuries ago the Everlasting League signed their pact on Rütli Meadow high up above Lake Lucerne. William Tell and the inaugural document of 1291 have even had museums dedicated to them at Bürglen on the Klausen Pass and in Schwyz. Arnold Winkelried, who with his heroic death at the Battle of Sempach in 1386 is alleged to have thwarted a further attack by the Habsburgs, is another Swiss institution commemorated by countless statues and school textbooks.

MYTHS AND LEGENDS

All of these people and events – sadly perhaps – are nothing more than fairytale myth. When and where just who actually met to seal the pact of the forest cantons is unknown; what is certain, however, is that they weren't freedom fighters concerned with the foundation of a Swiss state. Tell and Winkelried, the subject of legend since the 15th century, are also probably just the culmination of a number of individual historical events; after all, marksmen and martyrs crop up in fables all over Europe. As symbols of the desire for freedom and the fight for independence, however, from America to Poland, from the French Revolution to the present day they have developed a momentum of their very own which silences any claims to historical inaccuracy.

Above:
Tombstone of knight Walter von Hohenklingen who fell in the Battle of Sempach in 1386. The battle is also associated with the legend of Arnold von Winkelried whose ultimate self-sacrifice allegedly helped the forest cantons defeat the Austrians.

Left:
A statue of the legendary folk hero Wilhelm Tell, erected in 1893, stands proud in Altdorf.

·1307·

WILHELM·TELL

·1895·

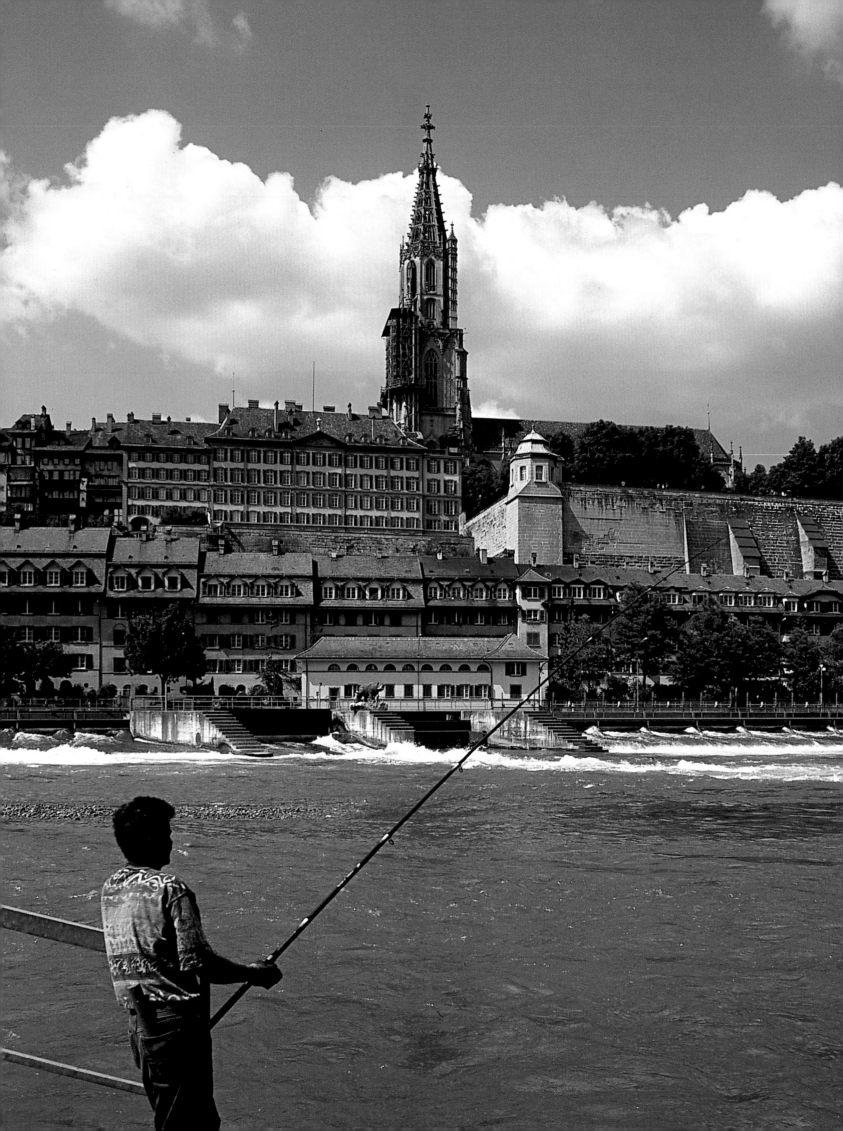

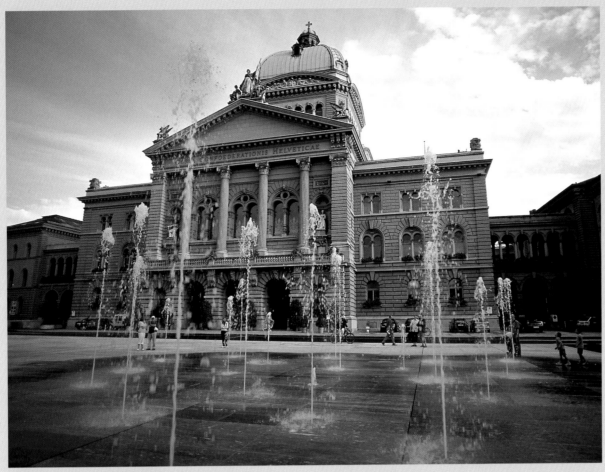

The steeple of St Vincent's, Bern's mighty minster, perforates the clouds on the banks of the River Aare. For centuries Bern was the largest and most powerful city state north of the Alps, ruled with an iron hand by its patricians.

The Bundeshaus in Bern is the seat of the Swiss government and parliament. The building was completed in 1902 using building materials from Switzerland alone. The square outside it was refurbished in 2003.

Over coffee and cake on the platform outside the minster there are marvellous views out across the Matte quarter of Bern and the weir in the Aare regulating the flow of water.

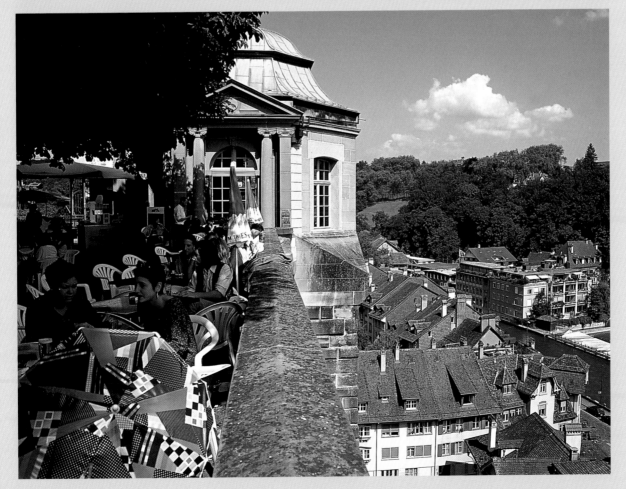

Typical Bernese farmland. Jakob Amman, Mennonite elder after whom the Amish People are named, came from this area. The Amish emigrated to the USA in c. 1700 and still live according to their beliefs, refusing to use either electricity or cars, for example.

In Wiedlisbach near Solothurn a squat tower is all that remains of the town wall built to protect the little 12th-century town from would-be intruders.

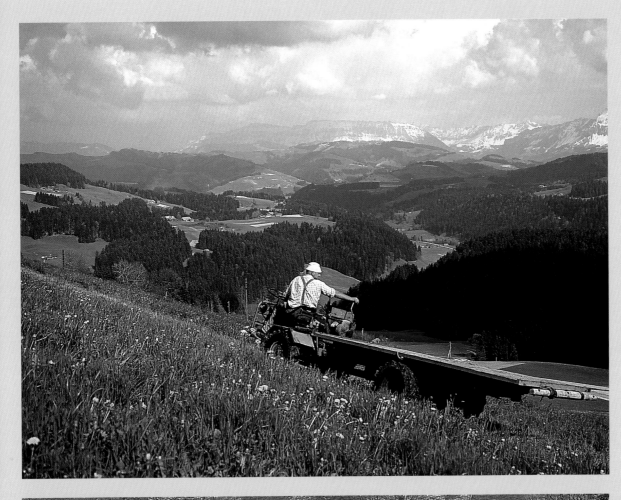

The grassy slopes of
Emmental near Chuderhüsi,
gourmet fodder for the
cattle whose creamy milk
is used to make the famous
cheese.

This chic, spacious farmstead
is near Langnau on the Ilfis
River, the centre of cheese
production in the Emmental
Valley.

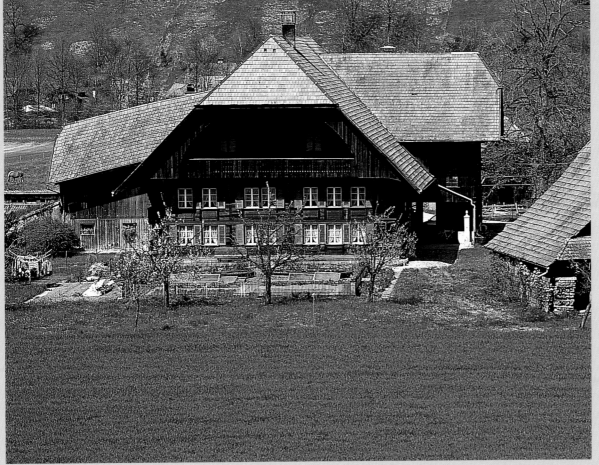

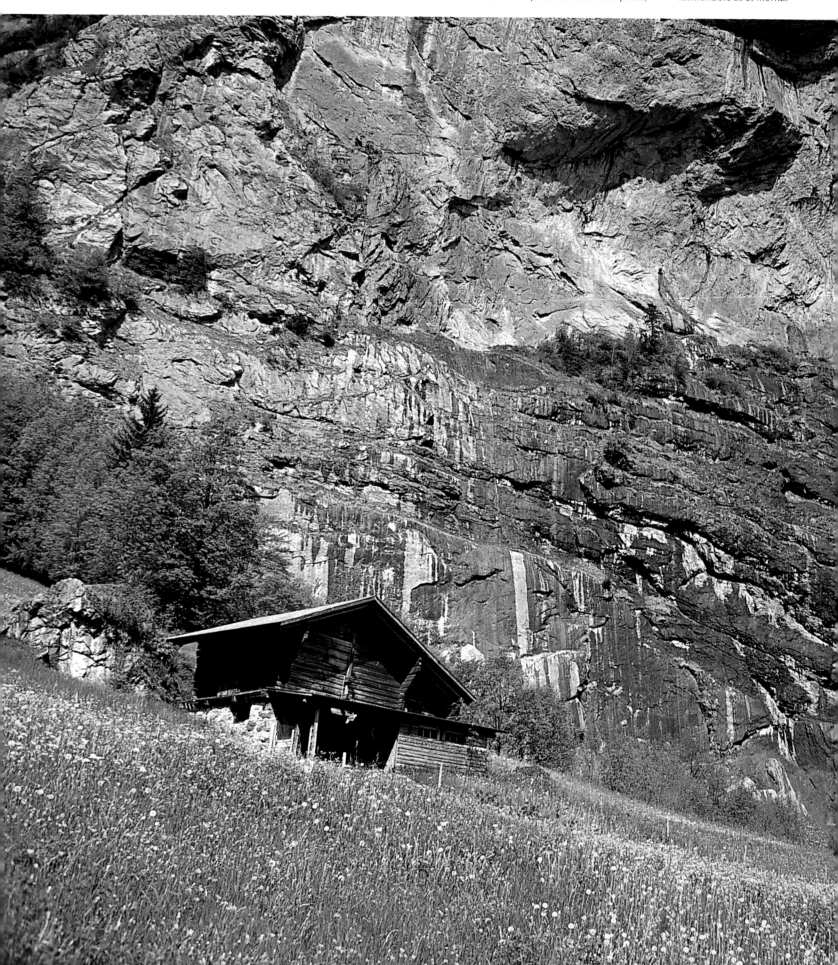

Centre right:
Near Meiringen the River Aare has carved its way through a rocky ravine 1,600 m (one mile) long. A narrow path runs along the resulting Aare Gorge, which drops down 200 m (656 ft) at its most precipitous point.

Bottom right:
The source of the River Simme bubbles from no less than seven openings in the Fluhhorn (2,139 m / 7,018 ft) before flowing into the Simme Valley. Not surprisingly this beauty spot near Lenk is known as Siebenbrunnen or "seven springs".

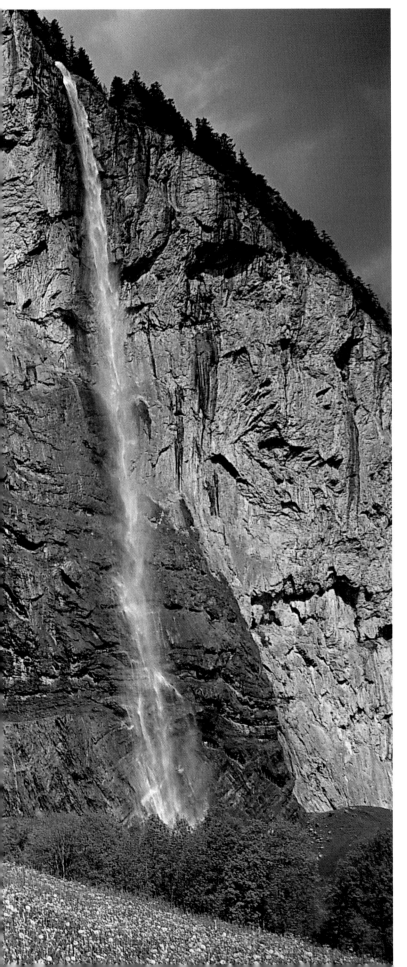

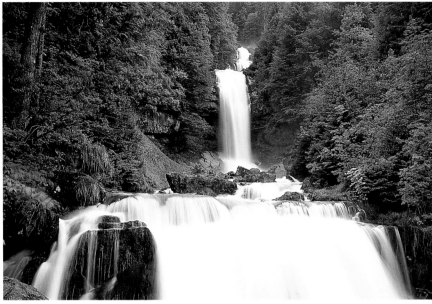

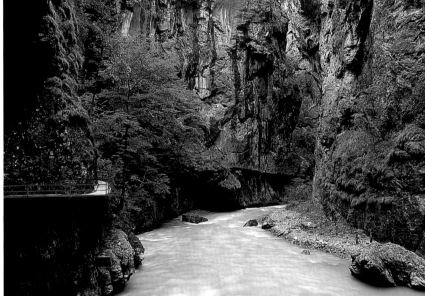

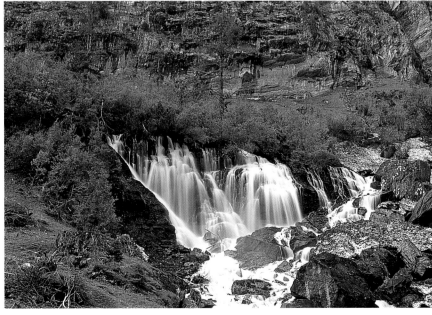

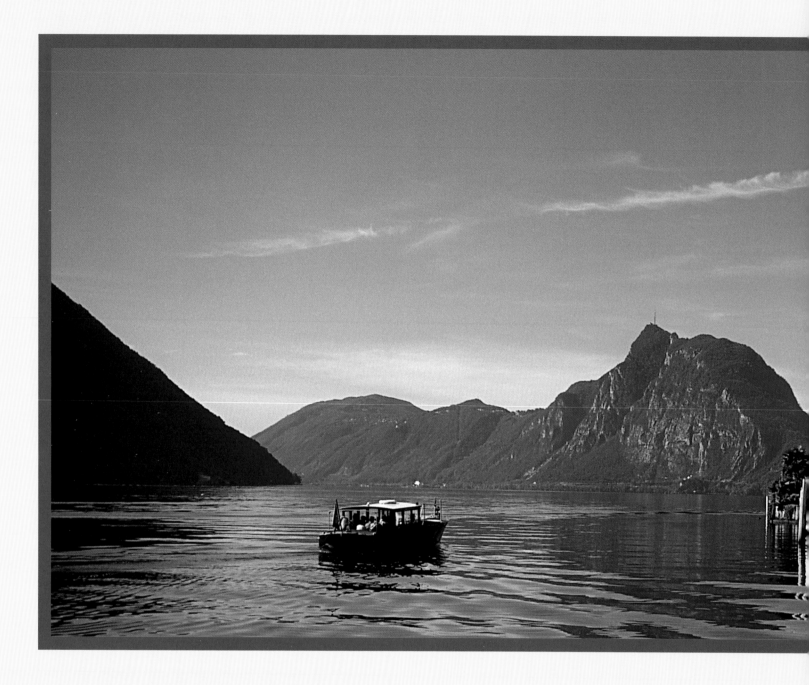

THE OTHER SWITZERLAND — GRAUBÜNDEN AND TICINO

As if Switzerland's infrastructure wasn't complicated enough with the "Rösti divide" and its sometimes blinkered regional mentalities, in the southeast quarter of the Confederation there are two cantons which are different again from the rest. Here other languages are spoken; here, a hundred years before the Rütli alliance, the first Confederate oath was sworn; here one of the cantons boasts both the ancient Swiss tradition of representative democracy and also active participation in the Thirty Years' War. This is where there are winter sports galore, Mediterranean "joie de vivre" and lake shores strewn with palms. For all its ice and snow, southeast Switzerland is also where lemons grow.

Gandria clings to the shores of Lake Lugano near the Italian-Swiss border in Ticino. The village wine and food cellars are on the other side of the lake in Cantine di Gandria, accessible only by boat.

Graubünden, the largest canton covering one sixth of Switzerland's surface area, is a "Confederation within a Confederation", a contradictory world all of its very own. Here Alpine ranges fizzle out into rocky crags, the valleys forming a "labyrinth network of mountains, a valley tucked into each crack and crevice", according to Rhaetian author PC Tscharner. "Almost no valley is like another; the hiker wandering through this maze, each time he sets foot in a new valley, enters a completely different part of the country, finds himself in a new natural environment, comes across yet another type of people."

The variety of Graubünden is mirrored in its linguistic prowess; besides the German spoken in the north and the Italian of the south, five Romansch languages have survived: Sursilvan, Sutsilvan, Surmiran, Vallader and Putér. As often only a few thousand speak any one of these vulgar Latin dialects, since the 1980s various attempts have been made to introduce an artificial common denominator called Rumantsch Grischun.

Despite its idiosyncrasies, Graubünden has never been out on a limb. The Septimer Pass, now almost completely deserted, was the first and for many centuries the only way across the Alps; prior to the event of the railway the Lukmanier Pass was used for much of the region's military and commercial transport.

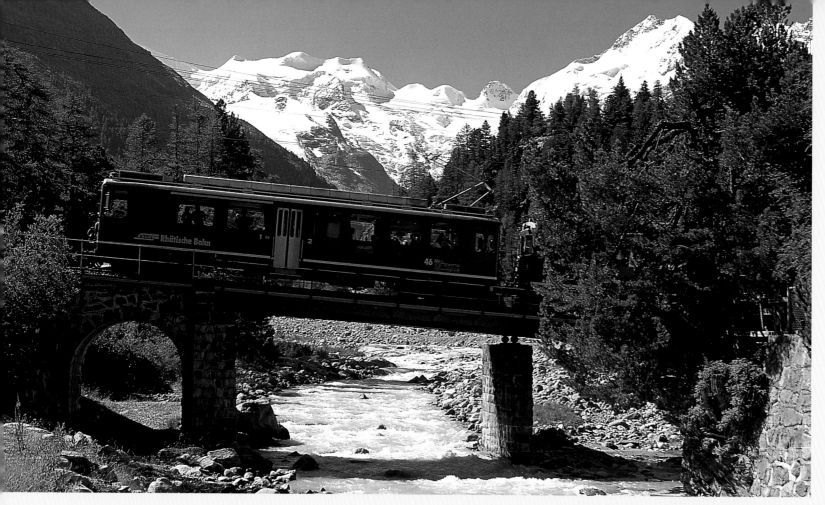

Near the Bernina Pass the Morteratsch Valley runs very close to the glacier. The meltwater of the Morteratsch Glacier feeds a gushing stream.

Tourists have long replaced the traders and soldiers. Across the south of the canton sprawls the Engadine, a valley of the River Inn cutting through lofty mountain ranges, whose highly ornamental dwellings with their funnel windows, elaborate oriels and gables in all shapes and sizes bond together in ever more original combinations to form a harmonious whole. The humming centre of the Upper Engadine is the chic ski resort of St Moritz, together with Davos on the Flüela Pass and Klosters in Prättigau the winter domain of the rich and beautiful. In the Lower Engadine, the quieter, wilder reaches of the Inn Valley, villages dotted about green pastures perch high above the winding roads.

The Rhine is to the western and northern corners of Graubünden what the Inn is to the Engadine. The Upper Rhine rises in the far west of the canton near the Oberalp Pass, forging its way through the spectacular Flims Rhine Gorge at Reichenau before merging with the Lower Rhine from the Rheinwald Valley 65 kilometres (40 miles) away, tearing through the precipitous, once feared Via Mala ravine along its route.

Just beyond Reichenau the river reaches Chur, the present heart of the canton and ancient capital of the Roman province of Rhaetia. The episcopal quarters with the cathedral, palace and seminary have been the epicentre of the region for over 1,500 years. Further north near Maienfeld, before disappearing into Liechtenstein the Rhine flows through scenery which wouldn't look out of place in a Heidi film.

SOLARIUM BATHED IN LIGHT

"A completely new attribute immediately and unequivocally becomes apparent: the unusual burst of light flooding everything in its path. The sky glows, the light sparkles, the ground dazzles." The sentiments of Carl Spitteler from Liestal, winner of the Nobel Prize for Literature, are undoubtedly shared by the majority of the travellers spilling across the Gotthard into Ticino, regardless of whether they follow the same route as Spitteler, who 100 years ago gazed down on his radiant canton from the old hospice atop the pass, or take the more convenient tunnel running through to Airolo.

The northern areas, such as Sopraceneri, the Blenio, Verzasca and Maggia valleys, the Val di Colla and the upper stretches of the River Ticino

which give the canton its name, are Alpine hinterland. Leaving the flower-strewn meadows behind you and driving south among vineyards, sweet chestnuts, figs and, believe it or not, palm trees, the burdens of the north simply melt into oblivion. The scenery here seems sunnier and more relaxed; even the "campanile", tall and slender alongside their respective churches, appear more

liberated than their solid counterparts in the German-speaking areas of the country. Ticino is Switzerland's solarium, its south-facing balcony, easily accessible from the north either via the 15 kilometres (9 miles) of the Gotthard railway tunnel, completed in 1882, or the slightly longer version for cars and juggernauts built 100 years later.

The Italianate towns perched along the shores of Lake Maggiore, whose northern tip juts into Switzerland, are set against striking backdrops. The Mediterranean facades and blossoming trees of Ascona's and Locarno's lakeside promenades

ripple in the glittering waters, with the Ticino Alps rising proud behind them. For decades the region's 2,000 hours of sunshine plus per year have drawn artists and other prominent figures from Lenin to Hermann Hesse to Ticino from all over the world.

Lake Lugano with the town of the same name at its northern edge is no less delightful. A major Roman settlement, it evolved at the foot of the pass across Mount Cerini which wound on through Bellinzona, the Blenio Valley and Castro to the Lukmanier Pass. The three piazzas in the old heart of town still effuse a bustling charm.

The unspoilt Maggia Valley, which has retained much of its original character, is much calmer. Along its upper rapids mountain villages of wooden houses cling to steep slopes, with waterfalls gushing down into the depths. In the lower valley the river is quieter, meandering through dappled

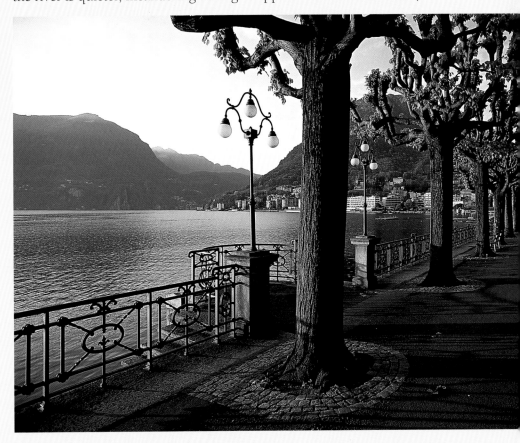

birch and chestnut forest and past typical "rusticas", Ticino farmsteads built from hewn boulders and decked with wooden galleries and stone roofs, such as those in the little wine village of Giumaglio.

Above left:
Once the busy heart of the Lower Leventina Valley, the village of Giornico on the Ticino River still has many of its ancient, lovingly kept stone houses which are decorated with flowers in summer. The Torre Attone in the village is ca. 1,000 years old and was probably part of a Lombardic castle.

Centre left:
The oldest sacred building in Switzerland is on the southern shores of Lake Lugano in Riva San Vitale. At the centre of the early Christian, 5th-century Battistero San Giovanni stands a baptismal font over the original pool (piscina) used for submersion baptisms. The frescos depicting scenes from the life of Christ are 12th century.

The largest of Ticino's cities, Lugano, lies at the northern end of the lake of the same name. The mild winters and sunny summers encouraged Etruscans, Celts, Romans, Lombards and Franks to settle here.

113

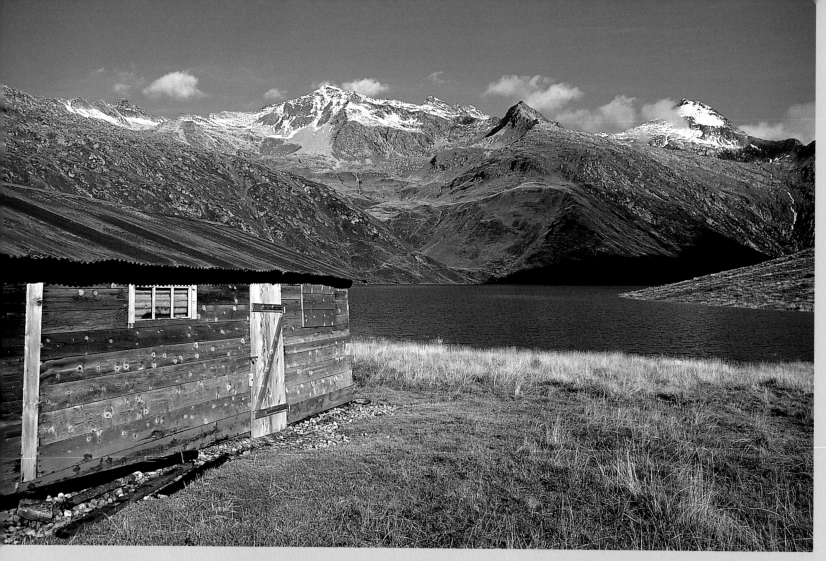

Above:

The Lukmanier Pass, Passo del Lucomagno or, in Romansch, Cuolm Lacmagn runs along the border between Graubünden and Ticino. At just 1,916 m (6,286 ft) the lowest of the Alpine crossings, it was a major thoroughfare through the mountains for both the Romans and later Staufer kings. The former hospice at the top of the pass sunk in the Santa Maria reservoir in 1967.

Right:

Between Ilanz and Reichenau the Rhine forges its way through Flims limestone in a deep gorge. The bizarre beauty of the ravine makes it popular with water sports fanatics, who in their rubber dinghies, kayaks and canoes are able to reach the more remote spots of the canyon.

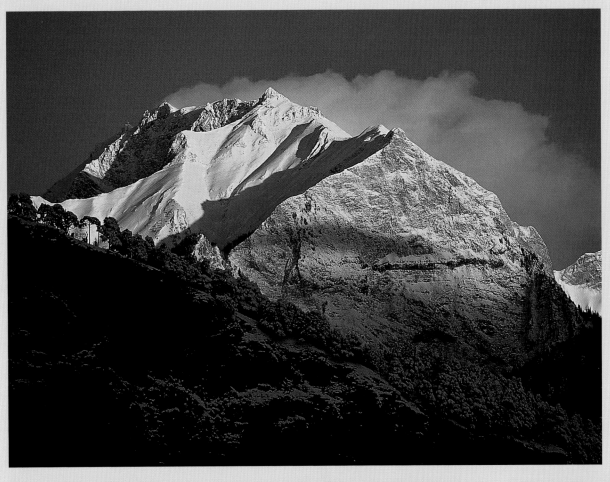

Left:
The cloudy peak of the Falknis (2,562 m / 8,406 ft) or "Heidi Mountain" near the Liechtenstein border, dramatically lit up by the evening sun.

Below:
Through the uplands of Graubünden runs the valley of the River Valser, famous for its natural beauty and mineral water. You can swim in its waters; the source in Vals has been tapped into the thermal baths built by Swiss architect Peter Zumthor from massive Graubünden rock.

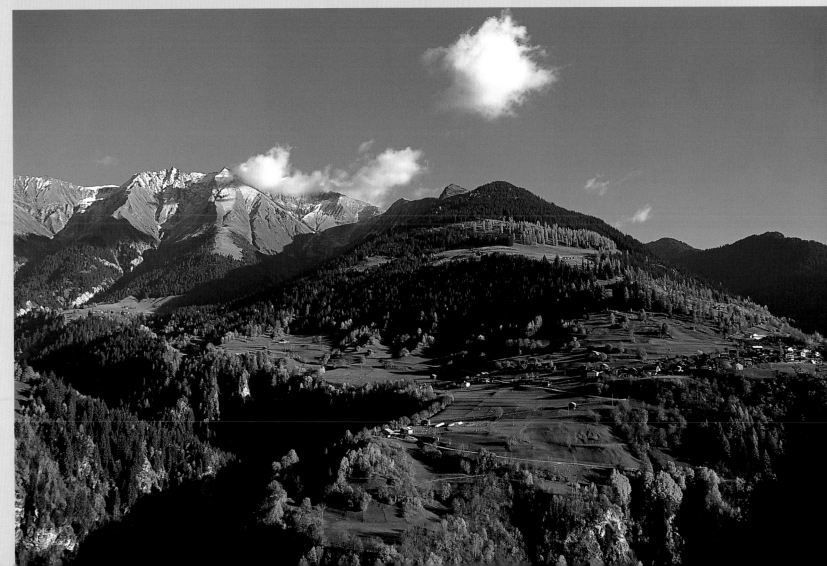

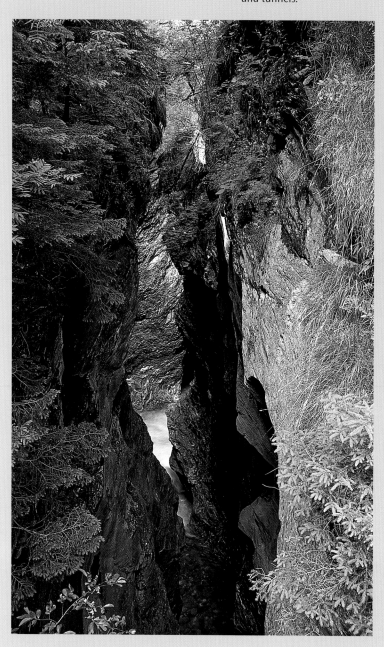

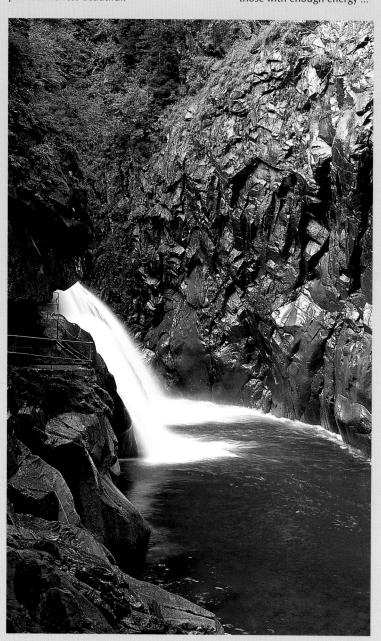

Right:
The 65 kilometres (40 miles)
of the Lower Rhine – or Rein
posteriur in Romansch –
pass through narrow ravines
and green pastures strewn
with wayside chapels.

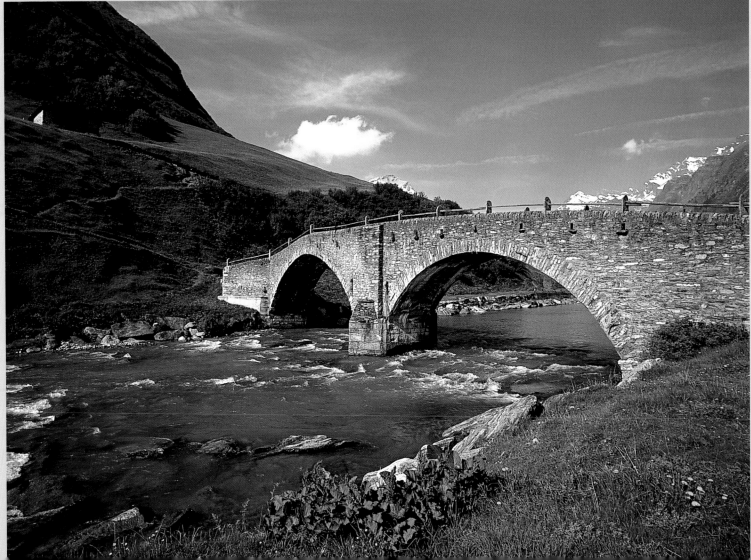

FANTASTIC ALPINE PANORAMAS –
SWITZERLAND'S MOUNTAIN RAILWAYS

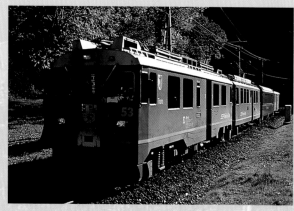

Above:
"I want to take everybody up the mountains so that all can enjoy the magnificence of our sublime country!" cried Niklaus Roggenbach in 1863, clutching the patent for his new invention which would transport trains up steep inclines using toothed wheels and racks.

Above right:
Full steam ahead for the Bernina Express near the spiral viaduct at Brusio. In autumn the turning leaves are a glorious sight.

Centre right:
The building of the Iltios railway in 1934 enabled new ski resorts to be opened in Toggenburg. In summer the trains carry daytrippers and hikers up to the Iltios.

There are over 600 mountain railways in Switzerland, some of which trundle up to over 3,000 metres (almost 10,000 feet), such as those climbing the Kleines Matterhorn (3,820 metres/12,533 feet) and the Jungfrau (3,457 metres/11,342 feet). The funiculars and cable railways serve skiers in winter and hikers in summer; for those not partial to such strenuous activities, there are also a number of special tourist trains with generous panorama windows from which to enjoy the beauty of the Swiss Alps and marvel at the simply genial Alpine engineering in comfort and style.

The superstar of panoramic trains is without doubt the Glacier Express. A seven-hour journey takes you from the fashionable ski resorts of St Moritz and Davos in Graubünden through seven valleys and over three mountain passes to Zermatt in Valais at the foot of the Matterhorn. The glass-roofed, pillar-box red carriages of the "slowest fast train in the world" cross 291 bridges, pass through 91 tunnels and, with the help of racks and cogwheels, even manage to master the 2,033 metres (6,670 feet) of the Oberalp Pass.

Like a fat caterpillar the Glacier Express snakes up from St Moritz through the spiral tunnel of the Albula Valley to the Landwasser viaduct giddily suspended between mountain peaks. Impressive views are guaranteed as you glide through the Swiss Grand Canyon of the Rhine near Reichenau, the railway line the only indication of human activity. Further southwest beyond Goms, where mountain goats flit across jagged peaks, you chug past the proud patrician houses of Valais's vintners. Speaking of which ... At the Gourmino restaurant car you can treat yourself to a slap-up meal amongst the elegant walnut furnishings.

Past Visp the train enters the Matter Valley, the deepest in Switzerland, and begins its final ascent to pedestrianised Zermatt 1,604 metres (5,263 feet)

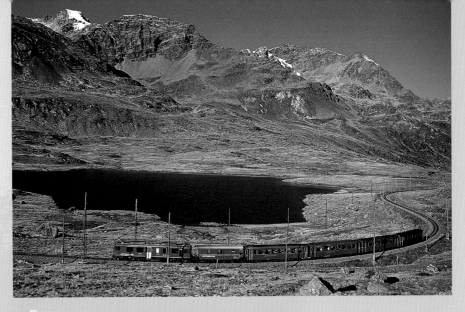

up, the Matterhorn inching nearer and nearer. Switzerland's best-known summit is said to have inspired the melange of elegance and durability which characterise the Glacier Express. Those wanting to enjoy fantastic vistas on solid ground without a pane of glass between them and the Alpine world take the rack railway up from Zermatt to the Gornergrat at 3,089 metres (10,135 feet), which offers breathtaking panoramas out over no less than 29 peaks topping 4,000 metres (13,000 feet).

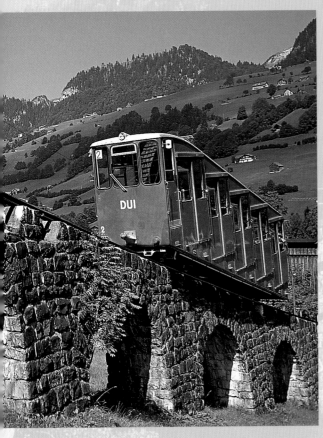

Above:
The Bernina Express struggles up an impressive 2,253 m (7,392 ft) to the Bernina Pass, making the highest rail crossing in the Alps past spectacular, giddy mountain panoramas.

Left:
On May 21 1871 the locomotive Stadt Luzern hauled the first mountain train in Europe up the Rigi. The line is still operating, with special steam trains and "belle époque" carriages laid on in summer.

Left:
The narrow gauge Furka–Oberalp railway connects Brig in Upper Valais with Disentis in Graubünden. Along the 100-kilometre (62-mile) stretch the trains pass through 17 tunnels, cross 87 bridges and whiz past some splendid mountain scenery.

The Glacier Express is not the only spectacular form of Swiss transport. You can approach the king of the Alps from Geneva aboard a historic, Lake Geneva steamer terminating in Montreux, where the railway's Rhône Express transports you to the foot of the Matterhorn. Also from Montreux, the Golden Pass Express run by the Montreux-Berner Oberland-Bahn whisks you to Zweisimmen where there are good rail connections to Interlaken and the Brünig Panorama Express on to Lucerne. One ingenious feature of the latter are the viewing carriages at the front of the train which look straight out onto the tracks, the engine driver tucked away out of sight above your head.

The Bernina Express is yet another superlative of the Swiss rail system. At a gradient of 7 % the steepest railway in the world to manage without cogs and racks, the trains make the highest rail crossing in the Alps over the Bernina Pass 2,253 metres (7,392 feet) above sea level. Along the 145-kilometre (90-mile) stretch the scenery is simply magnificent, the train wheezing across daring viaducts, through spiral tunnels and mountain galleries, past gushing streams, icy glaciers and blossoming Alpine meadows. In fine weather the roofs can be opened, enabling you to experience the transition of north to south from the bleak precipices of Piz Bernina to the palms gently swaying in the breeze at Tirano, the final destination on a truly sensational journey.

Below:
Chur has been a "peripheral centre" for thousands of years. The oldest city in Switzerland, the capital of the Roman province of

Rhaetia prima, episcopal see and cantonal capital, it has always been rather out of the way, apart from the rest with its own special status.

Top right:
Behind elegantly restored town houses towers the steeple of St Martin's, the city's Protestant answer to the bishop's Catholic cathedral

since 1526. Three of the glass windows in St Martin's were designed by Augusto Giacometti, Alberto Giacometti's uncle twice removed.

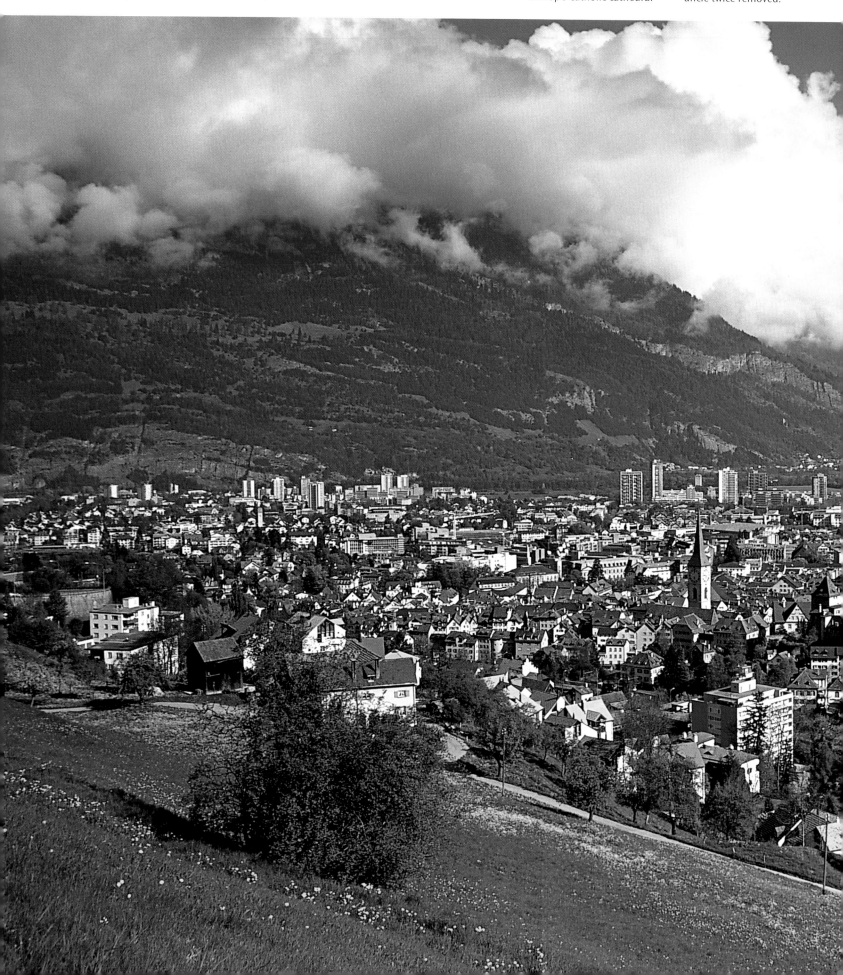

Centre right:
The narrow, winding streets and 15th-century buildings in Chur's old town squatting beneath the bishop's palace bear witness to the city's long history. They now house a number of tiny boutiques and cosy cafés.

Bottom right:
In the southwest of Old Chur, not far from the Obertor gate and the banks of the River Plessur, the long-established Zollhaus restaurant serves traditional Graubünden platters and pearl barley soups.

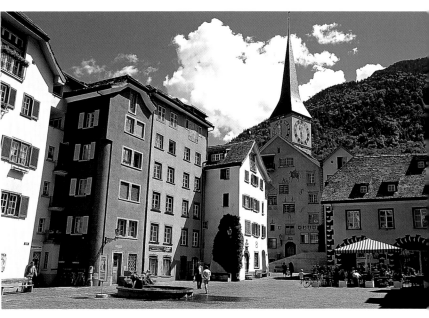

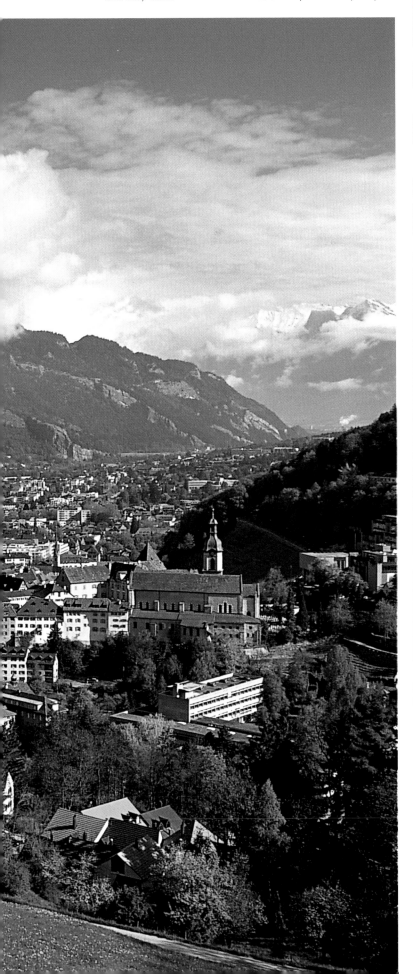

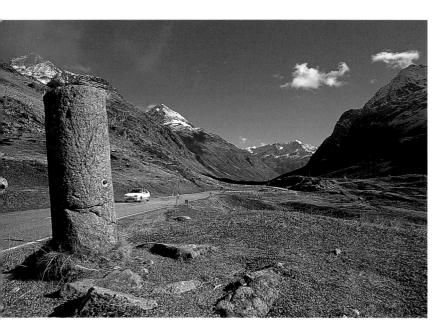

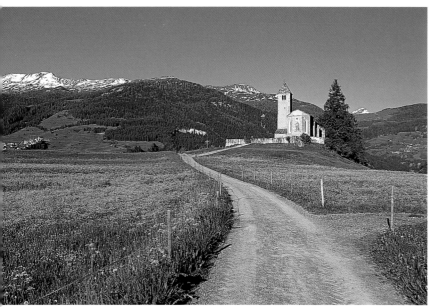

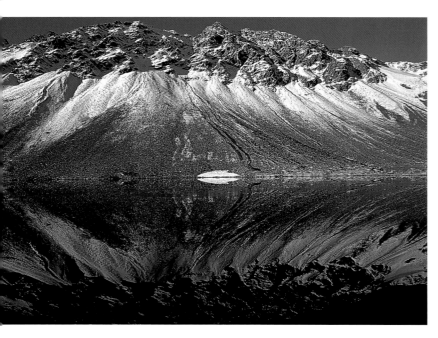

The stumps of two Roman pillars on the Julier Pass, the main Alpine crossing during the Roman period, still mark the triumphant victory of the legions of Drusus and Tiberius in 15 BC. "Now they are completely defeated and the passes secured", Roman geographer Strabo noted with satisfaction on learning of the conquest of the Rhaeti.

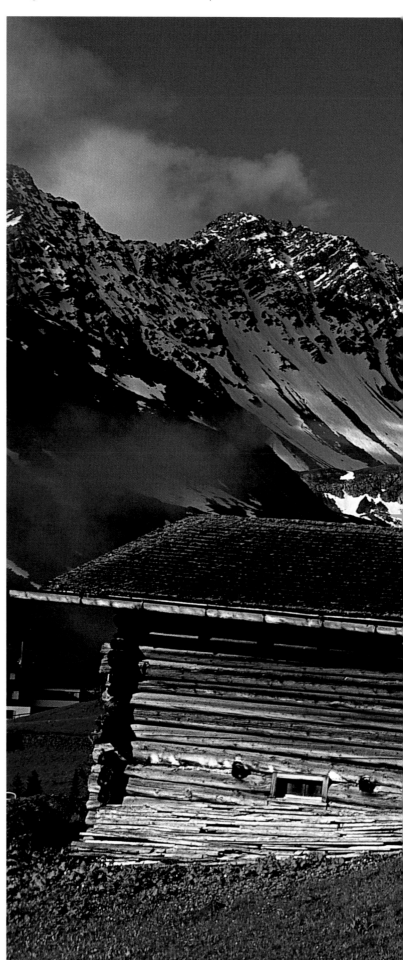

Centre left:
St Mary's near Lantsch (Lenz) is not far from the farm at Vazerol where in 1471 the three Upper Rhaetian leagues swore an oath, heralding the birth of the land and later canton of Graubünden.

Bottom left:
Squeezed in between the giant peaks of the Prättigau and Upper Engadine, the Flüela Pass tops 2,380 m (7,810 ft). As it is often closed in winter due to possible avalanches, most cars travel from Klosters to Susch aboard the motorail which zooms along 19 kilometres (12 miles) of tunnel.

Below:
Between the Weisshorn and Hörnli Arosa, up above Chur in the high-lying Schanfigg Valley, is one of Switzerland's prime ski resorts. In summer 150 kilometres (93 miles) of hiking trails await eager wanderers.

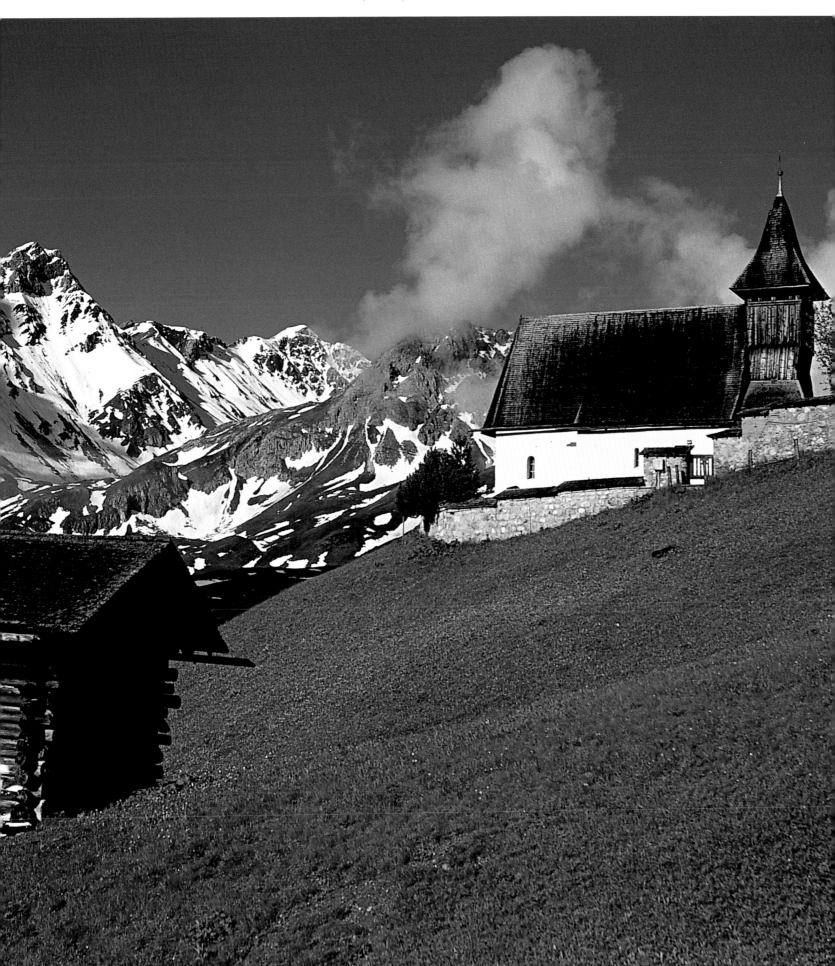

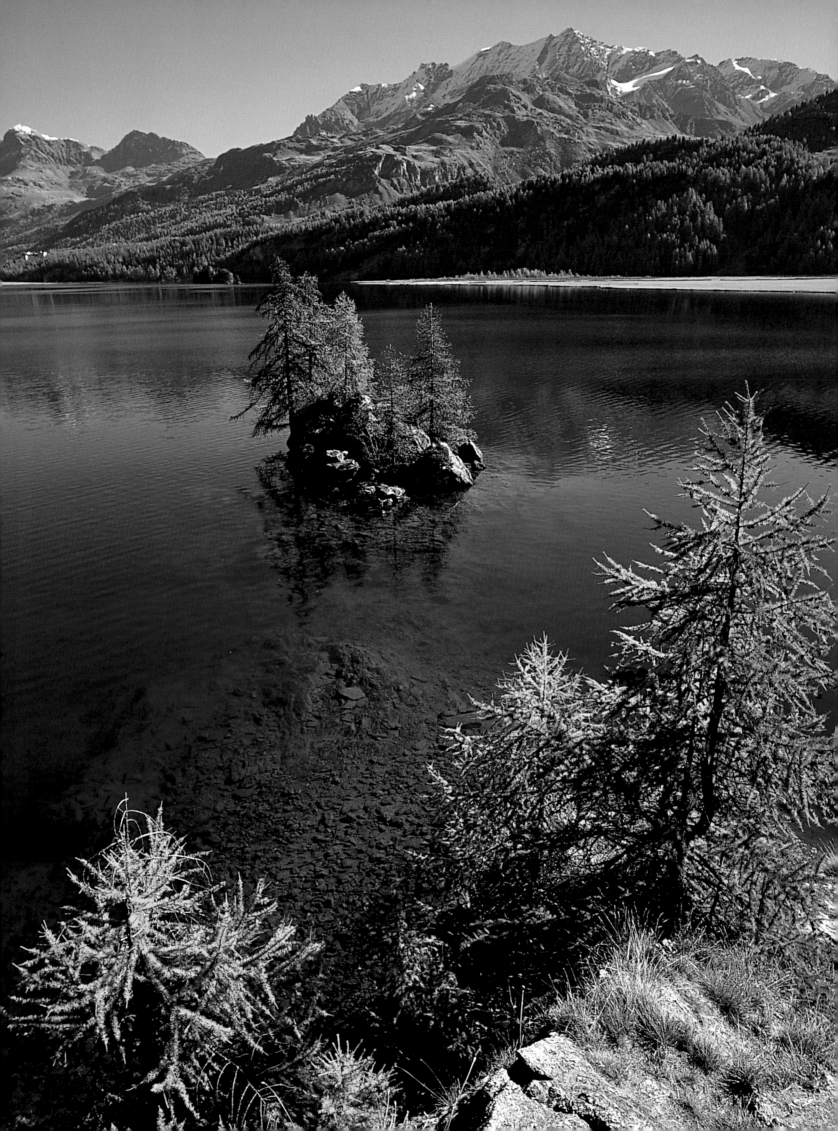

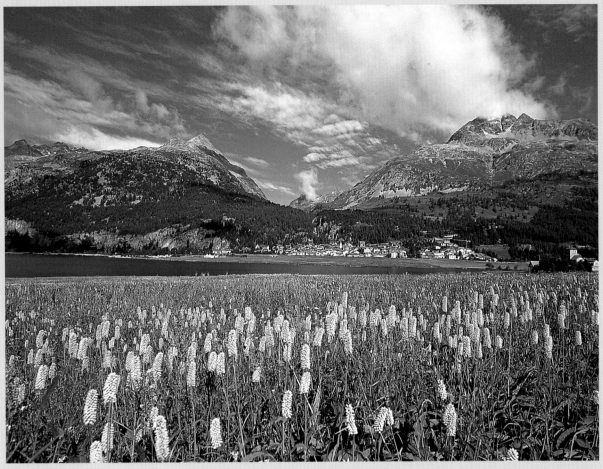

Left page:
Beneath the Maloja Pass the River Inn fills several lakes. The first is Lake Sils or Lej da Segl in Romansch which in summer provides ideal windsurfing conditions at 1,800 m (5,906 ft) above sea level.

A meadow of flowers on Lake Silvaplana north of Lake Sils. Friedrich Nietzsche spent his summers in Sils Maria between the two lakes from 1881 to 1889.

Further along the Julier Pass is the smaller Lake Champfèr, St Moritz's neighbour. If you want to enjoy the solitude of the natural surroundings here, you'd better rise early.

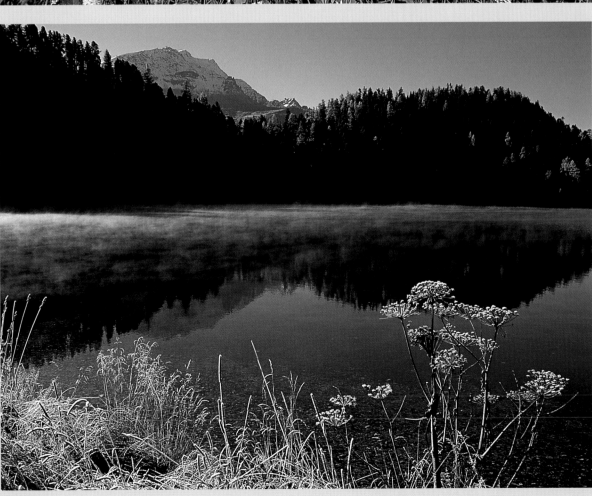

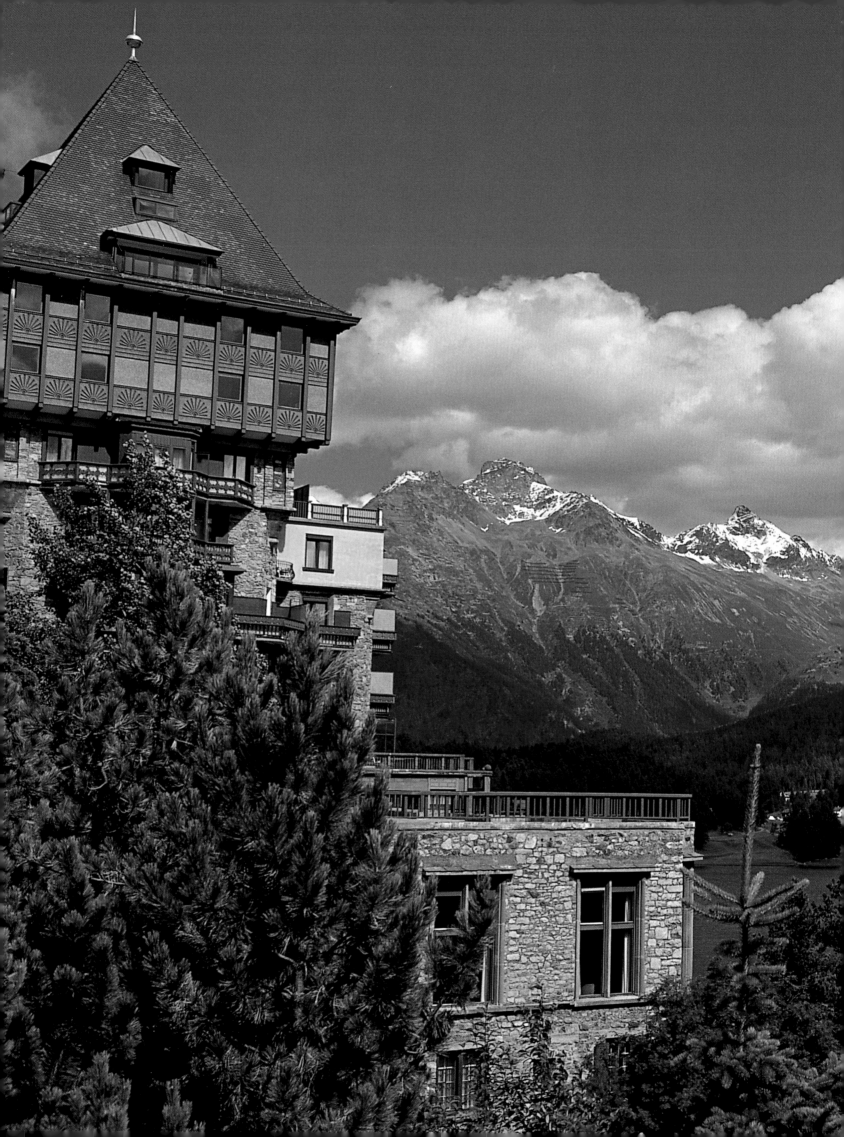

Left:
In 1896 Caspar Badrutt
opened the legendary
St Moritz Palace Hotel.
His father Johannes Badrutt
is revered as the "inventor"
of winter Alpine tourism;
in 1856 he set up the
Engadiner Kulm in St Moritz,
the first hotel in the Alps
to stay open all year round.

Below:
Stylish St Moritz has hosted
the Winter Olympics twice
(in 1928 and again in 1948)
and not without good
reason; it was here that
English tourists came up
with the idea of bobsleigh
and toboggan racing.

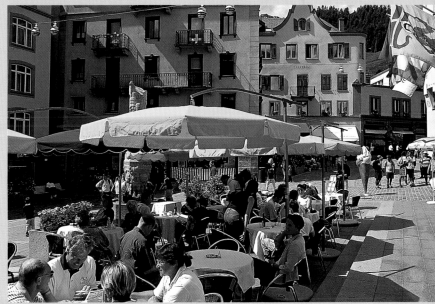

Above:
In summer, too, guests enjoy
the caviar-and-champagne
atmosphere of St Moritz, the
largest and most exclusive
"village" in Switzerland.

About a mile south in the
spa of St Moritz Bad, curative
mineral springs discovered
in the Bronze Age are used to
treat various aches and pains.

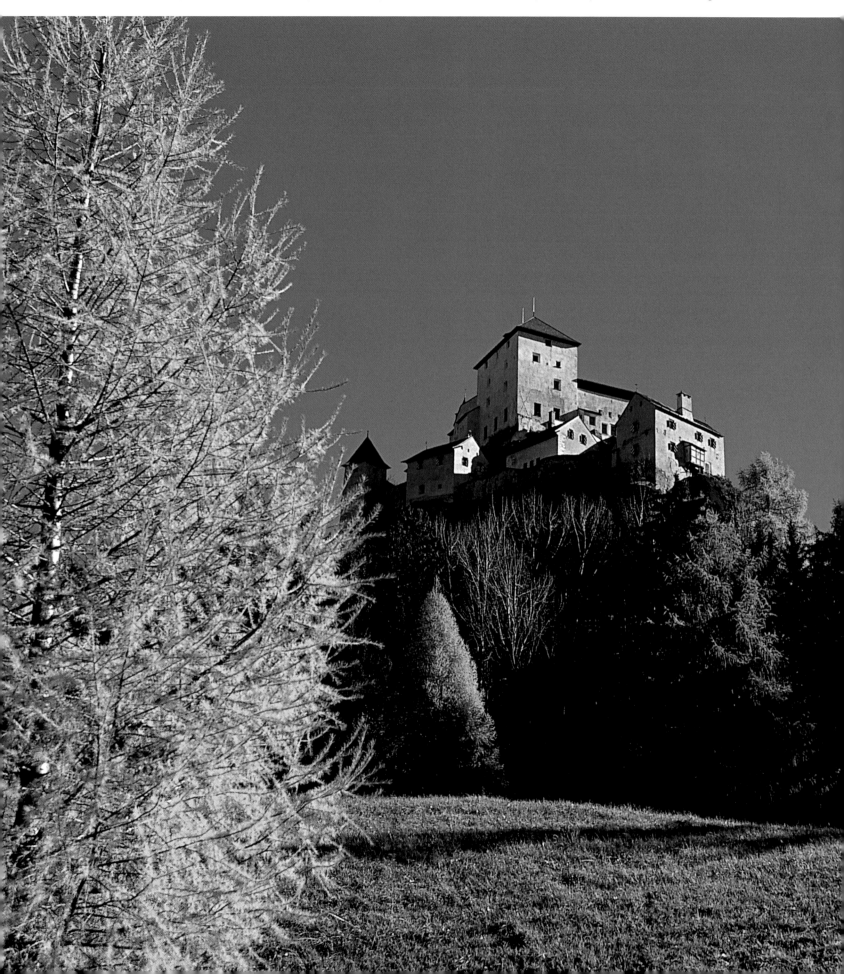

Below:
Autumn in the Lower Engadine. Once the seat of Austrian governors, during the 20th century a Dresden industrialist had the dilapi- dated Schloss Tarasp com- pletely refurbished. The castle museum has a collection of valuable rural furniture from Graubünden and Tyrol.

Top right:
Typical of the villages of the Lower Engadin, the quieter, wilder stretch of the Inn Valley, is Ardez, perched among Alpine meadows high up above the road.

Centre right:
The Müstair Valley, tucked away in the southeastern- most corner of Graubünden, is only accessible via the Ofen Pass (2,149 m / 7,051 ft). The monastery dedicated to St John the Baptist near Santa Maria at the end of the valley is said to have been founded by Charlemagne. A rare example of Carolingian architecture with early medieval ceiling frescos, the edifice is a UNESCO World Heritage Site.

Bottom right:
During the 19th century wealthy manufacturer of chocolates and liqueurs Giovanni de Castelmur built himself a lavish "palazzo" in the middle of the lush fields of his native Bregaglia Valley.

Once termed a "cheese-coloured monument to a confectioner's delusions of grandeur" (R. Just), the palace is now a nostalgic museum devoted to the great international Graubünden coffee house tradition.

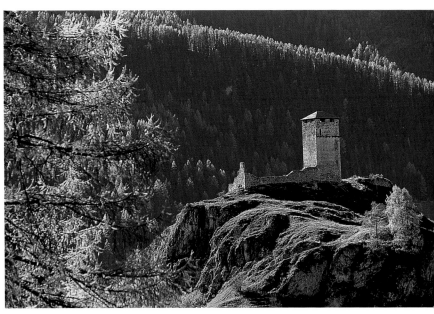

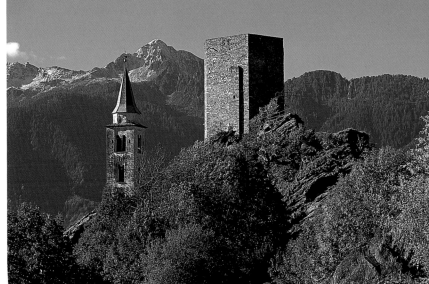

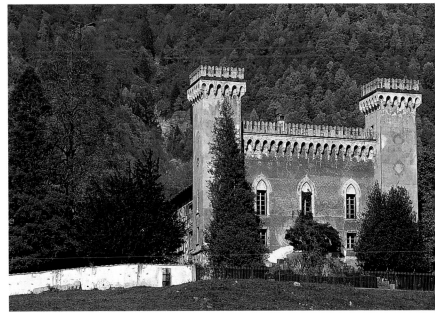

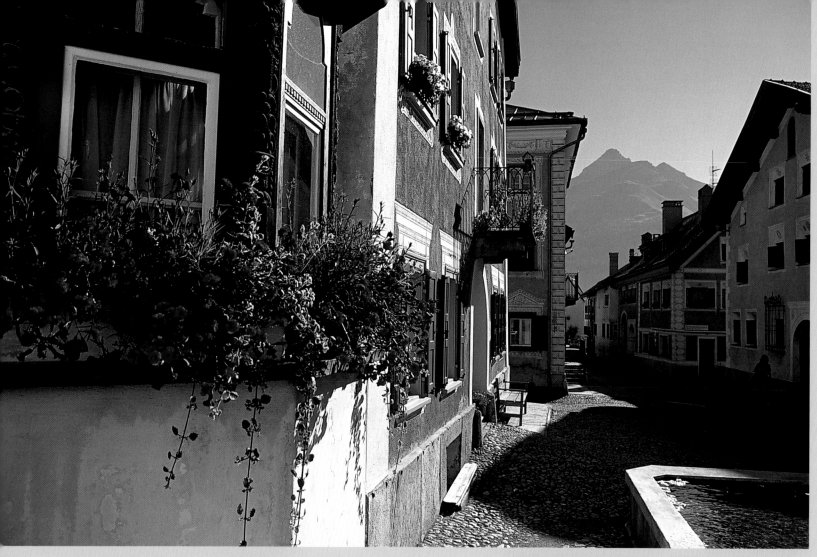

Above:
S-chanf, an elongated
village with several beautiful
old stone houses and an
authentic Romansch name,
is the point of departure
for forays out into the
Swiss National Park on the
Italo-Graubünden border.

Right:
Zuoz, a mile odd south of
S-chanf, was once the
principle town of the
Engadine. Ancient log cabins
with only the corners in
stone have been preserved;
in the 16th century this style
of building was replaced
by houses built entirely of
stone.

Left:
There are also log cabins adorned with flowers in Guarda, a tiny hamlet with just 200 inhabitants high up above the road at the south end of the Silvretta range.

Below:
The Clalgünahaus in Ardez not far from Guarda has the decorated oriels and folk art sgraffito typical of the Engadine.

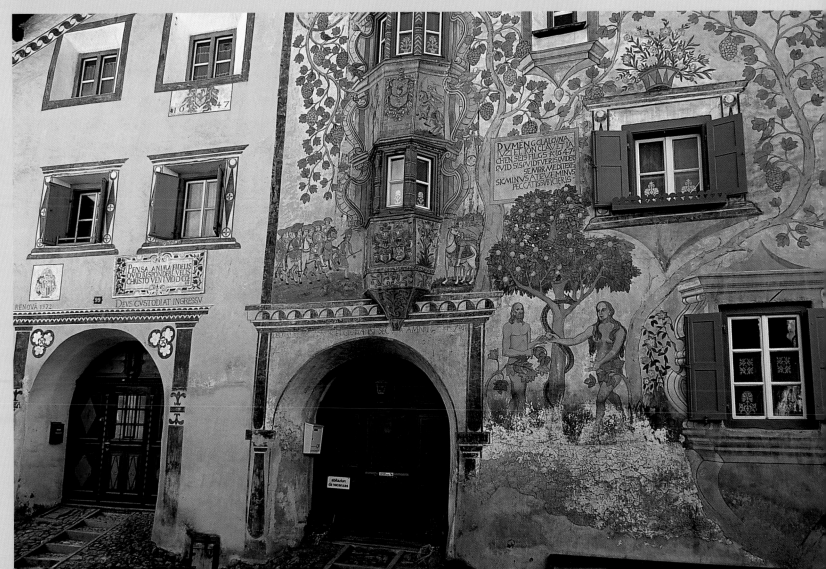

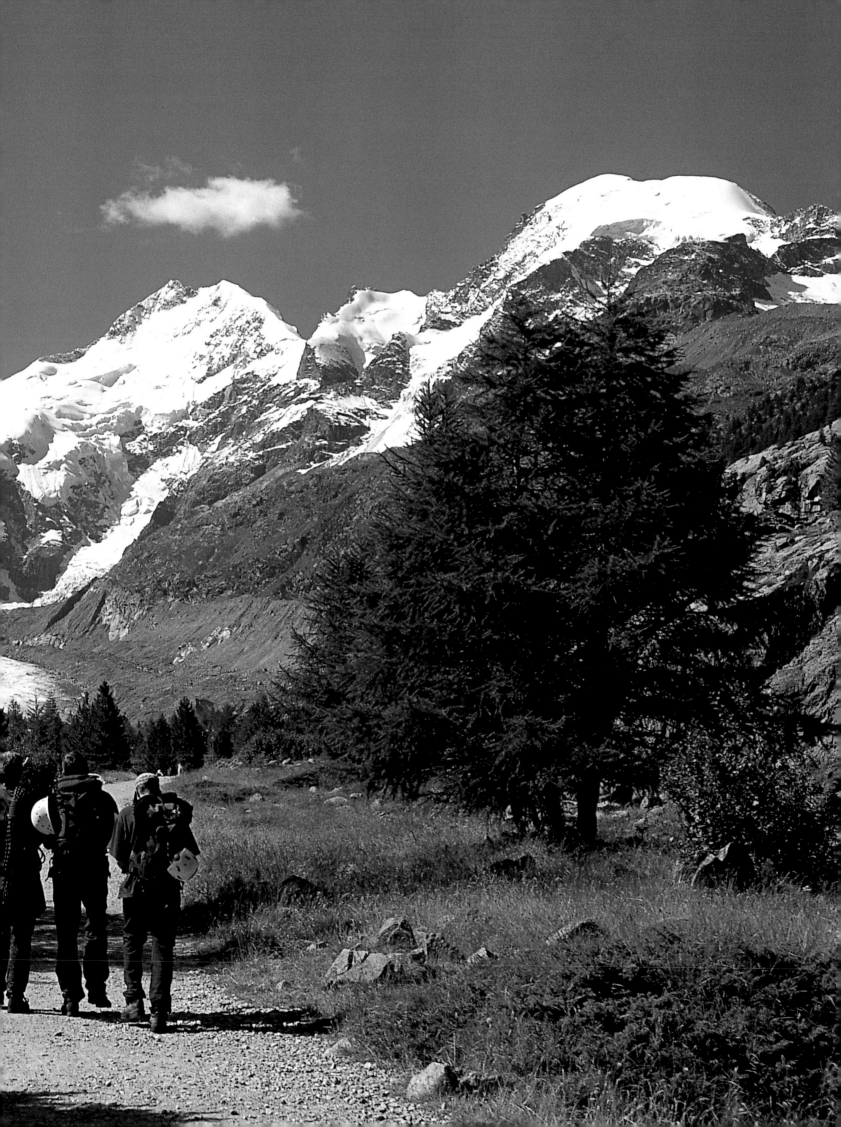

Page 132/133:
Near the Bernina Pass on
the way from St Moritz to
northern Italy the road opens
out onto the Morteratsch
Glacier and the peaks of Piz
Morteratsch, Piz Palü, Bella-
vista and the over 4,000 m
(13,000 ft) of Piz Bernina.

Below:
Soglio in Graubünden's Bre-
gaglia Valley is surprisingly
opulent with its baroque,
Italian-style "palazzi" more
reminiscent of a big city than
a small village. The local
Salis family were largely
responsible for the lavish
beautification of their
native town. For centuries
they were one of the ruling
dynasties of Graubünden
with far-reaching political
and economic privileges
which even included the right
to mint their own coins.

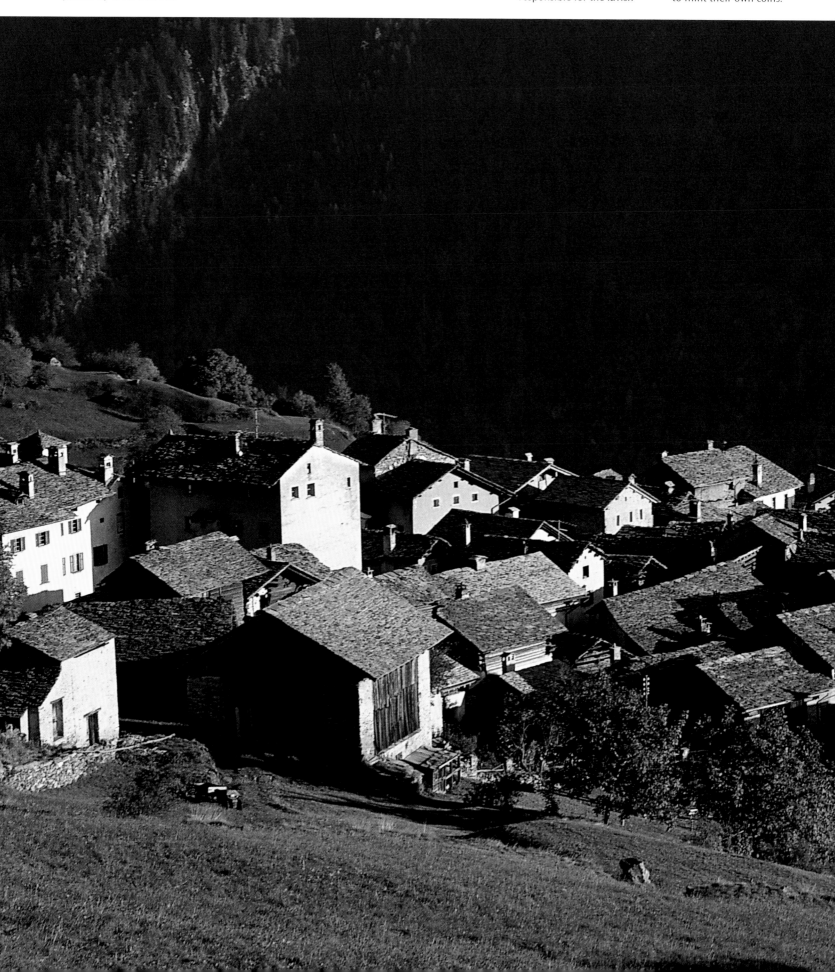

Soglio has received famous guests; Rainer Maria Rilke browsed the Salis library here and Alberto Giacometti was another summer visitor. Soglio is now better known for its chestnuts, harvested from the areas of forest surrounding the village.

Bottom right:
The Calanca is the most westerly and most remote of Graubünden's southern valleys. Some of the villages can only be reached on foot or by cable car or chair lift. In Arvigo, for example, time seems to have stood still.

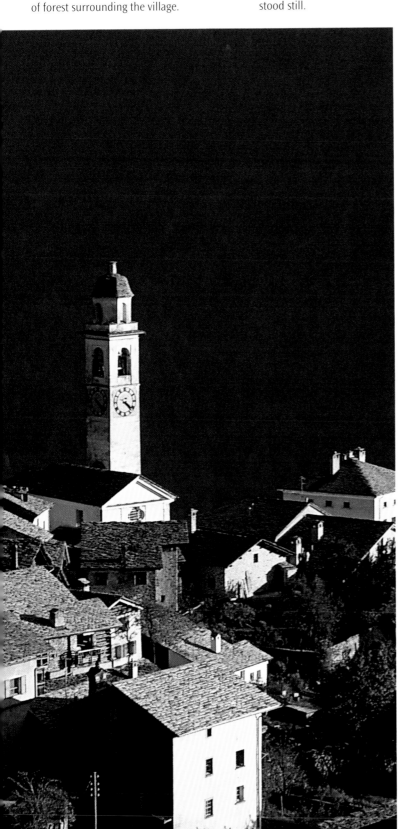

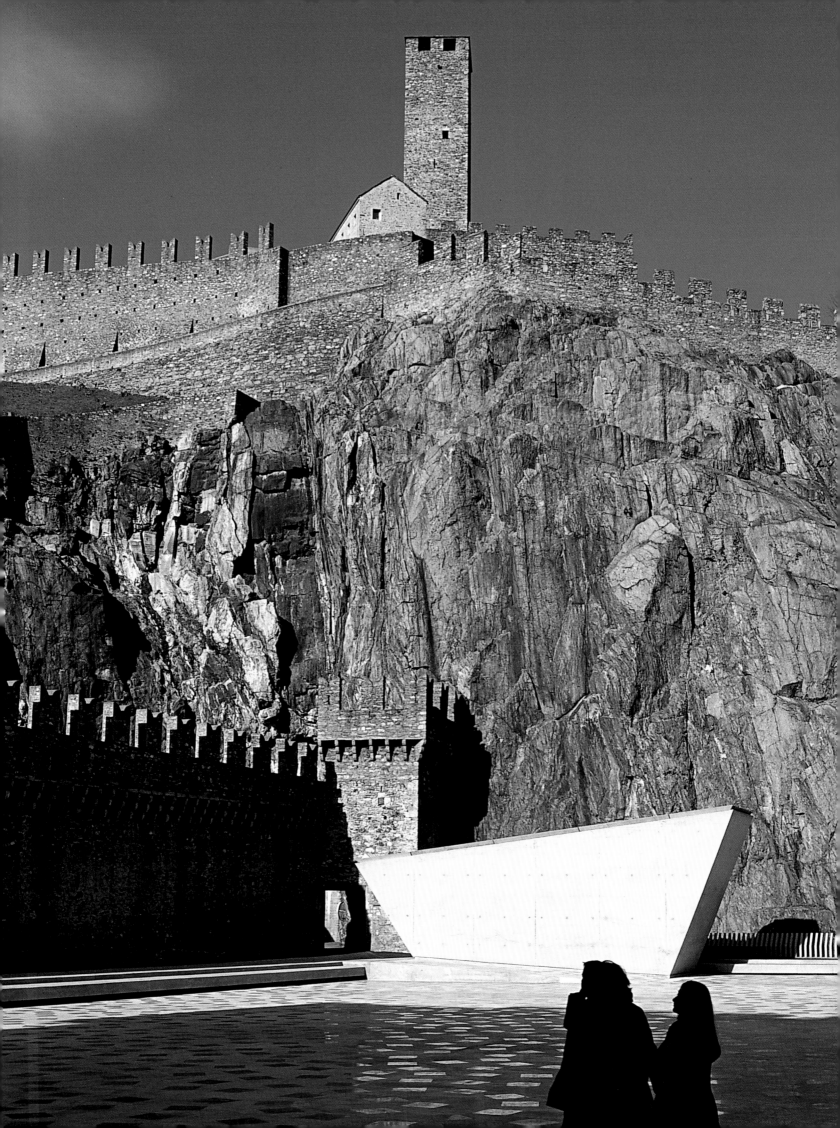

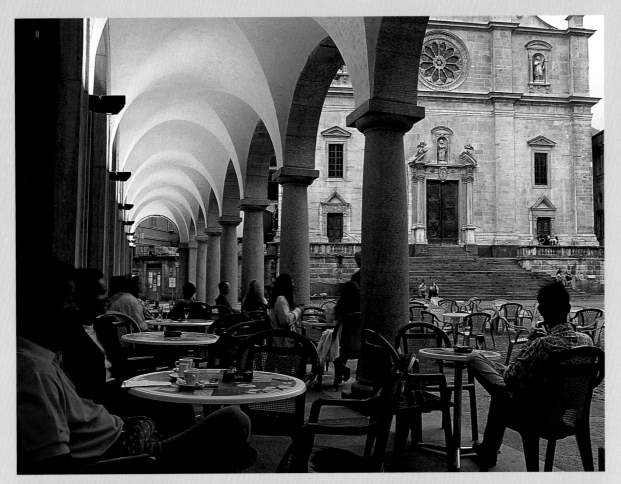

The roads leading across the Gotthard, San Bernardino and Lukmanier passes converge in Bellinzona. The Romans erected a mighty fortress here, on the foundations of which the defensive Castello Grande was later erected as a final place of refuge by the dukes of Milan and, after 1500, the Confederates.

Sitting under the Rococo arcades lining Piazza Collegiata and sipping a cappuccino or a Grappa nostrano ticinese you can admire the fantastic facade of SS. Pietro e Stefano with its multifoil rose window.

The town hall in Bellinzona, the capital of the canton of Ticino. The neo-Renaissance courtyard is the most impressive part of the Palazzo Civico, constructed in 1924.

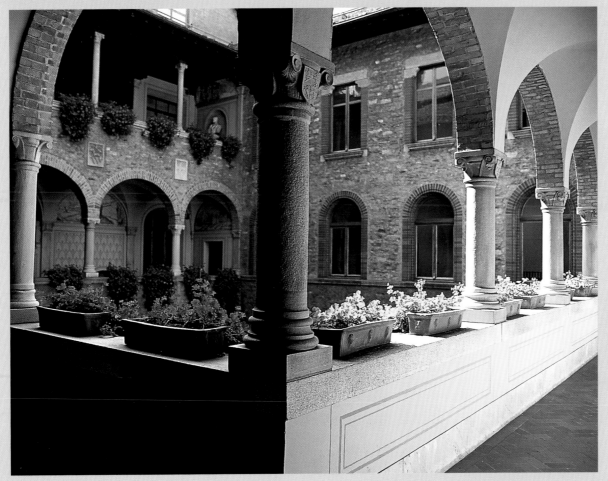

137

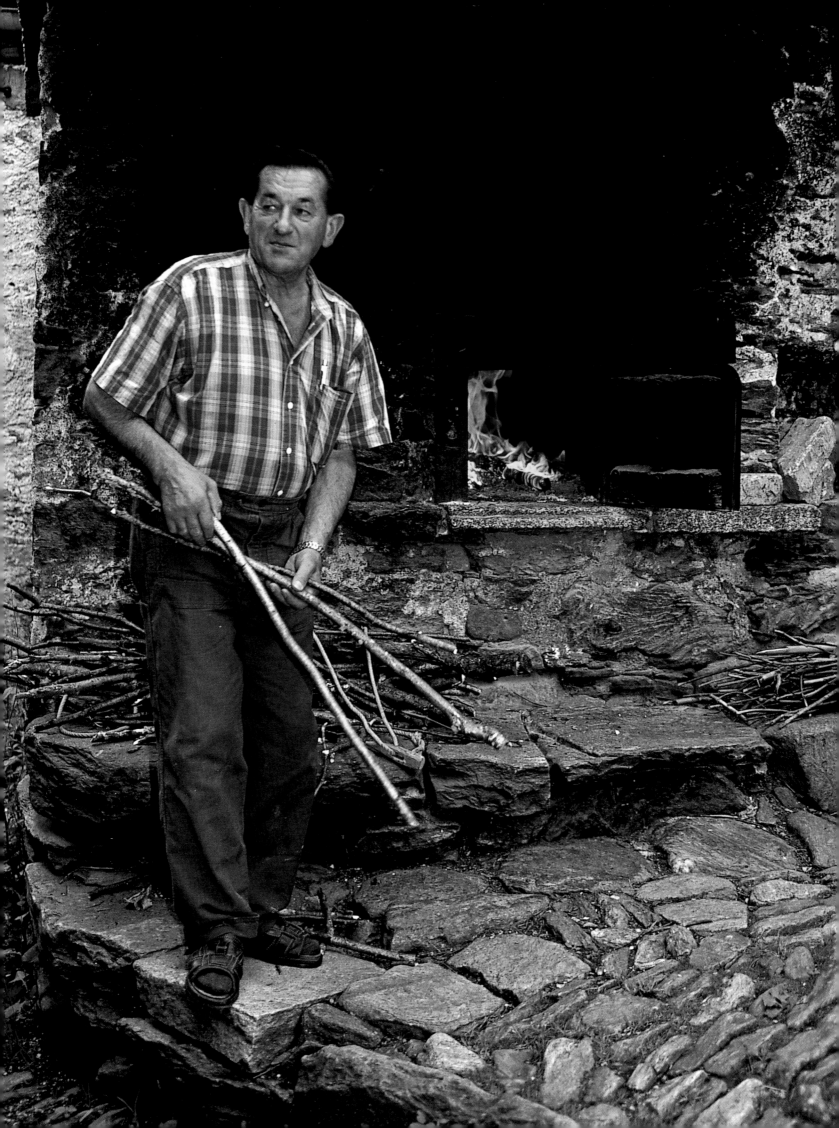

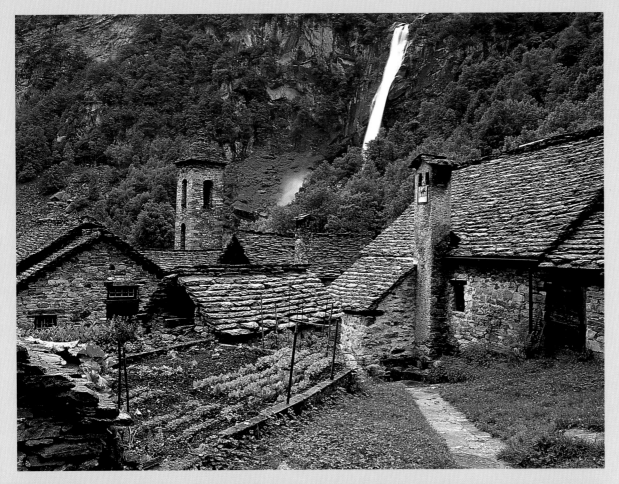

Left page:
North of Locarno runs the glacial Ice Age gap of the Verzasca Valley. In isolated Sonogno, the highest village in the valley, much of Ticino's mountain culture has remained intact. The villagers have their own dialect and still bake their bread in the traditional manner at the community bakehouse.

The villages of the Bavona Valley, an offshoot of the Maggia Valley, are marked by a wild beauty and only populated in summer. Foroglio, whose chapel of Santa Maria Assunta affords grand views of the waterfall, is also abandoned in winter.

The practically deserted village of Corippo in the Verzasca Valley has a historical unity so rarely found in Ticino. Its typical stone houses have been built into the hillside so that the various storeys are often accessed from different street levels.

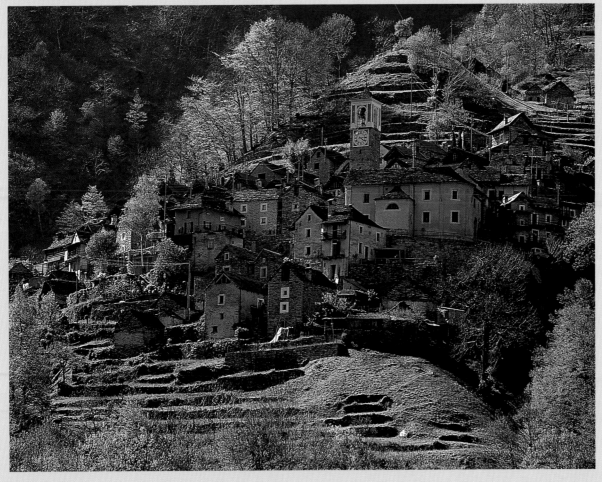

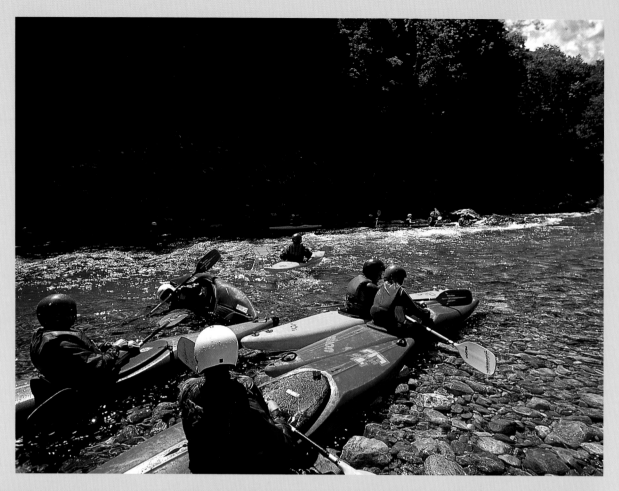

Right:
The Maggia Valley (Valle Maggia) is a hot favourite with canoe and kayak sports-men and -women. The clear, blue water is extremely clean, the scenery magnificent. The difficult stretch of river with its fierce current near Gorde-vio presents a particularly exciting challenge.

Below:
West of the mouth of the Maggia is Centovalli, the valley of a hundred valleys, whose inhabitants tradition-ally plied their trade as chimney sweeps in Italy. At Intragna at the confluence of the Isorno and Melazza rivers a stone bridge daringly spans the valley floor.

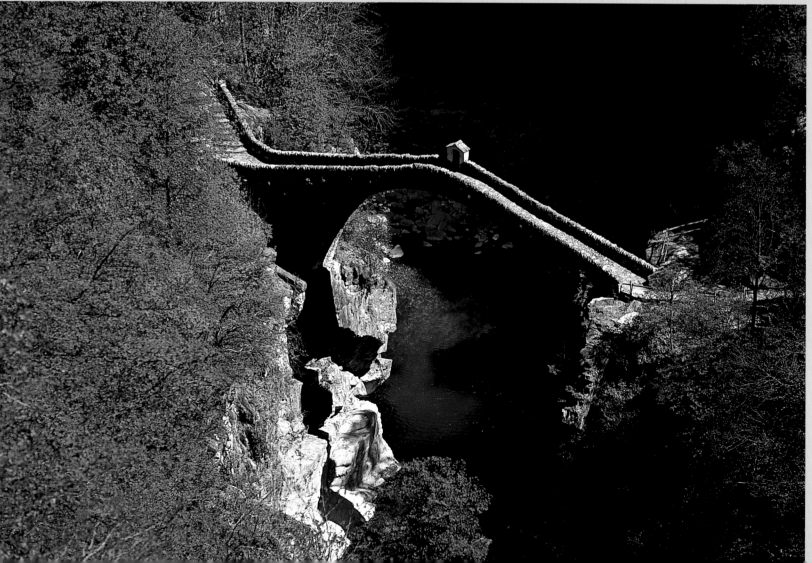

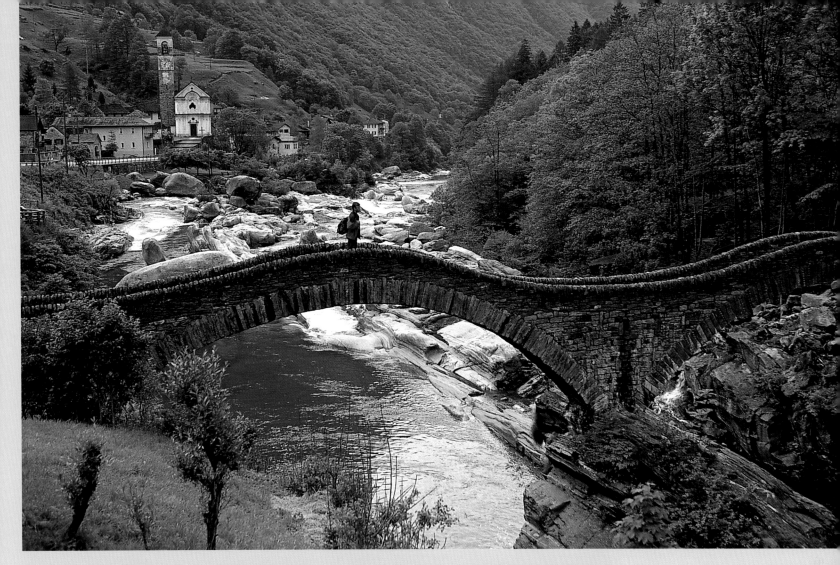

Above:
Outside Lavertezzo, which in Santa Maria degli Angeli has the only baroque church in the Verzasca Valley, the twin arches of the Ponte dei Saltri provide a safe crossing over raging torrents. The river is so wild that swimming here is strictly forbidden.

Left:
In the striking gorge at Ponto Brolla the Maggia has hewn bizarre shapes out of the granite rock. Along its last few miles from here to the estuary at Lake Maggiore the river has been canalised and tamed.

"PROSE IS THE WORK OF A SNAIL" (CARL SPITTELER) –

SWISS LITERATURE

Montag, den 8. November 1920
im kleinen Tonhallesaal

2. Abend des Lesezirkels Hottingen

Zwei Schweizerdichter

1. Robert Walser: Verse und kleine Prosa.
2. Karl Stamm: Seine Persönlichkeit und seine Lyrik,
dargestellt von S. D. Steinberg.

Anfang 8 Uhr, Ende um 9½ Uhr

Eintrittskarten Fr. 6, 5, 4, 3 und 2: a) für Mitglieder bis Freitag im Bureau, Gemeindestraße 4, und bei Kuoni (Bahnhofplatz), b) für jedermann von Samstag bis Montag nachmittags 4 Uhr ebenda, ferner Montag abends von 7 Uhr an an der Tonhallekasse

Above:
In 1920 Robert Walser was given the rare opportunity of presenting himself and his work at a literary reading in Zürich which also featured the poems of the late Karl Stamm. Towards the middle of his life Walser became very confused, spending his final 25 years in a psychiatric clinic in Herisau.

Right:
"Der Richter und sein Henker" (The Judge and his Hangman), Friedrich Dürrenmatt's best-known novel, was written out of financial necessity and published in eight instalments in the "Beobachter" newspaper. In 1956 Franz Peter Wirth made a film of the book from a screenplay penned by the author. The vicar's son (1921–1990) was primarily famous for his plays, however, among them "Der Besuch der alten Dame" (The Visit).

Books in Switzerland are written in four different languages, making their reception neither within nor outside the country particularly easy. Swiss-German authors don't write in their mother tongue, the thick dialect of the east, but in standard German. Only a few, such as Kurt Marti or Franz Hohler, use the Swiss-German vernacular, largely sacrificing any chances of an international readership in doing so. Other authors live in areas whose languages they haven't really mastered: Friedrich Dürrenmatt from Emmental in French-Swiss Neuchâtel, Max Frisch from Zürich in Rome, Berlin and Ticino, and German ex pat Hermann Hesse in the sunny climes of Switzerland's Montagnola. Several major Swiss-German works have been penned in Berlin, such as Gottfried Keller's "Grüner Heinrich" (Green Henry) – after Goethe's "Wilhelm Meister's Apprenticeship" the most significant Bildungsroman in German Literature – and Robert Walser's trilogy "Geschwister Tanner", "Der Gehülfe" and "Jakob von Gunten".

French-Swiss authors are often drawn to their French-speaking neighbour, out of cultural rather than linguistic necessity. The most famous Swiss Romand of the 20th century, master of the lyric novel Charles-Ferdinand Ramuz, spent the second half of his life in Paris.

Fleur Jaeggy from Ticino has lived in Milan for years where in her miniaturist Italian prose she explores the most secret areas of the female Swiss soul.

Romansch or Rhaetro-Roman literature constitutes the smallest percentage of Switzerland's literary output and is easily overlooked. Like their Swiss-German colleagues, authors of the younger generation, such as Leo Tuor and

Left:
Robert Walser (1878–1956) spent his most creative years in Berlin from 1905 onwards. The breakthrough he dreamed of never occurred, however, and in 1913 he returned to Switzerland. Until his final silence in 1933, in minuscule writing he pencilled a series of "micrograms", a total of ca. 4,000 pages of modern, self-reflective prose of the highest artistic calibre.

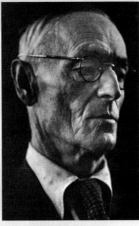

over 100 years ago between 1880 and 1881, they are still the most frequently translated and purchased books to come out of Switzerland. The story of the witty Swiss orphan from Maienfeld in Graubünden, suffering from homesickness at her aunt's in Frankfurt until allowed to finally return to her beloved Swiss grandfather Alpöhi and Peter the goatherd, has been filmed over 20 times and is due to hit the box offices this year in a completely new guise. The transfiguring myth of Heidi has done much to mould the image of Switzerland across the globe.

Unlike Heidi the life and work of the first and to date only "proper" Nobel Prize winner from Switzerland, Carl Spitteler, are long forgotten. Born in 1845 in Liestal, Spitteler created a genre of narrative poetry based on the works of the Greeks and the epic poets of the Italian Renaissance which even in his lifetime no longer captured the spirit of the age. The dedicated speech he delivered in Zürich in December 1914 had more impact than his entire oeuvre put together; entitled "Our Swiss Standpoint", in it Spitteler warned of identifying too closely with the warring neighbouring states, calling for neutrality and national concord. His unambiguous statements may have contributed to his chief work "Olympischer Frühling" (The Olympic Spring) being awarded the Nobel Prize for Literature in 1919 – the first to go to a German-speaking writer who was not German.

Above:
Almost the only work by Conrad Ferdinand Meyer (1825–1898) to still be read today is the text on Jürg Jenatsch, army commander of Graubünden during the Thirty Years' War. In his other novels he also tackles – with aristocratic finesse – the existential conflict of great historic personalities bewitched by power.

Top centre:
Gottfried Keller (1819–1890), one of the great realist narrative writers of the 19th century, wrote his main work "Der Grüne Heinrich" (Green Henry) in 1855 in Berlin. After a period of deprivation abroad he returned to Zürich to spend 14 years as clerk to the canton, prompting the description of "reconciled, bourgeois, pacified artist".

Top left:
Hermann Hesse was born in 1877 in Calw in Swabia, yet lived from 1919 until his death in 1962 in Montagnola on Lake Lugano. Like Spitteler before him after the First World War in 1919, in 1946 Hesse, a German-speaker who was considered 'politically sound', was presented with the Nobel Prize for Literature.

Flurin Spescha, tend to now write in High German.

The most famous figure in Swiss literature is Heidi from the novels by Johanna Sypri. Written

143

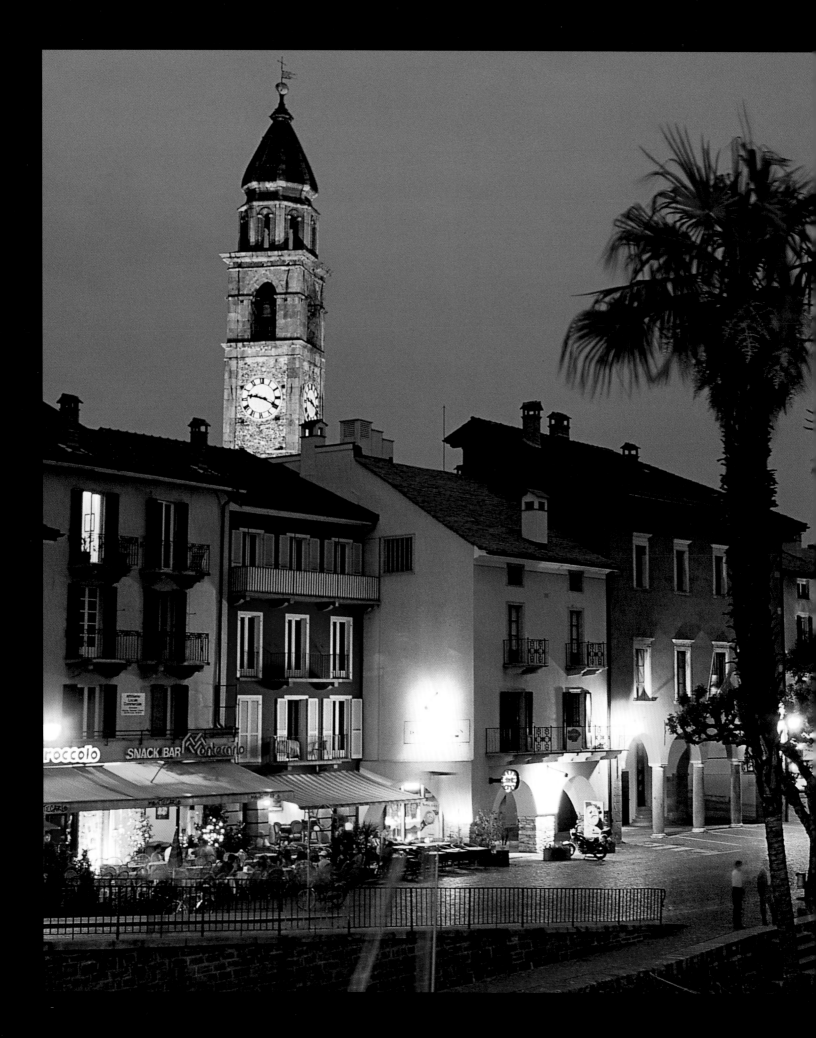

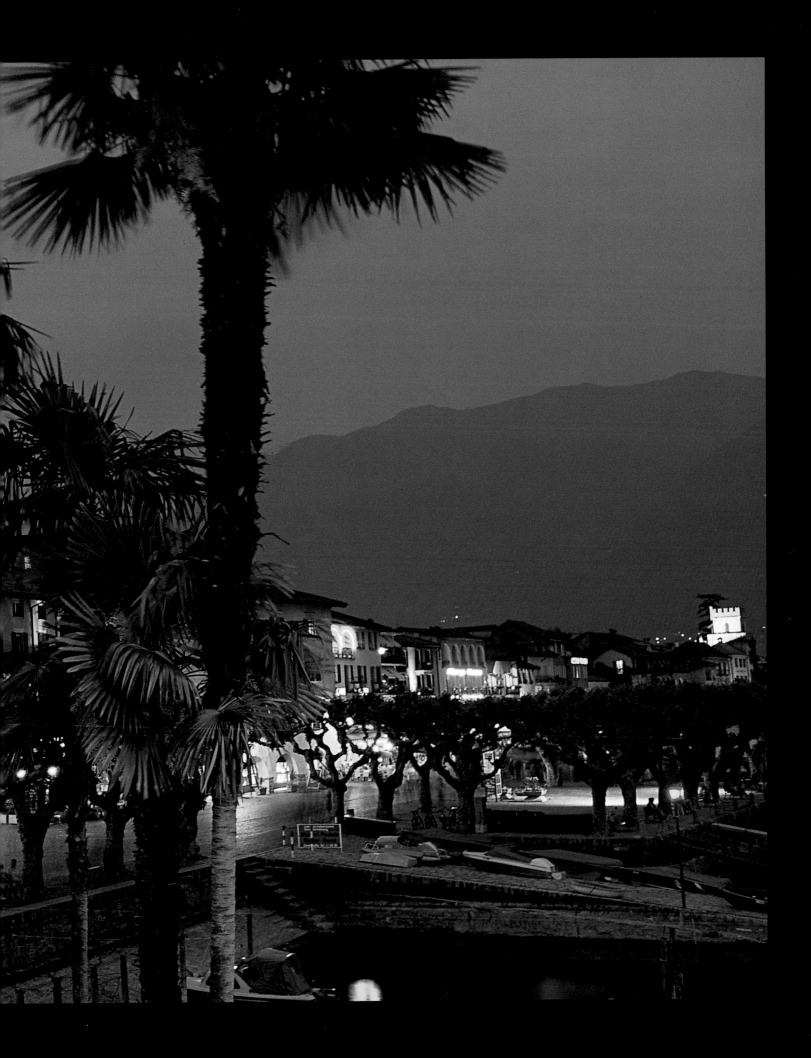

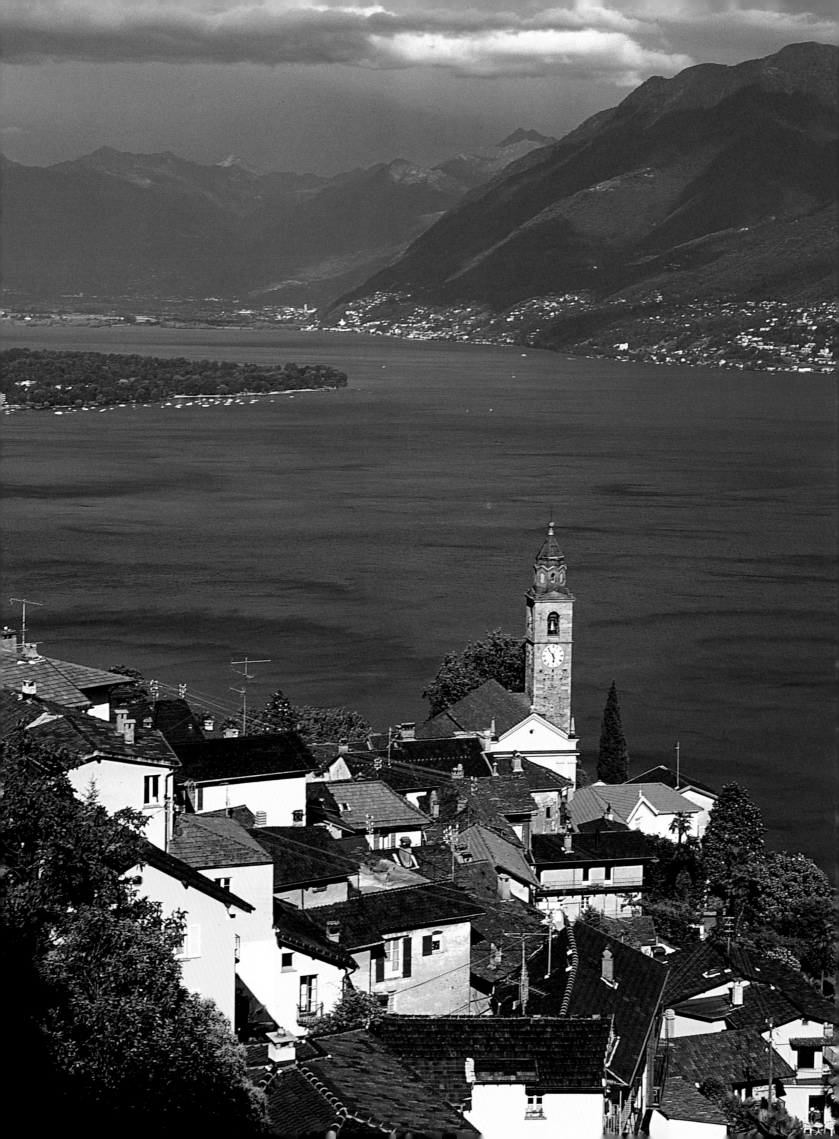

Left page:
Ronco sopra Ascona, perched on a rocky ledge high up above Lake Maggiore and the Isles of Brissago, was once a popular artistic domain. From the little town, with its narrow streets and twining archways, there are stunning views of the surrounding countryside.

The Isles of Brissago in Lake Maggiore are known for their particularly mild climate; the temperature only sinks below freezing for just two weeks in the year. The conditions are thus ideal for Ticino's cantonal botanical gardens, laid out on the largest of the two islands, Isola di San Pancrazio. Huge eucalyptus trees vie with vibrant rhododendrons and azaleas for the attention of the island's horticultural visitors.

Locarno on Lake Maggiore wallows in the warm autumn sunshine while storms rage further north.

Page 144/145:
SS. Pietro e Paolo's campanile pokes up from behind the houses and palms along the lakeside promenade in Ascona, bathed in the warm evening light. Introduced to northern Europe around 100 years ago, palms thrive on all of Ticino's lakes.

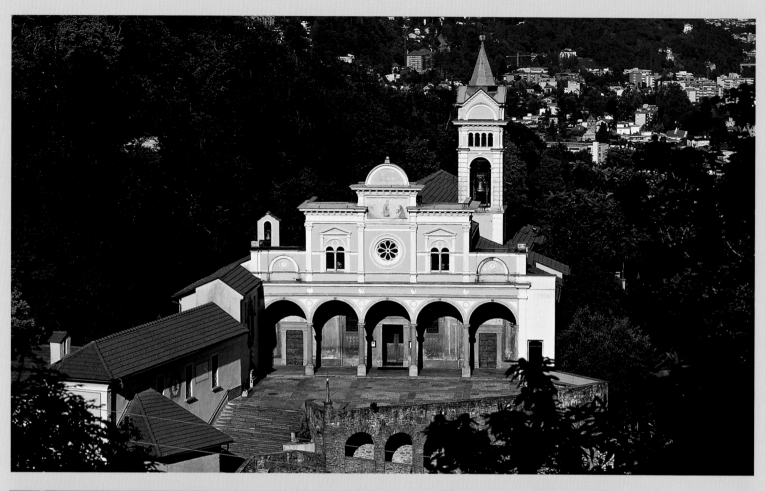

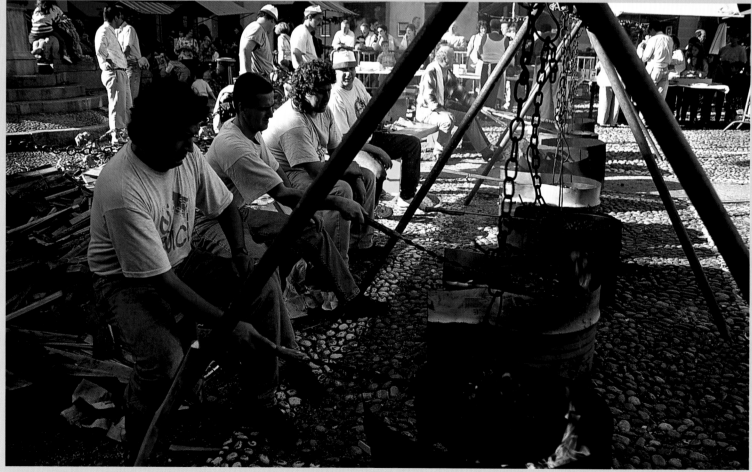

Left:
The pilgrimage church of Santa Maria Assunta, better known as Madonna del Sasso (the madonna of the rock), protectively guards the town below. The story goes that in 1480 the Virgin Mary appeared before a monk in an apparition. A Capuchin monastery takes care of the many pilgrims who come here, leaving a museum of votive tablets in the church in their wake.

Below:
In August film stars and wannabes throng the Piazza Grande in the heart of Locarno for the second-oldest film festival in Europe. Throughout the year the square is otherwise the venue for the weekly Thursday market selling fruit, vegetables and fish grown and caught locally.

Below:
Locarno takes its name from the River Maggia, the Celtic "Leukera" or "white river" which flows into the lake here. The permanent floral array along its banks would make "the colourful river" a more fitting epithet.

Left:
Chestnuts or "marroni" from Ticino are famous all over Italy. In the past many a young man from the canton has tried his luck as a chestnut seller south of the Alps. In Locarno during the Castagnata festival the autumn chestnut harvest is cause for celebration.

149

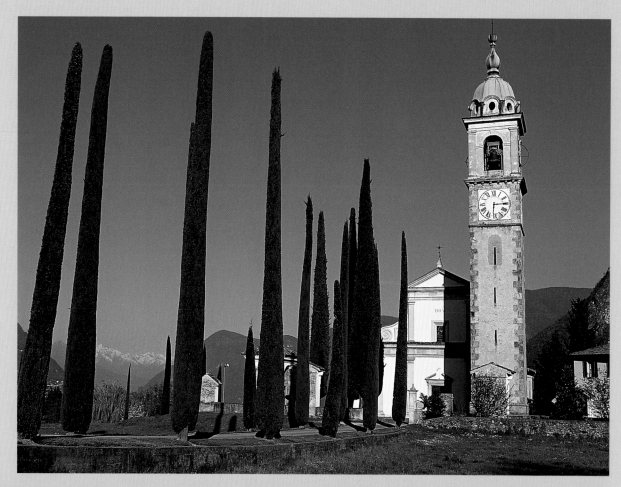

Right:
Near Gentilino the free-standing bell tower of San Abbondio competes with the cypress trees to see who is nearer to the gates of Heaven. The complex dates back to the 16th and 17th centuries.

Below:
The villa quarter of Castagnola at the foot of Mount Brè with its baroque church of San Giorgio and beautiful old mansions effuses a faded elegance and wealth. The cemetery is a mecca for motor racing fans; racing driver Rudolf Caracciola (1901–1959) lies buried here.

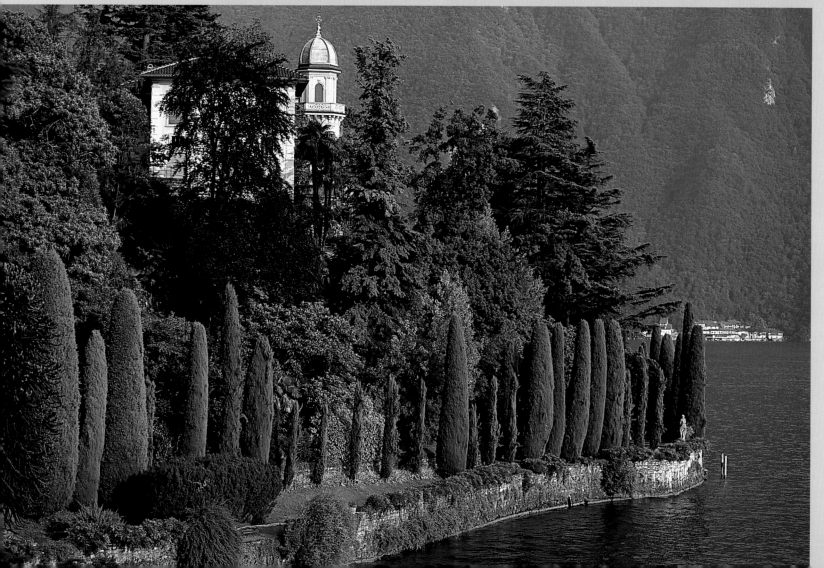

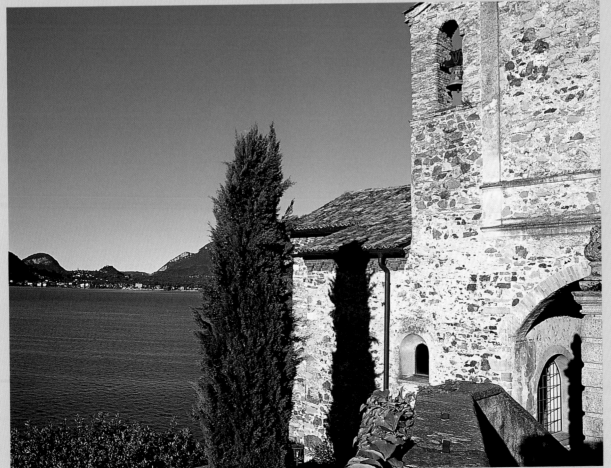

Above:
The picturesque little town of Gandria clings to the steep precipice high up above Lake Lugano like a swallow's nest. Only accessible by boat or on foot, in the past its vicinity to the Swiss-Italian border was used to advantage by local smugglers. Today the town makes a more honest living from its restaurants boasting panoramic views.

Left:
The chapel of Sant'Antonio Abate outside Morcote was founded by French monks in the 14th century. The frescos in its interior show scenes from the lives of various apostles and the Holy Family.

Page 152/153:
Lugano, the "pearl of Lake Lugano", sparkles in the sunset, wedged protectively between the two local mountains San Salvatore and Mount Brè.

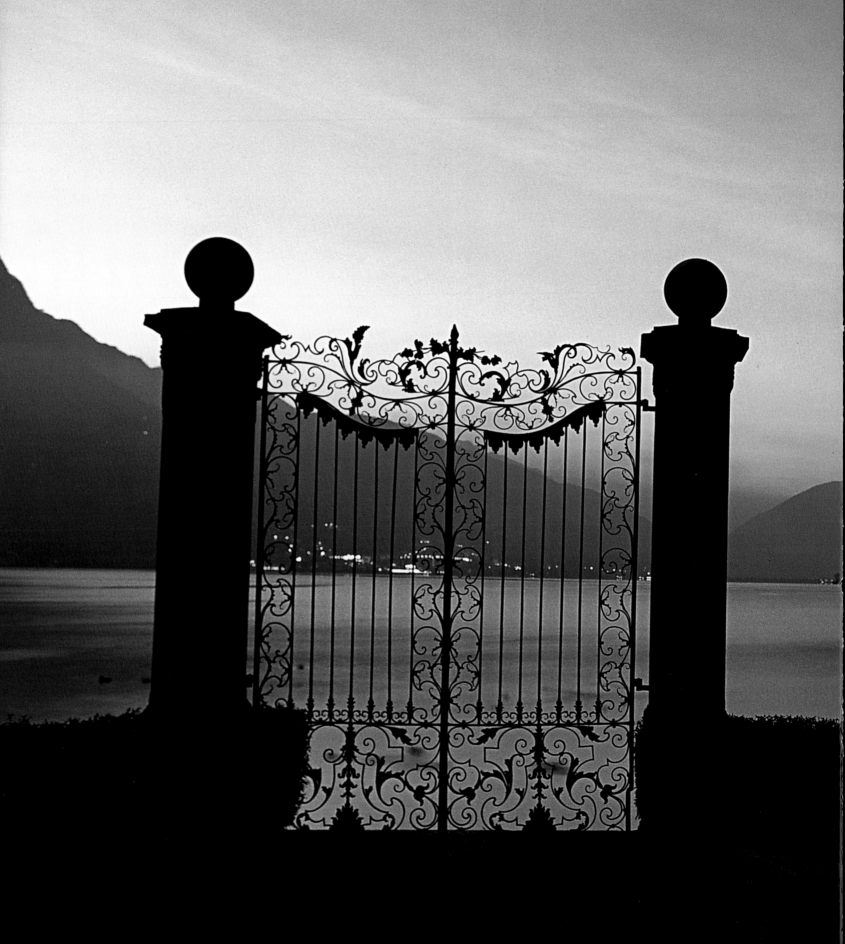

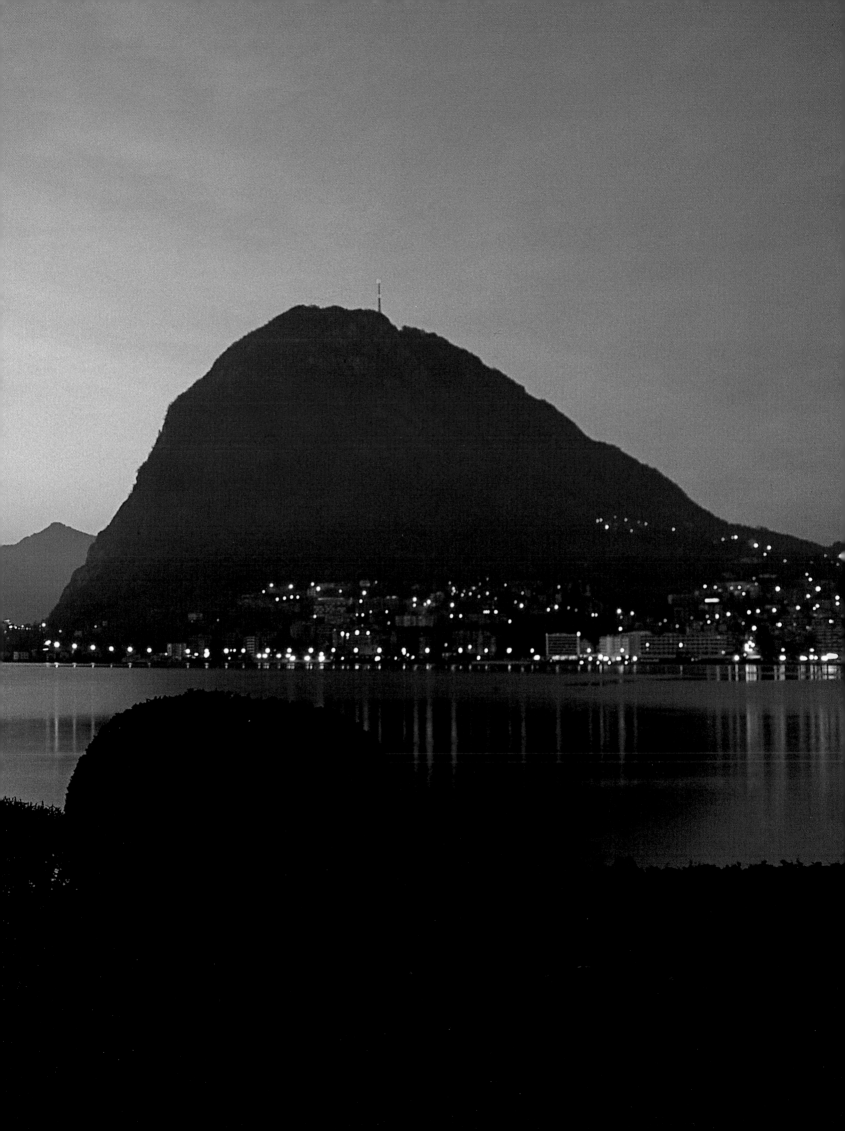

INDEX

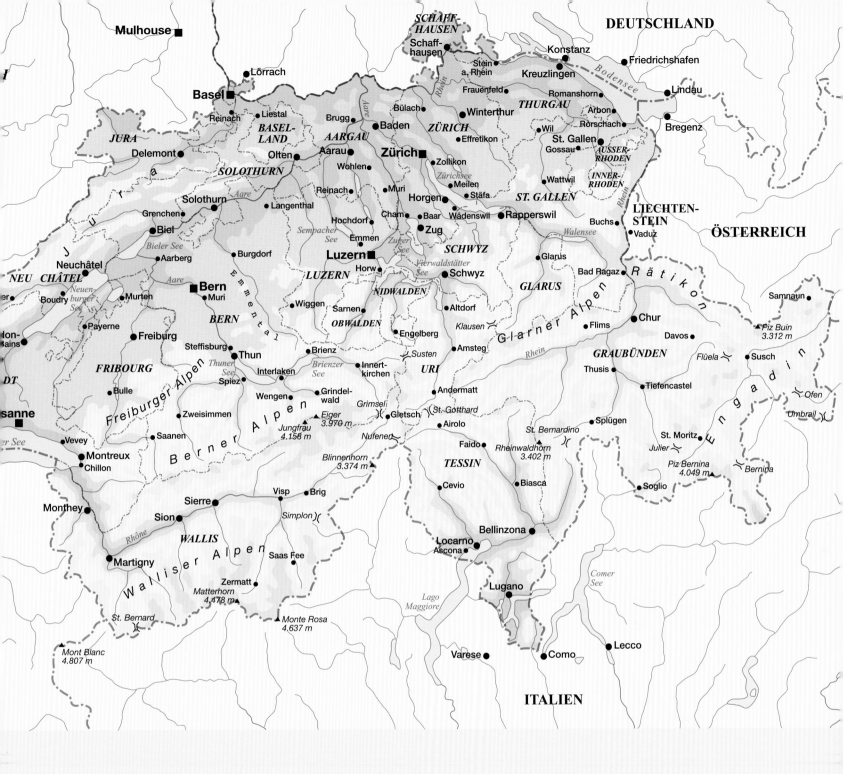

CREDITS

Design
silberwald-Agentur für visuelle Kommunikation
www.silberwald.biz

Map
Fischer Kartografie, Aichach

Translation
Ruth Chitty, Schweppenhausen

Printed in Germany
Repro by Artilitho, Trento, Italy
Printed and bound by
Offizin Andersen Nexö, Leipzig

© 2006 Verlagshaus Würzburg GmbH & Co. KG
www.verlagshaus.com
© Photos: Roland Gerth

ISBN-13: 978-3-8003-1720-2
ISBN-10: 3-8003-1720-6

A last glimpse of Morcote on Lake Lugano:
Ciao, Svizzera; Au revoir, Suisse; Sin seveser,
Svizra; Auf Widerluege, Schwyz!